LINCOLN'S ASSASSINS

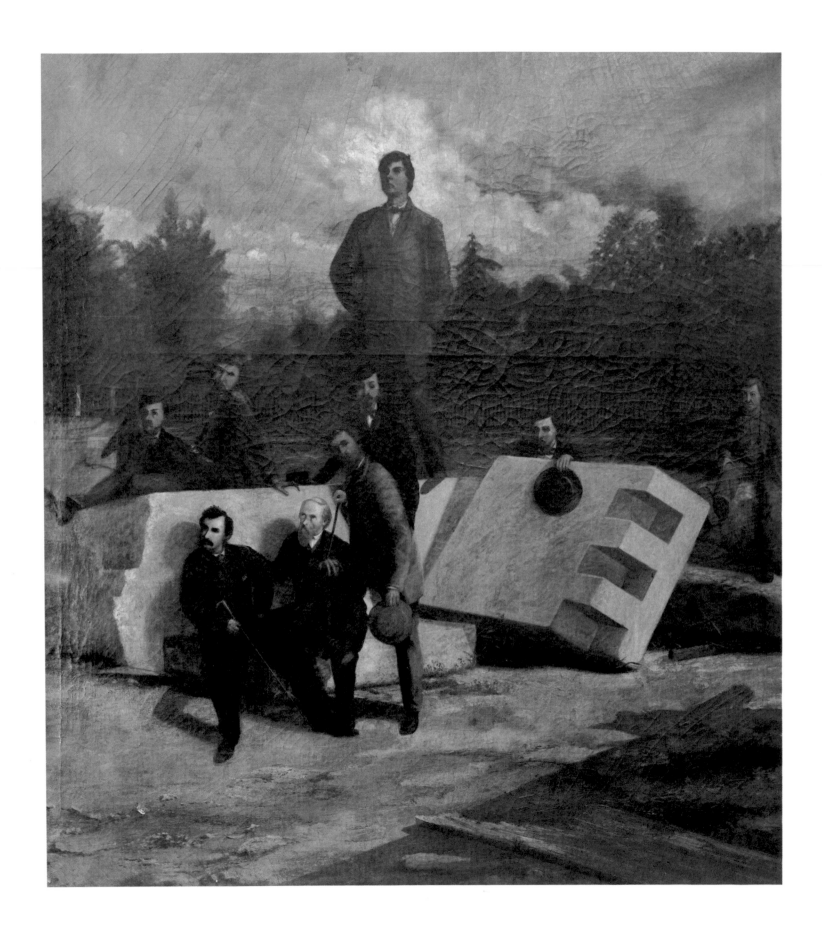

LINCOLN'S ASSASSINS
Their Trial and Execution

An Illustrated History

by

James L. Swanson and Daniel R. Weinberg

WILLIAM MORROW
An Imprint of HarperCollinsPublishers

Previous page, frontispiece. Conspirators' tableau. A fanciful painting of John Wilkes Booth and his associates on the grounds of the U.S. Capitol as they watch Abraham Lincoln deliver his second inaugural address on March 4, 1865. Major General Lew Wallace, who served on the military commission that tried the assassination conspirators (and who later wrote *Ben Hur*), was also an amateur artist who sketched the defendants during their trial and painted this group portrait. *First row, left to right:* John Wilkes Booth, Dr. Samuel A. Mudd, John H. Surratt; *second row, left to right:* Samuel Arnold, George Atzerodt, David Herold, Michael O'Laughlin, Edman Spangler; *third row:* Lewis Powell.

PREFACE

PERHAPS WE SHOULD SAY AT THE OUTSET what this book is not. It is not a complete history of the great crime of the nineteenth century—the assassination of Abraham Lincoln. Nor is it a biography of his murderer, John Wilkes Booth, or of the actor's band of conspirators. It is not a full account of the events of April 14, 1865, of what happened at Ford's Theatre, of the assassin's escape into the night, or of the deathbed vigil for the president.

Instead, this book is about what happened after the assassination—after the frantic hunt for Booth and his accomplices was over, after the mourning and grand funeral pageant for the nation's beloved president, after both Lincoln and his murderer were dead and buried. This book tells the story of what happened next, when eight alleged conspirators in the assassination were put on trial for their lives.

Although the subject of our book is the great conspiracy trial of 1865 and the fate of the accused, we have made no attempt to write the definitive history of that proceeding. The trial lasted several weeks, featured more than three hundred witnesses, resulted in a transcript of several thousand handwritten pages, and yielded a number of contemporary published accounts that vary wildly in accuracy and completeness. It would take a volume of several hundred pages to tell the complete story of the trial. Nearly a century and a half later, that book has not been written, but it should be.

The trial was a landmark in the history of American journalism and popular culture. Nothing like it had ever happened before. As one commentator observed, "No other event in history so affected this country as did the assassination of Lincoln. Lincoln's death stood out in people's minds in the same way that a solar eclipse or a convulsion of nature had stood out in earlier ages. From it people dated things before and after."

Our book is the first illustrated history of the arrest, trial, and execution of Abraham Lincoln's assassins. We examine not only what happened in the spring and summer of 1865 but also how the events were reported to the American people. We interpret the events not through modern eyes but through the prism of nineteenth-century American popular culture. In many ways, our book is a history of the customs and practices of journalism, publishing, and photography at the close of the Civil War.

The story of the trial and execution of the Lincoln conspirators is, in part, the story of nineteenth-century commercial publishing, popular tastes, technological limitations on printing and photography, and news gathering and marketing for mass consumption. It is also a story of how people participated in the great events of their time by purchasing the products of material culture. Americans devoured newspapers and extras to learn every detail of the assassination and death of the president. They wore mourning badges and silk ribbons on their clothing and displayed freshly made prints and broadsides in their homes.

The trial of the conspirators transfixed the nation. They became the media celebrities of the season. The public had an insatiable demand for information about the conspirators, and newspapers reported every detail of their capture, physical appearance, and demeanor. Photographer Alexander Gardner visited them while they awaited trial. He made their portraits and then sold carte-de-visite copies to a fascinated public. Newspapers, illustrated weeklies, pamphlets, and books included woodcut likenesses, along with breathless histories of the conspiracy that were written even before the trial was over. The trial became a popular entertainment, especially among newlyweds. A ticket to the court-room was a coveted prize, and many prominent politicians, officers, and ladies enjoyed the visitors'

gallery. Aside from these lucky few, the rest of the nation read daily transcripts of the proceedings in the major newspapers. Later, rival publishers hawked competing, book-length transcripts.

Execution day, July 7, 1865, was more than the climax of the conspiracy trial. It was also a seminal event in the history of American journalism. For the first time, reporters, artists, and a photographer gathered in advance to cover a planned historical event—perhaps the first successfully staged multimedia event in American history. Adding to the excitement, one of the condemned would be the first woman ever executed by the U.S. government. Talented newspaper writers reported every detail, sketch artists captured the scene for woodcuts, and Alexander Gardner, in perhaps the most striking sequence of historical photographs ever made, recorded the execution in chronological tableaux. Most of Gardner's images have been published before, but in scattered fashion. For the first time, we publish them all, and in their proper order.

We wrote the book that we wanted to read. The result is not a complete history of events, but rather a comprehensive history of how those events were presented to the American people. We hope that our readers experience the trial and execution of Lincoln's assassins in the same way that Americans alive in 1865 experienced them. Similarly, if our book could be transported back in time from the present day to the end of the Civil War, we are confident that its contents would be instantly recognizable, reflecting a contemporary perception of the events memorialized on the pages that you now hold in your hands. This book is a scrapbook of another time, preserving the words once read and the images once seen by people long gone. In creating it, we hope we have achieved our foremost goal—namely, to publish a book that captures the mood of the people and the visual iconography of the spring and summer of 1865, and one that evokes the spirit of the age, when the death of one man after the deaths of so many caused a nation to weep.

James L. Swanson
Daniel R. Weinberg
Chicago, July 2001

INTRODUCTION

The real war will never get in the books. In the mushy influences of current times, too, the fervid atmosphere and typical events of those years are in danger of being totally forgotten. . . . Its interior history will never be written—its practicality, minutiae of deeds and passions, will never even be suggested. . . .Think how much, and of importance, will be—how much, civic and military, has already been buried in the grave, in eternal darkness.

—Walt Whitman, *Specimen Days*

THEY ARE FORGOTTEN NOW, long buried in their graves. Today their names awaken no memories, no flash of recognition. But once, in the spring and summer of 1865, theirs were the most reviled names in the United States: Mary Surratt, Lewis Payne,[1] David Herold, George Atzerodt, Dr. Samuel A. Mudd, Samuel Arnold, Michael O'Laughlin, and Edman Spangler.

Their names were on every citizen's tongue. Newspapers in every city, town, and hamlet across the country wrote about them. People bought their photographs. Their notoriety was deserved, for they were accused of committing a great crime—a foul deed that no one had ever attempted on American soil—which they had conspired to accomplish. They were defendants in the great trial of the nineteenth century—the prosecution of the assassins of the President of the United States, Abraham Lincoln.

It was more than a murder trial. The alleged conspirators were actors in a national drama, the courtroom was the stage, the trial was a morality play, and the spectators were the American people. The great conspiracy trial of 1865 was the penultimate act in an unprecedented drama that unfolded during the final weeks of the Civil War.

On April 3, 1865, Richmond, Virginia, the capital and citadel of the Confederacy, fell to Union troops. On April 9, Robert E. Lee surrendered the Army of Northern Virginia at Appomattox. A few days later, on April 14, 1865, in the harbor of Charleston, South Carolina, Union forces reoccupied Fort Sumter and raised Old Glory over the place where the war had begun four years earlier. The same night, Abraham Lincoln was assassinated. He died the next morning.

His funeral in the East Room of the White House on April 19 transfixed the nation, while a frenzied manhunt pursued the assassin, John Wilkes Booth, and his accomplices. Although several of Booth's conspirators were arrested, the arch villain refused to be taken alive. He was shot on April 26 in a burning barn in the Virginia countryside. As Lincoln's funeral train carried his body through the great cities of the North on the way home to Springfield, Illinois, the prosecution prepared its case against those it accused of conspiring to murder the president. On May 1, 1865, the new president, Andrew Johnson, ordered that those who had conspired in the great crime against his predecessor must not be tried by a civil criminal court in the District of Columbia, but by a military commission.

Looking back on this rapid succession of events, it is clear that the American people had, in less than a month, lived through the most intensely dramatic series of events in the history of the United States.

On March 4, 1865, the day of Lincoln's second inauguration, no one could have imagined the disaster to come. Everyone knew that the war would end soon. The South was finished, and it was only a matter of time. Knowing this, Lincoln devoted little time in his inaugural address to the war, noting: "The progress of our arms, upon which all else chiefly depends, is as well known to the public as to myself; and it is, I trust, reasonably satisfactory and encouraging to all. With high hope for the future, no prediction in regard to it is ventured."

Instead, looking to the future and reunion, the president focused on reconciliation: "With malice toward none; with charity for all; with firmness in the

right, as God gives us to see the right, let us strive on to finish the work we are in; to bind up the nation's wounds; to care for him who shall have borne the battle, and for his widow, and his orphan—to do all which may achieve a just and lasting peace, among ourselves, and with all nations."

By the end of March, it was obvious that a Union victory was near, but no one, including the president, knew exactly when the war would end. Lincoln, government officials, the press, and the people could only wait for news by telegraph. It came on April 3, 1865. In its third edition of the day, printed at four o'clock in the afternoon, the *Evening Star* of Washington, D.C., reported "The Glorious News": "As we write Washington city is in such a blaze of excitement and enthusiasm as we never before witnessed here in any approachable degree. . . . The thunder of cannon; the ringing of bells; the eruption of flags from every window and housetop; the shouts of enthusiastic gatherings on the streets; all echo the glorious report. RICHMOND IS OURS!!!"

According to the *Star*, the news emanated from a single point and spread through the city as far and as fast as people could shout or run: "The first announcement of the fact made by Secretary Stanton in the War Department building caused a general stampede of the employees of that establishment into the street, where their pent-up enthusiasm had a chance for vent in cheers that would assuredly have lifted the roof from that building had they been delivered with such vim inside. . . . The news caught up and spread by a thousand mouths caused almost a general suspension of business, and the various newspaper offices especially were besieged with excited crowds."

To placate the impatient throng while they prepared the late afternoon edition for press, *Evening Star* editors rushed a one-page extra into print. According to the editors, "then followed such a rush for copies as surpassed anything in our newspaper experience. The demand seemed inexhaustible, in fact, and almost exhausted the power of our lightning press to supply . . . it seemed impossible to supply the eager demand."

Journalist Noah Brooks, White House and Washington correspondent—and a favorite of President Lincoln—recalled the day in his classic memoir *Washington in Lincoln's Time*:

[T]he news spread like wildfire through Washington, and the intelligence, at first doubted, was speedily made certain by the circulation of thousands of newspaper "extras" containing the news in bulletins issued from the War Department. In a moment of time the city was ablaze with excitement the like of which was never seen before; and everybody who had a piece of bunting spread it to the breeze; from one end of Pennsylvania Avenue to the other the air seemed to burn with the bright hues of the flag. The sky was shaken by a grand salute of eight hundred guns, fired by order of the Secretary of War—three hundred for Petersburg and five hundred for Richmond. Almost by magic the streets were crowded with hosts of people, talking, laughing, hurrahing, and shouting in the fullness of their joy. Men embraced one another, "treated" one another, made up old quarrels, renewed old friendships, marched through the streets arm in arm, singing and chatting in that happy sort of abandon which characterizes our people when under the influence of a great and universal happiness. The atmosphere was full of the intoxication of joy.

Bands of music, apparently without any special direction or formal call, paraded the streets, and boomed and blared from every public place, until the air was resonant with the expression of the popular jubilation in all the national airs, not forgetting "Dixie," which, it will be remembered, President Lincoln afterward declared to be among the spoils of war.

The American habit of speech-making was never before so conspicuously exemplified. Wherever any man was found who could make a speech, or who thought he could make a speech, there a speech was made; and a great many men who had never before made one found themselves thrust upon a crowd of enthusiastic sovereigns who demanded of them something by way of jubilant oratory.

The day of jubilee did not end with the day, but rejoicing and cheering were prolonged far into the night. Many illuminated their houses, and bands were still playing, and leading men and public officials were serenaded all over the city. There are always hosts of people who drown their joys effectually in the flowing bowl, and Washington on April third was full of them. Thousands besieged the drinking-saloons, champagne popped everywhere, and a more liquorish crowd was never seen in Washington than on that night.[2]

It was only the beginning, and "greater things were yet to come," promised Brooks:

Most people were sleeping soundly in their beds when, at daylight on the rainy morning of April 10, 1865, a great boom startled the misty air of Washington, shaking the very earth, and breaking the windows of houses about Lafayette Square. . . . Boom! boom! went the guns, until five hundred were fired. A few people got up in the chill twilight of the morning, and raced about in the mud to learn what the good news might be, while others formed a procession and resumed their parades, —no dampness, no fatigue, being sufficient to depress their ardor, but many placidly lay abed, well knowing that only one military event could cause all this mighty pother in the air of Washington; and if their nap in the gray dawn was disturbed with dreams of guns and of terms of armies surrendered to Grant by Lee, they awoke later to read of these in the daily papers; for this was Secretary Stanton's way of telling the people that the Army of Northern Virginia had at last laid down its arms, and that peace had come again.[3]

The celebrations continued for the rest of the week. On April 11 the city was illuminated, thousands of ex-slaves gathered at Arlington House and sang "The Year of Jubilee," and a crowd gathered at the Executive Mansion and implored Abraham Lincoln to come out on the balcony and speak to them. Noah Brooks, who was with the president that night, recalled the fervor of the people: "The notable fea

ture of the evening, of course, was the president's speech, delivered to an immense throng of people, who, with bands, banners and loud huzzahs, poured into the semi-circular avenue in front of the Executive Mansion. After repeated calls, loud and enthusiastic, the president appeared at the window, which was a signal for a great outburst. There was something terrible in the enthusiasm with which the beloved Chief Magistrate was received."[4]

On Good Friday, April 14, 1865, the *Evening Star* devoted its entire front page to what may have been the most beautiful night in the history of Washington before or since—the magnificent, grand illumination of the city on the night of April 13. Every house and public building, it seemed, glowed with candles, flames, gaslight, or fireworks: "Last night Washington was all ablaze with glory. The very heavens seemed to have come down, and the stars twinkled in a sort of faded way, as if the solar system was out of order and the earth had become the great luminary. . . . Far as the vision extended were brilliant lights, the rows of illuminated windows at a distance blending into one, and presenting an unbroken wall of flame . . . high above all towered the Capitol, glowing as if on fire and seeming to stud the city below with gems of reflected glory as stars light upon the sea. Away to the right a halo hung over the roofs, rockets flashed to and fro in fiery lines, and the banners waved above the tumultuous throng, where shouts and cheers rolled up in a dense volume from the city, and with the incense of the grand conflagration drifted away to the darkness of the surrounding hills."

Among the many decorated buildings that the *Star* singled out for special praise was Ford's Theatre, "which attracted much attention." Inside the paper, a small notice buried unobtrusively among other advertisements announced a special occasion: Tonight President Lincoln and General Grant would attend a play, the comedy *Our American Cousin*, at Ford's. What happened next is part of American folklore and barely needs retelling.[5]

It was so easy. It was more a matter of will than guile or elaborate planning. When Abraham Lincoln walked into Ford's Theatre on April 14, 1865, he entered John Wilkes Booth's world. As a celebrated actor and friend of the owner, Booth had the run of the place. He knew the stage, the main floor, the balcony, the private boxes, and the employees. He also knew the back doors, the hidden passageways, and other secrets that only a habitué of the theater would know. If Booth could have picked any place in Washington as the most advantageous site to assassinate the president of the United States, he probably would have chosen Ford's.[6]

While Booth crept into the president's box and aimed a pistol at the back of Lincoln's head, another man attacked Secretary of State William H. Seward at home. Claiming to be a messenger delivering medicine from Seward's physician, the man insisted on being admitted. The ruse seemed plausible. The secretary had been injured in a bad carriage accident and was under doctor's care. But when told that he had to leave the medicine at the door and could not see Seward, the stranger became a wild man. He pushed past a servant, smashed a pistol into the head of one of Seward's sons, ran upstairs, pounced on Seward in bed, and tried to stab him to death. A male army nurse, Seward's daughter, and another of his sons grappled in the dark with the attacker and fought him off. Abandoning his knife, pistol, and hat, the man ran off into the night shouting, "I'm mad." Although wounded, the secretary of state survived the vicious assault.

Not long after Secretary of War Edwin M. Stanton rushed to Lincoln's side, news of the Seward attack reached him. Obviously, in a last desperate effort to win the war, a Confederate conspiracy was underway to murder the highest officials of the government. The vice president—or other members of the cabinet—could be the next targets. When news of the attacks on Lincoln and Seward spread through Washington and then the nation, the press and the public agreed.

On Easter morning 1865, known forever as Black Easter to those who lived through it, the *Sunday*

Morning Chronicle of Washington summed up the mood of the nation in a series of headlines: "THE NATIONAL CALAMITY. A WAIL THROUGHOUT THE LAND. THE NATION HORROR-STRICKEN AT THE DEED. A SEASON OF REJOICING TURNED INTO MOURNING. Stern justice to be Awarded to Traitors."[7]

According to datelines from other cities, rough justice was already being meted out in the streets: "NEW YORK, April 15—9 A.M.—Intense sorrow is depicted on all countenances at the horrible events that occurred in Washington city last night. The grief of all good men is apparent everywhere at the demise of the President. . . .The people appear perfectly horrified and the utmost rage is undoubtedly felt toward all known secessionists and rebel sympathizers"; "POUGHKEEPSIE, N.Y., April 15—An intense excitement prevails here in relation to the national disaster. A woman named Frisbee exulted in public over the assassination, when the house on Main street in which she resided was immediately surrounded by several hundred infuriated people who demanded her immediate arrest. A young man named Denton interfered with the mob when he was immediately throttled and with the woman handed over to the authorities, who lodged them in jail"; "TROY, N.Y., April 15—Amidst the general lamentations this morning, a man named D. L. Hunt, of Rochester, made the remark that 'Mr. Lincoln ought to have been assassinated four years ago.' A crowd gathered around him at once and summary vengeance was feared; but an officer interfered and Hunt was arrested and lodged in jail"; "NEW YORK, April 15—Two men, expressing respect for Jeff Davis, were driven out of a newspaper counting room and hunted by a crowd. They sought safety in flight"; "BALTIMORE, April 15—It was rumored that this [photography] establishment had on hand a picture of Booth, the assassin, who, by the way, is well known here, this being his native city. The picture, however, was removed before the mob reached the place, or serious consequences might have resulted."[8]

After reporting all the latest news, the editors of the *Sunday Morning Chronicle* contemplated the meaning of what their headline called "THE TRANSCENDENT CRIME":

The closing hours of the great American rebellion have been marked by its greatest crime; a crime which will live in history as the most truthful representation of diabolical wickedness since the crucifixion of Christ. . . . On the latest anniversary of that mournful day Abraham Lincoln was murdered by a hired assassin who was employed and paid by a set of autocrats who defy the power of a free people, and set at nought the righteous laws of God. The assassination of Abraham Lincoln was truly characteristic of the spirit of the rebellion. It will be pretended, doubtless, that this foul murder was the work of a maniac, or the result of a combination gotten up by crazy fanatics. But the truth is that the dreadful crime was planned by the leaders of the rebellion. Such a dastardly and cowardly act is in strict accordance with their spirit. They have murdered, and starved, and butchered our prisoners of war; they have inflicted unheard-of barbarities upon such loyal men as have, by any chance, fallen into their hands.

The magnanimity and the self-respect of the American people will never permit them to inaugurate a French Revolution. There will be no spilling of blood in the streets; no cries of "a la lanterne;" no guillotining of innocent men. But there should be, and will be, a feeling of indignation throughout the North which will result in a great change in the very lenient laws which now exist in regard to the insurgents. The tenderness which we have shown to the rebels, and of which Abraham Lincoln was the leading advocate, has been defeated of its purpose by the unparalleled crime committed by a miserable emissary of the Southern Confederacy. This wicked deed was not the work of a single man; it was a consistent illustration of the cowardly arrogance of the slave-drivers of the South. . . . Assassination is to them an affair of everyday life. They were sagacious enough to see that the murder of Abraham Lincoln would take away the most generous, consistent and humane friend of the common people. They murdered him, therefore, for their own interests. . . . Let justice be done. Let not the innocent suffer, but let the guilty expiate their crowning crime.

But justice could not be done until the assassin and his conspirators had been captured. Where was Booth? Who and where were his accomplices? And when would they be seized?

⸺◆⸺

Tracking down John Wilkes Booth proved to be a challenge for the secretary of war. Soldiers, government detectives, private investigators, and informers, spurred on by the offer of a $100,000 reward that was eventually paid in full and divided among them, scoured Washington, D.C., Maryland, and Virginia for the assassin's trail but made little progress. It was easy enough to discover Booth's route from Ford's Theatre to the outskirts of Washington, but then the trail went cold. Booth rode hard to put distance between himself and the news. As long as he did, he could pass through checkpoints and travel the roads with little suspicion paid him. The public expected a quick capture, and Booth's ability to elude his pursuers embarrassed the authorities. Newspapers speculated on his whereabouts, published false reports of his arrest, and even suggested that he had never left Washington but was secluded in a safe house.

It was not until April 26, 1865—twelve days after the assassination—that soldiers tracked him to a barn in the Virginia countryside and shot and killed him. In comparison, rounding up several of his alleged conspirators was surprisingly easy. Every day, it seemed, the newspapers announced the apprehension of more suspects.

The first clues turned up within hours of the assassination. Talk of Booth's friendship with John H. Surratt, a reputed Confederate spy, prompted soldiers to search for him and Booth at his mother's boardinghouse at 541 H Street, a few blocks from Ford's Theatre. Disappointed in their mission, the soldiers returned on April 17. Late at night, while the soldiers were inside questioning the inhabitants, an imposing, powerful man toting a pickax knocked on Mary Surratt's door. When he saw the soldiers, he said he had made a mistake and tried to walk away. Then he claimed that he had come to the house to dig a gutter. His clothes, while soiled, seemed of too fine a quality for a day laborer.

Suspicious, and realizing that he matched the description of the unknown assailant who had tried to murder the secretary of state, the soldiers relieved the stranger of his menacing tool. They brought Mrs. Surratt to the hall, raised a lantern to the man's face, and asked if she recognized him: "Before God, sir, I do not know this man, and have never seen him, and I did not hire him to dig a gutter for me."[9] The soldiers searched him and found a document identifying him as a paroled Confederate soldier named Lewis Payne. He was arrested, along with Mary Surratt, her daughter, and her boarders. William H. Seward's servant identified Payne as the knife-wielding maniac. If he had not blundered into the government's hands that night, Lewis Thornton Powell might have vanished from history.

Samuel Arnold was arrested the same day, April 17. On the night of the assassination, detectives had gone to John Wilkes Booth's hotel room, searched his trunk, and discovered a mysterious letter from an unknown correspondent—signed only with the name Sam—that seemed related to the conspiracy. Along with a detective's tip, the document, which the press sensationalized as "the Sam Letter," led to Arnold's arrest. Arnold, age thirty-one, a boyhood friend and former schoolmate of Booth's and a veteran of the Confederate army, confessed his participation in Booth's earlier scheme to kidnap the president but denied any involvement in or knowledge of the assassination. He argued that the Sam Letter, rather than proving his guilt, was evidence that he had quit the conspiracy weeks before Booth killed the president. Michael O'Laughlin, age twenty-eight, another of Booth's boyhood friends and a former Confederate soldier from Baltimore, was also taken on April 17.

Edman Spangler, thirty-nine years old, was easy pickings. A stagehand at Ford's Theatre, he had held the reins of Booth's horse while the actor went inside to murder Lincoln. When Booth fled out the back door of the theater into the alley, he jumped on his horse and galloped away. Spangler was arrested on April 15, released, and then seized again on April 17.

George A. Atzerodt, a thirty-year-old German immigrant and carriage painter, was captured in bed early on the morning of April 20. Prior to the assassination, he had taken a room at the same hotel occupied by Vice President Johnson, and a search of his room revealed weapons and some property belonging to Booth. Atzerodt, too, would admit complicity in the kidnapping plot but denied that he had agreed to assassinate Andrew Johnson. Loose talk after the assassination led detectives to his cousin's house in Germantown, Maryland, where he was hiding.

The next conspirator arrested was Dr. Samuel A. Mudd, age thirty-two, taken into custody on April 24. During Booth's escape from Washington, he and David Herold had stopped at Mudd's farm, where the doctor treated the actor's injured leg and allowed his guests to spend the night. Rumors about Mudd created suspicion, and he seemed cagey when questioned by government agents. Mudd denied recognizing Booth and claimed he had no knowledge of the assassination. The forthcoming trial would reveal more about Mudd than the doctor cared to have made known.

The last conspirator arrested was David E. Herold, age twenty-two, taken alive when he surrendered at Garrett's farm before the barn was set on fire and Booth was killed. A Washington, D.C., druggist, Herold was an outdoorsman who possessed expert knowledge of the Maryland countryside. He was caught in Booth's company, in the act of fleeing with the assassin; his complicity was clear to all.

These were not the only arrests. The dragnet rounded up the Ford brothers of the eponymous theater; Junius Booth, the assassin's brother; George Atzerodt's cousin Hartmann Richter; a mysterious Portuguese sea captain named Celestino; various Confederate sympathizers and agents; others who expressed disloyal or pro-assassination sentiments; and several people who aided Booth and Herold during their twelve days at large, from April 14 through April 26.

During this period, the newspapers were filled with unsubstantiated gossip. They tantalized readers by claiming that spectacular arrests were only days—and hours—away; readers assumed that high leaders

of the Confederacy were about to be named as conspirators. One paper boasted that more than one hundred criminals were to be put on trial, and another wrote that certainly twenty-one and perhaps even twenty-three would hang. Of course, the public was fascinated by the conspirators and wanted to know everything about them, the circumstances of their capture and present confinement, and what they looked like.

Mary Surratt and Dr. Mudd were jailed at the Old Capitol Prison. Herold, Arnold, Powell, O'Laughlin, Spangler, Atzerodt, Richter, and Celestino were imprisoned on the ironclad vessels *Montauk* and *Saugus.* The government would not allow reporters to meet or interview the prisoners, a source of great frustration to the press. But on April 27, photographer Alexander Gardner was allowed to come aboard and take the first photographs of the alleged conspirators. An account from the *Evening Star* recorded the event: "The prisoners during their confinement here, were brought upon deck, one at a time, where they were photographed by Gardner. Herold was brought up for this purpose on the same day he arrived, and it was some time before a satisfactory picture was got. On this occasion he appeared sullen, and he put on a pouty look as he took his seat in the chair and glanced with dissatisfaction in the direction of the wharf, where a number of spectators were watching every movement of the vessel, many of whom were his old acquaintances."[10]

Gardner took more photographs of Lewis Powell than of any other prisoner—perhaps to show to members of Seward's household to establish Powell's identity as Seward's assailant. Under the watchful eye of a U.S. Marine Corps guard, Powell helpfully assumed a variety of poses for Gardner. He was photographed like the rest, seated in a chair on deck, and then standing in various ways, with and without wrist irons and modeling the coat and hat that he allegedly wore the night he attacked Secretary of State Seward. Powell had lost his hat that night, but it had been retrieved and would be introduced as an exhibit at the trial.

The images of the other conspirators are routine portraits, bound by the conventions of nineteenth-century photography. In his images of Powell, however, Gardner achieved something more. In one startling and powerful view, Powell leans back against a gun turret, relaxes his body, and gazes languidly at the viewer. There is a directness and modernity in Gardner's Powell suite unseen in the other photographs.

Gardner developed his images, provided prints to the press for woodcuts, and then printed cartes-de-visite that he sold to the public. Curiously, records in the Library of Congress show that although Gardner copyrighted six images of Powell, he did not bother to file for protection for his images of the other conspirators.

Strangely, Gardner took no photographs of Mary Surratt or Samuel A. Mudd. As a result, the public did not know what they looked like during the entire period of their arrest and trial. A veil that Surratt wore throughout the trial kept sketch artists from getting a good look at her, and although Mudd could be observed in the courtroom, the woodcuts produced of Surratt and Mudd were crude, approximate likenesses.

Surratt and Mudd were not aboard the ironclads when Gardner photographed the other conspirators, but he could have transported his camera to the Old Capitol Prison to photograph them there. Furthermore, once all eight conspirators had been moved to the Old Arsenal Penitentiary for the trial, Gardner could have photographed them there any time in May or June. But he never came to photograph them there or the courtroom. Why he did not remains one of the many small unsolved mysteries of the Lincoln assassination.

Many observers commented on the physical appearance of the prisoners and suggested in a fashion typical of the nineteenth century that looks equaled character. In the introduction to his published transcript, *The Conspiracy Trial for the Murder of the President,* Ben: Perley Poore recalled each defendant. The four who eventually escaped death were deemed the least sensational figures and merited only brief descriptions:

Samuel Arnold, a young Baltimorean, had a rather intelligent face, with curly brown hair and restless dark eyes. . . . An original conspirator, his courage failed him. . . . Samuel A. Mudd, M.D., was the most inoffensive and decent in appearance of all the prisoners . . . with sharp features, a high bald forehead, astute blue eyes, compressed pale lips, and sandy hair, whiskers, and a mustache. . . . Edward Spangler was a middle-aged man, with a large, unintelligent looking face, evidently swollen by an intemperate use of ardent spirits, a low forehead, anxious-looking grey eyes, and brown hair. Doleful as Spangler looked when in court, the guards declared that he was the most loquacious and jovial of the prisoners when in his cell. . . . Michael O'Laughlin . . . was a rather small, delicate-looking man, with rather pleasing features, uneasy black eyes, bushy black hair, a heavy black mustache and imperial, and a most anxious expression of countenance, shaded by a sad, remorseful look.[11]

The public was more interested in the four major conspirators. Perhaps because he was a lower-class German-born immigrant, Atzerodt was singled out for much abuse. As Poore concluded, "George B. Atzerodt was a type of those Teutonic Dugald Dalgettys who have taken an active part in the war . . . sometimes on one side, and sometimes on the other. . . . He was born in Germany, but was raised and lived among the 'poor white trash' in Charles County, Md. He was a short, thick-set, round-shouldered, brawny-armed man, with a stupid expression, high cheekbones, a sallow complexion, small grayish-blue eyes, tangled light-brown hair, and straggling sandy whiskers and a mustache. He apparently manifested a stoical indifference to what was going on in the Court, although an occasional cat-like glance would reveal his anxiety concerning himself. Evidently crafty, cowardly, and mercenary, his own safety was evidently the all absorbing subject of his thoughts." Journalist Noah Brooks called Atzerodt a "low and cunning scoundrel" who possessed a "villainous countenance."[12]

David Herold, also perceived as weak and cowardly, got bad press. The *Philadelphia Inquirer* of May 18, 1865, featured a woodcut portrait of him to illus-trate its point that he: "[L]ed a very dissipated life and was notoriously indolent. . . . Harold [*sic*] is an inveterate talker, and a great coward, as his anxiety to surrender . . . proves . . . when in his cell he frequently gives way to fits of weeping."

Poore painted an equally unflattering picture: "David E. Herold was a doltish, insignificant-looking young man . . . with a slender frame and irresolute, cowardly appearance. He had a narrow forehead, a somewhat Israelitish nose, small dark hazel eyes, thick black hair, and an incipient mustache which occupied much of his attention. Few would imagine that any villain would select such a contemptible-looking fellow as an accomplice."

Mary Surratt was the penultimate star conspirator. Some newspapers damned her as little more than an ugly malevolent witch, but Poore, who saw her regularly at the trial, was more fairly neutral: "Mrs. Mary E. Surratt . . . was a belle in her youth . . . and, when she raised her veil in court that some witness might identify her, she exposed rather pleasing features, with dark gray eyes and brown hair. While some of the spectators could see upon her face a haunting revelation of some tragic sorrow . . . others declared that she was evidently the devoted mother."[13]

The star attraction, and the conspirator who fascinated the press, the public, and his own guards, was Lewis Powell, alias Payne. Mysterious at the trial but a well-liked practical joker in prison, Powell was admired for his courage and magnificent physique. Poore's description is typical: "Lewis Payne was the observed of all observers, as he sat motionless and imperturbed, defiantly returning each gaze at his remarkable face and person. He was very tall, with an athletic, gladitorial frame; the tight knit shirt which was his upper garment disclosing the massive robustness of animal manhood. . . . Neither intellect nor intelligence was discernible in his unflinching dark gray eyes, low forehead, massive jaws, compressed full lips, small nose with large nostrils, and stolid, remorseless, expression."[14]

Noah Brooks was more favorable: "[Paine] sat bolt upright against the wall, looming up like a

young giant above all the others. Paine's face would defy the ordinary physiognmist. It certainly appeared to be a good face. His coarse, black hair was brushed well of his low, broad forehead; his eyes were dark and gray, unusually large and liquid. His brawny, muscular chest, which was covered only by a dark, close-fitting 'sweater,' was that of an athlete . . . his face, figure and bearing bespoke him the powerful, resolute creature that he proved to be. It was curious to see the quick flash of intelligence that involuntarily shot from his eyes when the knife with which he had done the bloody work at Seward's house was identi- fied by the man who found it in the street near the house . . . after that dreadful night."[15]

The public also had a morbid curiosity about how the conspirators were restrained and sequestered. In fact they were locked in separate cells and allowed no contact with each other. The men were shackled to balls and chains and wore a curious type of handcuff that featured not links of chain but a straight, inflexi- ble iron bar that kept their hands apart. These irons are visible in many of Gardner's photos. Pictured in newspapers and books, they became symbols of the trial in the public mind.

Even more compelling to the public were the cloth hoods the prisoners were forced to wear from their arrests through most of the trial. These hoods, which some writers credited to the devilish desire of Secretary of War Edwin M. Stanton to torture the conspirators, became a powerful symbol of the con- spiracy trial and were written about widely then and for years afterward. The conspirators were never pho- tographed in these hoods, but they appear in several contemporary sketches and woodcuts, and several of them are extant. In one of the earliest accounts of the hoods, the *New York Herald* reported on April 28 that "[t]he alleged would-be assassin of Secretary Seward, Lewis Paine, who attempted yesterday to beat out his own brains against the walls of his prison, has been fitted with an irremovable cap, well wadded, and while his hands are secured so that he cannot reach his head, he will have no opportunity to com- mit suicide in this manner."

The most graphic description of the hoods comes from a man who wore one, Samuel Arnold, one of the conspirators who survived the trial and wrote his memoirs of the experience: "[O]n or about the 25th of April, Captain Muroc, U.S. Marines, under whose charge I was, came into my quarters and in a very soft and kind voice, stated that he had orders from Edwin M. Stanton, Secretary of War, to encase my head in a cap, that I must not become alarmed and that it would remain but a few days. . . . This covering for the head was made of canvass, which covered the entire head & face dropping down in front to the lower portion of the chest, with cords attached, which were tied around the neck and body in such manner, that to remove it, was a moral impos- sibility. No doubt Stanton wished to accustom oneself to the death cap before one's execution."

Arnold wrote that for one week the hood was never removed. He could not bathe, and the hood made it difficult to eat. After he was transferred to the Old Arsenal for trial, the hood was removed, and he was allowed to bathe. But when he returned to his cell he found:

a differently constructed hood had been pre- pared for head cover, of a much more torturous and painful patern than the one formerly used. It fitted the head tightly, containing cotton pads which were placed directly over the eyes and ears, having the tendancy to push the eye balls far back in their sockets, one small aperture allowed about the nose through which to breathe, and one by which food could be served to the mouth, thence extending with lap ears on either side of the chin, to which were attached eyelets and cords, also the same extending from the crown of the head backwards to the neck. These cords were pulled tight as the jailor in charge could pull them, causing the most excru- ciating pain and suffering, and then tied in such a manner around the neck that it was impossible to remove them. . . .This manner of treatment continued uninterrupted, the hoods never being removed excepting when being brought before the Court and always replaced on our exit . . . from on or about the 25th of April to the 10th of June, 1865.[16]

On April 28 Major General John F. Hartranft was appointed governor of the military prison at the arsenal and commander of the troops assembled for its defense. He became responsible for the incarceration, care, and, ultimately, execution of the conspirators. From the moment he took control on April 29, he kept a diary of the daily routine at the prison. Prior to the prisoners' arrival, he swept out the cells and removed all nails from the walls. Daily, the prisoners received coffee, soft bread, and salt meat at 8 A.M. and coffee and soft bread at 5 P.M.—each time under Hartranft's supervision. Surgeon George L. Porter inspected the prisoners twice a day. Hartranft reported that at various times their bedding was removed and shaken out in the open air. New clothing was sometimes given, but their underwear could not always be replaced, "as the ball and chain prevented it."

Cell guards were rotated during the day; the same soldier never standing guard twice on the same spot. On May 2 Hartranft had a special stairway constructed from the arsenal's second story to the courtroom, so that "persons going to the court need not pass through the prison." On May 5 he asked that "the Court Martial Room, adjoining rooms, and stairs leading to these rooms be covered with matting" so that when the prisoners walked to and from their cells, their leg chains wouldn't make too much noise. "One hundred yards of material one yard in width" was immediately delivered.

Hartranft reported each day, writing about the ongoing events at the prison. Even though Powell would later thank him for his kindness, Hartranft rebuffed him on at least one occasion: On May 4 Powell asked to speak with him. "I do not mean now, but when you have time," said the conspirator. "I answered 'I have no time,'" Hartranft wrote.

Ordered to safeguard the prisoners until their fates were decided, Hartranft may have saved Powell from a second suicide attempt. On June 2 he wrote, "The sentinel over the cell of Powell discovered the prisoner handling the balls attached to his limbs, placing them against his head. I, at once, unfastened the balls from the shackles and removed them."

The general was cognizant of the rule of law. On May 15 he urged that counsel for the prisoners not be permitted to talk with them in the cells but only in the courtroom, for he found it too difficult to guard the prisoners and still be "out of hearing" when they spoke with their lawyers. He also worried about the prisoners' health. On June 6 he wrote that they were suffering very much from the padded hoods (Spangler's mind in particular was "wandering"), and he had them removed. On June 20 he recommended that "all prisoners be allowed some reading matter and be allowed into the open air once a day." This was allowed, plus tobacco "for those who wished it after a meal." A small box was placed in each man's cell to sit on while reading, and Mary Surratt was given an armchair, probably brought over from her boardinghouse.

Chained and secluded, with no news from the outside world, the alleged conspirators awaited word of their fate. At least there would be no summary executions. Immediately after the assassination, amidst the mourning and anger, the newspapers had called for restraint. On April 20, the *Daily Morning Chronicle* of Washington opined on "THE DUTY OF THE HOUR": "The feeling of horror and exasperation is everywhere increasing. . . . Every loyal American feels that the death of Mr. Lincoln is not only a national, but a personal, bereavement, and every one is controlled, in some measure, by revengeful feeling. We should not, however, allow ourselves to be carried away by passion. Let us not imitate the barbarous ferocity and the insane rage which have characterized those who have promoted this wicked rebellion and incited assassins to do this dreadful deed. Let us be stern and just and dignified. Let the law—not lynch law—take its proper course."

Abott A. Abott, who wrote a famous account of the assassination, published in New York City within days of the crime, agreed: "In executing vengeance upon the author of this great crime let us therefore not commit the mistake, nay the crime, a crime equally as great as the original one which may provoke it, the crime of seeking vengeance upon either the lives or the liberty or even the fair repute of the innocent."[17]

The fact that the government was gathering

evidence and interviewing witnesses suggested that it was preparing a legal case, not a lynching. There would be a trial, but of what kind?

—✦—

Edwin M. Stanton wanted the assassination conspirators prosecuted by the judge advocate general of the U.S. Army and tried swiftly by a military commission. In his wartime diary, Secretary of the Navy Gideon Welles recalled Stanton's haste: "The trial of the assassins is not so promptly carried into effect as Stanton declared it should be. He said it was his intention the criminals should be tried and executed before President Lincoln was buried. But the President was buried last Thursday, the 4th [of May], and the trial has not, I believe, commenced."

Welles objected to trying civilians before a military commission: "I regret they are not tried by the civil court, and so expressed myself . . . but Stanton, who says the proof is clear and positive, was emphatic, and Speed advised a military commission, though at first, I thought, otherwise inclined."[18]

Gideon Welles was not alone in objecting to the trial. Edward Bates, Lincoln's former attorney general, opposed the commission, believing it unconstitutional. In his diary he wrote: "Trial of the Assassins at Washington, by a secret *military court*. Some one sends me the Phila. 'Ledger' of May 12, containing copious extracts from the N.Y. *Post*, the *Tribune* and the *Times*—all denouncing bitterly, the proceeding as, at once, a dangerous breach of law, and a gross blunder in policy. . . . I wrote . . . the other day, to tell . . . how the government fell into the blunder of insisting upon trying the conspirators, by a military court."[19]

George Templeton Strong, New York attorney, loyal Unionist, and incomparable diarist of his era, recorded his doubts: "There is much dissatisfaction because the assassination plotters are tried by a military court and not by ordinary methods of criminal law. The *Tribune*, *Times*, and *Post* are of one mind with the *News* and the *World* in this matter. There may be reasons for the course adopted of which we know

nothing, but it seems impolitic and of doubtful legality."[20]

To defuse criticism, President Johnson and Secretary Stanton asked Attorney General James Speed to prepare a formal legal opinion on the propriety of trying the assassins by a military commission. That opinion survives today in the form of a sixteen-page printed pamphlet.[21] His answer was definitive: The assassination of Lincoln and the attack on Seward were acts of war during an armed rebellion against the lawful government. Not only could the conspirators be tried by a military commission but they should be. On May 1, 1865, President Johnson issued the order to proceed.

Former Attorney General Bates was skeptical: "I am pained to believe that my successor, Atty Genl. Speed, has been wheedled out of an *opinion*, to the effect that such a trial is lawful. If he be, in the lowest degree, qualified for his office, he must know better. Such a trial is not only unlawful, but it is a gross blunder in policy: It denied the great, fundamental principle, that ours is a government of *Law*, and that the law is strong enough, to rule the people wisely and well; and if the offenders be done to death by that tribunal, however truly guilty, they will pass for martyrs with half the world."[22]

Rumors spread that the proceedings of the commission would be secret and that the press and public would be barred from the trial. The press opposed a secret trial vigorously, not only on grounds of fairness to the defendants but also because it would prove catastrophic to their business. With a secret trial, there would be no stories to write or newspapers to sell. The press demanded participation; Gideon Welles agreed. In his diary he wrote:

> It is now rumored, the trial is to be secret, which is another objectionable feature, and will be likely to meet condemnation after the event has [and excitement has] passed off. The papers, and especially those of New York, are complaining of the court which is to try the assassins, and their assault is the more severe, because it is alleged that the session is to be secret. This

subject is pretty much given over to the management of the War Department, since Attorney-General Speed and Judge-Advocate General Holt affirm that to be legal, and a military court the only real method of eliciting the whole truth. It would be impolitic, and, I think, unwise and injudicious, to shut off all spectators and make a "Council of Ten" of this Commission. The press will greatly aggravate the objections, and do already. . . . I inquired of the Secretary of War if there is any foundation for the assertion that the trial of the assassins is to be in secret. He says it will not be secret, although the doors will not be open to the whole public immediately. Full and minute reports of all the testimony and proceedings will be taken and in due time published; and trusty and reliable persons, in limited numbers, will have permission to attend. This will relieve the proceeding of some of its most objectionable features.[23]

No one knew exactly when the trial would begin, so newspapers speculated while they continued to lobby for access to the courtroom. On May 3, the *New York Herald* countered a rumor that the trial had already begun, on May 6 predicted that the trial would commence the next week, and on May 8 editorialized vigorously against a secret trial: "Much anxiety is evinced in reference to the court martial to try the assassination conspirators. It is rumored that the trial is to be held with closed doors. This will be a great mistake on the part of the authorities. . . .These criminals are charged with the gravest of crimes, and their trial should be conducted in the face of the whole world. Star-chamber proceedings do not accord with the spirit of the age and the people."

On May 9, General John Hartranft went to each cell and read the charges and specifications against the prisoners. He wrote: "I . . . served the same between the hours of 6 and 9 pm personally, in each cell. I had the hood removed, entered the cell alone with a lantern, delivered the copy, and allowed them time to read it, and in several instances, by request, read the copy to them, before replacing the hood."[24]

Samuel Arnold, understandably, remembered the episode more passionately: "The canvass bag still continued upon my head, never having allowed its removal to wash my swollen face. I had been but a few days incarcerated at this place when I was arroused at *midnight* in my cell by Major General Hartrauth [*sic*], holding in his hand a lantren and some papers, which was seen after the removal of the hood from my head. He asked me if I could read, to which I replied in the affirmative. He then placed in my hand a paper containing the charge & Specifications against me & others, which I perused in that silent midnight hour by the dim glimer of a lantren, after which, the hood being replaced upon my head, he retired leaving me to ponder over the charge, alone in my solitude."[25]

Finally, on May 8, 1865, the government was ready. Judges and prosecutors were appointed, an improvised courtroom on the third floor of the Old Arsenal Penitentiary was made ready, and the commission held its first session on May 9. The first day revealed the government's advantage. During their confinement the prisoners had not been allowed to seek legal counsel. Not until they were brought into the courtroom on May 9 were they asked if they would like to seek counsel.

The trial began in earnest on May 12, with the taking of the first testimony. The proceedings were not like a modern criminal trial. The defense attorneys had no time for pretrial preparation or extensive consultation with their clients. They had insufficient time to locate, prepare, and call all the witnesses they wished and little time to investigate the government's witnesses. They had no influence over the agenda or timetable of the trial, no right to put their clients on the stand, and no citation to particular statutes that the defendants were alleged to have violated. They faced a court of nine judges—most of them army generals and not one of them a lawyer—who had no professional knowledge of criminal law or rules of evidence. A simple majority vote would result in conviction; a majority of two-thirds could impose the death sentence. Ominously, there was no right of appeal. The verdicts and sentences of the commission would be final, the only available appeal being directly to the president of the United States.

The defense had few advantages. The courtroom was not a solemn chamber built for justice—it was a big room at an army post that had been quickly converted to an ersatz courtroom. The proceedings were not hushed and solemn. Instead, the atmosphere was more like a salon, with visitors coming and going and talking about their "favorite" conspirators, while judges talked to each other and in one case drew sketches of the conspirators as they sat in the dock.

The defendants' best protection against a show trial would be the opening of the proceedings to the public and press, with daily transcripts published in the newspapers. Then, at least, the public would know what was happening, and its sense of fairness might inform and influence the conduct of the judges. Reluctantly, Stanton relented and opened the trial to the press and public. To attend, however, one had to obtain a coveted written pass from Major General David Hunter.

The eight conspirators in the dock disappointed the public. The press had led people to believe that dozens of conspirators—and perhaps even former Confederate President Jefferson Davis—would be in the dock the day the trial began. Instead, when the canvas hoods were yanked off the defendants' heads, witnesses beheld seven blinking, anonymous men and a veiled woman. Was this the best the government could do? At least John Wilkes Booth was famous and acted with sinister flair. With the exception of the mighty Lewis Powell, who quickly became the public's favorite conspirator, and Mary Surratt, whose gender made her an object of curiosity, the others were nonentities. The press and public deemed them unworthy of their great crime and in anger mocked and disparaged their appearance and characters. A pronouncement from the *New York Herald* of May 4 was typical: "The persons engaged in the plot are a motley crew, from the wild and eccentric actor down to a mere carpenter, including the Pennsylvania avenue dandy, blockade runners, and many with their heads silvered over from many winters, and rattle-headed youths hardly of their teens."

Why the government failed to prosecute additional conspirators—several of whom were in custody—is one of the great mysteries of the Lincoln assassination. Others, more culpable than the eight on trial, could have been charged. Perhaps the government distinguished between those it claimed plotted the crime and those who aided Booth afterward during his escape.

The trial plodded on through May and June. It was a tedious affair, and the case against the conspirators was, at times, merely a backdrop for an indictment against the Confederacy, its leaders, the Southern people, and the way the South fought the war—from the monstrous treatment of Union prisoners to an alleged plot to spread yellow fever throughout the North and win the war by contagion instead of the cannon. Witnesses gave meandering and irrelevant testimony. Occasionally the boredom was punctured by a dramatic moment, as when Powell stood to face an accuser or when Mary Surratt raised her veil to allow a witness identify her.

A few champions spoke out publicly on behalf of the defendants. On June 24, John T. Ford, owner of Ford's Theatre, stood up for his employee Edman Spangler by publishing a transcript of the testimony related to his case, along with a provocative message to the public:

> This part of the "GREAT CONSPIRACY TRIAL" contains all the evidence which in any and every way relates to my Theatre, and to the acts of "EDWARD SPANGLER," the only person connected with it upon trial. —it is published from the OFFICIAL COURT RECORD for the use of my friends and for the sake of truth. Much exaggeration incidental to the charges upon which this trial was founded was indulged in at a time of great public excitement. The offer of rewards for information brought many ambitious detectives to the surface, who were manifestly more ambitious to convict than to learn truth—willing and florid newspaper correspondents caught up their tales and attractively placed them before the public, and through such means "PUBLIC OPINION" was created, condemning the accused before trial. How much wrong has been done in this way, the

patience and fairness of the reader must now judge.[26]

An anonymous supporter of Mary Surratt who styled himself "Amator Justitiae" (translated from the Latin as "Lover of Justice") published on June 14 a now-rare four-page pamphlet, *Trial of Mrs. Surratt*, in her defense. The writer praised her character and chided those who defamed it: "But it is the *Press* which . . . has hunted and maligned this unfortunate woman with the unrelenting ferocity of the sleuth-hound and the venom of asps. Prejudged, condemned, sentenced in advance by every scribbler who can pen a sensation paragraph and stab a defenceless female with impunity, whilst he calls her 'conspirator,' 'traitress,' 'she-devil,' 'she-fiend,' 'murderess,' Mrs. Surratt has found no bold, brave, independent spirit to come to her rescue, no voice to silence the slanderer, no hand to punish the coward!"

Careful not to hurt Mrs. Surratt's cause by alienating her judges before they even rendered a verdict, Amator Justitiae flattered the members of the commission: "In all this, we address no words of disrespect to the Military Commission. It is composed of gallant and honorable gentlemen who have not chosen the seats which they occupy, and who, we believe, are better disposed to make charges against enemies on the battle field, than to receive charges against a weak, unprotected woman in a courtroom."[27]

In principle, the evidence against the conspirators was this: Mary Surratt knew John Wilkes Booth; Booth, Lewis Powell, David Herold, and George Atzerodt had visited her home; her son was a Confederate agent; when Powell came to her house after the assassination, she swore that she did not know him; she allegedly told John M. Lloyd, the man who rented her country tavern, to have shooting irons ready to be picked up there; Booth visited her on the afternoon of the assassination; that same afternoon she delivered Booth's field glasses to her tavern, where later that night the assassin stopped to pick up firearms and supplies; finally, Louis Weichmann, government clerk, friend of her son John, and a boarder at her house, testified against her. No single piece of evidence damned her, but

together these circumstances convinced the military commission to hang her.[28]

The only evidence against Arnold and O'Laughlin was their participation in Booth's earlier plot to kidnap Lincoln. There was no persuasive evidence that they were involved in or even knew of Booth's plan to kill the president. The evidence against Powell and Herold was fatal. Without a doubt, Powell was the man who had nearly stabbed to death the secretary of state. David Herold had aided and abetted Booth's escape by guiding him out of Washington after he shot Lincoln. He was caught with Booth at the Garrett farm.

Atzerodt had met with Booth, Powell, and Herold on the day of the assassination. A participant in the kidnapping plot, valued for his knowledge of the local waterways and his skill in ferrying Confederate agents safely across them, Atzerodt balked when Booth told him to assassinate Vice President Johnson. He got drunk and wandered the city instead. He could have prevented Lincoln's assassination by exposing Booth's plot, but he chose to say nothing.

Dr. Mudd lied. He knew Booth, had met with him on several occasions, and was involved with the Confederate underground. It was Mudd who introduced Booth to John Surratt and other rebels.

Edman Spangler merely accepted the reins of Booth's horse while the actor went inside Ford's Theatre for a brief errand. Unfortunately for Spangler, who had nothing to do with Booth's plans, that errand happened to be assassinating the president of the United States. Spangler was caught in the wrong place at the wrong time.

By the time the trial was over, the military commission had been in session for seven weeks, had taken the testimony of 361 witnesses, and had produced a transcript of 4,900 pages. On June 29, the commission went into secret session to review the evidence. After such a long and complicated trial, observers speculated that it might take weeks to reach verdicts.

But the end came swiftly. After deliberating for just a few days, the court presented the verdicts and sentences to President Andrew Johnson on July 5, 1865. He approved them at once, and the next day Generals Winfield Scott Hancock and John Hartranft visited the defendants in their cells and informed them of their fates. Hartranft carried in his pocket sealed envelopes addressed to each defendant. As he walked from cell to cell, he read each prisoner's sentence aloud and then handed over the written copy. Powell's copy survives, a parting gift to his minister, the Reverend Dr. Gillette, who preserved it as a relic of Powell's fate.

All eight had been found guilty, and Lewis Powell, Mary Surratt, David Herold, and George Atzerodt were sentenced to death. That news was bad enough for the defendants, but the rest was worse. They would be hanged the very next day, July 7, 1865. An order from President Johnson was read to each of the condemned: "Executive Mansion, July 5, 1865. The foregoing sentences in the cases of David E. Herold, G. A. Atzerodt, Lewis Payne . . . Mary E. Surratt . . . are hereby approved, and it is ordered that the sentences in the cases of David E. Herold, G. A. Atzerodt, Lewis Payne and Mary E. Surratt be carried into execution by the proper military authorities, under the direction of the Secretary of War, on the 7th day of July, 1865, between the hours of ten o'clock A.M. and two o'clock P.M. of that day. . . . Andrew Johnson, President."

Indeed, as the defendants were informed of their sentences, construction of a scaffold was already underway in the yard of the Old Arsenal Prison. There would be no time for legal appeals of the verdict, little time to seek clemency from the president, and barely enough time to summon family, friends, and ministers. The press was not sympathetic: "Doubtless there will be some to say, as they *have* said already, 'but this is too short notice; these wretches ought to have longer time in which to prepare for their dreadful fate.' Ay! but how much shorter was the time *they* allowed their hapless victim to prepare for *his* fate?"[29] Another paper noted that "the announcement of the sentences was rather more sudden than was expected, and occasioned some surprise, though every one approved the dispatch with which the subject had been disposed of."[30]

The public still knew nothing of the events of July 5 and 6. Not until the July 6 *Evening Star* came off the press that afternoon did the citizens of Washington learn that four of the conspirators would die the next day. Indeed, it was from that newspaper that Mary Surratt's attorneys, John W. Clampitt and Frederick A. Aiken, learned that their client would hang. Newsboys hawked the issue to eager readers: "EXTRA. THE CONSPIRACY. THE FINDINGS OF THE COURT. The Sentences Approved by the President. Mrs. Surratt, Payne, Herold and Atzerodt to be Hung!! The Sentences to be Executed To-Morrow!! Mudd, Arnold and O'Laughlin to be Imprisoned for Life! Spangler to be Imprisoned for Six Years!"

The paper's second edition that day provided more details, including how the condemned had reacted to the news:

The Great Conspiracy. THE CRIMINALS. THEIR DEATH WARRANT READ TO THEM. WHERE THEY ARE TO BE HUNG. THE PREPARATIONS FOR THEIR EXECUTION. This morning General Hancock, commanding Middle Military Division, proceeded to the Arsenal and handed the death warrants of Payne, Herold, Mrs. Surratt, and Atzerodt, to Major General Hartranft, in charge of the prisoners, and they at once proceeded to the prison, when they informed the prisoners of their sentences— General Hartranft reading the warrants in each case. The announcement did not take Payne by surprise, as he expected no other sentence, and he showed little emotion. Atzerodt tried hard to assume an indifferent air, but vainly, as shown by the tell-tale tremor of his extremities and the ashen pallor upon his face. The sentence was a thunderbolt to Herold, who had expected nothing more serious than a short imprisonment at the penitentiary. The frivolous simper deserted his face, and for once he seemed totally

unmanned. Mrs. Surratt was completely unstrung.

The news prompted a flurry of activity. At the prison, General Hartranft asked the condemned whom they wanted to see. He used his best efforts to locate friends, family, and ministers. At their law office, Clampitt and Aiken drafted legal papers in a last-ditch effort to save Mary Surratt. At the White House, Surratt's daughter, Anna, and others tried to see President Johnson to beg for mercy, but he would not receive them. At the prison, work on the scaffold continued, and plans were made for the execution protocol.

The execution was the hottest ticket in town. People besieged General Hancock for passes to witness the event. The second July 6 edition of the *Evening Star* warned readers that passes would not be easy to get: "The execution is to take place in the prison yard of the Arsenal, which is not large enough to accommodate many spectators, and therefore, while the execution will be in effect a public one, it will require a pass for admission signed by Major General Hancock, who is charged with the execution of this order, and these will be given sparingly—no more being admitted than can find convenient standing room."

But curiosity seekers would not be deterred, reported the *Star* on July 7: "Gen. Hancock . . . gave passes to such parties as were privileged to witness the execution. These were limited to the regular members of the press, the necessary witnesses, and a few officers. . . . At the Metropolitan Hotel, where Gen. Hancock stops, a great crowd assembled in hopes of meeting him and procuring passes to the execution. His letter-box was filled with letters and cards that projected like a fan, and for a time the entrances to the hotel were completely blockaded. The applicants for admission were without number until a late hour last evening, and early this morning Gen. Hancock's headquarters were besieged for passes. The rule of limitation, however, was strictly adhered to, and none permitted to attend the execution for the mere gratification of curiosity."

The curiosity seekers needed no pass to surround Mary Surratt's boardinghouse. Hundreds of people converged on H Street as soon as word of the next day's execution spread. The *Evening Star* dispatched a reporter to watch the street and uncovered a morbid promenade:

Mrs. Surratt's residence on H Street, near Sixth, was closed on Thursday, after the announcement of her fate had been made public. At night the house was robed in darkness, save a faint glimmering of light which shone alone from one of the rooms. Miss Anna E. Surratt early in the evening returned to her house from the prison, whither she had been during the day attending her mother. She appeared heart-broken, and her cries and sobbings elicited the sympathies of all who were standing near the carriage, from which she was assisted by a gentleman. On entering the house she was completely exhausted, and had to be supported by the inmates. All day yesterday the residence of Mrs. Surratt was the cynosure of hundreds of curious eyes. From the dawn of morning until the close of day the neighborhood of the house was visited by inquisitive people, who were anxious to see the place where the junta of conspirators assembled to deliberate upon their terrible plan.[31]

One man whose admission to the execution was assured was photographer Alexander Gardner. On July 5, the day the sentences were approved by the president, Gardner visited the prison confidentially to view the execution site and select positions for his cameras.

Gardner was the obvious choice to record the hanging. He had photographed Abraham Lincoln many times, and Lincoln liked him. In April the War Department had allowed him come aboard the ironclads and photograph the conspirators soon after their arrests. The War Department had also summoned him for secret work—to make the only photographs of the corpse of John Wilkes Booth after the assassin's body was brought back from the Garrett farm in Virginia.

Because Gardner would be the only photographer present at the historic execution, it was vital that he be prepared to record the events. He decided to bring two cameras—a standard view camera that held large glass plates, and a stereo camera that would take double images and create a three-dimensional effect. He and his assistant, Timothy O'Sullivan, prepared their glass plates carefully in advance and planned how to photograph the event. The cameras were big and awkward, and the plates had to be loaded one at a time. After each exposure, Gardner would have to remove the glass plate from the camera, protect it from damage, load a fresh plate, and make another exposure. Unlike in his portrait studio, where there was a margin for error, and he could make additional images of his subject until he obtained the perfect portrait, there would be no second chances in the yard of the Old Arsenal Prison.

Gardner was well known, and his presence two days later at the execution did not escape notice. One paper published a humorous aside in its otherwise somber coverage: "THE PHOTOGRAPHER ABOUT. At 12 o'clock the click of a hammer was heard in the upper story of the old workshop of Penitentiary days, in the centre of the prison yard, and the eyes of all were turned in that direction. Presently a window was raised, and forth with was seen protruding the familiar snout of the camera, showing that the inevitable photographer was on hand. Gardner's good-humored face presently was seen over the camera, as he took 'a sight' at the gallows, to see that it was focussed properly."

On July 7, execution day, the morning newspapers screamed with banner headlines. The *Daily Morning Chronicle* was representative of the Washington press: "THE CONSPIRACY CONVICTION OF ALL THE PRISONERS. ANNOUNCEMENT OF THEIR SENTENCES. FOUR TO BE EXECUTED TO-DAY." According to the lead story, when the findings and sentences of the military commission had been announced the day before, they "created considerable sensation throughout the city, the more so from the fact that a number of absurd and contradictory rumors upon the subject had been in circulation during the week."

Like the *Evening Star*, the *Chronicle* reported the prisoners' response: "Payne, as usual, preserved his stoical demeanor, as though he had fully anticipated the verdict. Herold was considerably affected. Atzerodt made an effort to appear indifferent, but when the awful reality broke upon him, his face became deathly pale, and his knees trembled. Mrs. Surratt was completely unnerved, and begged for a reprieve."

The editors of the *Chronicle*, like most of the press, endorsed the sentences. In an editorial entitled "The Doom of the Assassins," they declared that these "hardened and remorseless fiends" should suffer "that most dreadful of all penalties allowed by the civilized world—death by hanging."

But many people believed that Mary Surratt would not be hanged. Up until the moment she stood on the gallows, minutes before the trap fell, even the officers in charge of the execution thought that she might be saved. Her champions tried several tactics. The night before the execution, Anna Surratt had gone to the White House and begged to see President Johnson, who refused to receive anyone seeking mercy for the conspirators.

The July 7 *Daily National Intelligencer* of Washington, D.C., reported on these doings: "There was a great rush to the Executive Mansion on Thursday by counsel for the prisoners, by their friends, and by their spiritual advisers for pardon for the condemned, or for an extension of time. It is needless to say that all applications were refused. Yesterday morning early Miss Surratt, accompanied by a lady friend, visited the Executive Mansion and plead for an interview with President Johnson. Two of Herold's sisters also visited the White House to plead in behalf of their unfortunate brother, but all interviews were refused. Miss Surratt also called upon General Hancock, but of course he was powerless to do anything but carry out the orders given him by the President and Secretary of War."

Early on execution day, Surratt's attorneys won a writ of habeas corpus from a civil court, ordering her release from military custody. But General Hancock and Attorney General Speed rushed to court with an

executive order from the president suspending the writ. Five of the judges of the commission had signed a document suggesting that President Johnson should commute her sentence to life in prison. Later, this document was the subject of much controversy. Johnson complained that he never saw it, but Judge Advocate General Joseph Holt testified that he did show it to the president.

While these developments unfolded, General Hartranft remained at the prison, waiting. Rumors spread that Mary Surratt had been pardoned, or that civil authorities were on the way to arrest General Hancock and to rescue her. Hartranft's orders gave him some discretion: The conspirators had to be executed between 10 A.M. and 2 P.M.; it would not violate orders if he waited a few hours to see what news arrived.

The U.S. marshal bearing the writ never came, and no rider from the White House saved the day with news of presidential clemency. Surratt would die with the rest. The order to proceed startled the hangman, Christian Rath, who asked, "Her, too?" before he placed the noose around her neck. "She can not be saved,"[32] replied Hancock.

There are many accounts of the execution of the Lincoln assassination conspirators. Contemporary newspapers, plus memoirs of the some of the participants published later, provide the best evidence of what happened on July 7, 1865. The gentlemen of the press were experts at their trade, and after four years of reporting the drama of the Civil War, they knew how to paint a picture vividly with words. They had no choice. Newspapers of the time could not print photographs, and the first woodcuts in *Harper's Weekly* and *Frank Leslie's Illustrated Newspaper* were several days away. Gardner's photographs would not be available commercially for a few weeks. Therefore, the first reports of the execution would be entirely written, without the benefit of illustrations or photographs. It was the reporter's job to conjure up in the minds of readers, through exquisite verbiage and close factual observation, what it was like to witness the hanging.

The first published account of the execution appeared in the *Evening Star* on July 7, 1865, just hours after the hanging. The editors pronounced satisfaction with the day's work and affirmed public opinion that what had happened was more than just the trial and execution of simple criminals: "The last act of the tragedy of the 19th century is ended, and the curtain dropped forever upon the lives of four of its actors. Payne, Herold, Atzerodt and Mrs. Surratt, have paid the penalty of their awful crime. . . . In the bright sunlight of this summer day . . . the wretched criminals have been hurried into eternity; and to-night, will be hidden in despised graves, loaded with the execrations of mankind."

The editors reminded readers that the trial had been fair: "Their deeds have been judged patiently and impartially. Seven weeks were devoted to their trial, witnesses have been summoned from remote locations, every point that in some manner suggested innocence was carefully weighed, and the sentence of death executed only because there was not one reasonable doubt of overwhelming guilt." After rebuking the supporters of Mary Surratt, who had hoped that her life might be spared because of her age or sex, the *Star* went on to report what its readers wanted most—full details on how the conspirators had died.

Newspaper accounts adopted the classic narrative convention of crime and punishment literature that readers expected. The drama read like a script: The last hours of the condemned in their cells the night before their deaths; intimate descriptions of their visitors and what was said; the tantalizing possibility of last-minute confessions; bizarrely detailed descriptions of their clothing and appearance; the walk to the scaffold and the watchful eye for signs of bravery or cowardice; the reading of the death sentence. But in this version of the story there were no last words: The condemned had not been invited to speak. (Unbidden, one did.) Then the drop—and grotesquely detailed accounts of the death struggles at the end of the ropes. Then death, and the dishonor of a criminal's unmarked, unconsecrated grave. It was like a script, and the *Star* and other papers followed it to the letter.

The *Star* took its readers up to the scaffold: "Atzerodt was the first up. His arms were bound behind him with strips of white cotton cloth. He was similarly bound at the knees and at the ankles. Herold, Payne, and Mrs. Surratt were bound in the same manner; the operation with the latter requiring more time than with the others, from the difficulty of dealing with her dress. The fatal nooses were now opened to admit the heads of the criminals, and the knots, as usual, were adjusted exactly under the left ear. Payne worked his neck in the noose as if dissatisfied with the adjustment and the noose was widened a little to suit his ample neck."

The hangman, Captain Christian Rath, whispered into Powell's ear "I want you to die quick." Rath admired Powell's bravery and did not want him to suffer. Powell answered with his last words: "You know best, Captain."[33]

With each successive paragraph, the *Star* heightened the drama:

Mrs. Surratt seemed to find it difficult to stand and said to those near her, "Please don't let me fall." This was just before the drop fell. Atzerodt, who seemed to grow excited as his last moments approached, just before the white cap was placed over his head, attempted in a gasping manner to address the spectators. His parched lips would not obey the helm, and it was distressing to see him convulsively endeavoring to make himself intelligible. At last he managed to get out the words, "Gentlemen, take ware," meaning, evidently, "take warning." The white cap was drawn over his head, as was done, with the others, and it was supposed that no more would be heard from the prisoners. But just before the drop fell Atzerodt's voice was again heard in muffled accents, saying "Good by, gentlemen, who are before me now. May we all meet in the other world! God help me now! Oh! Oh! Oh!" and as the last broken exclamations were on his lips the drop fell, and the four criminals hung quivering in the air.

At that moment Alexander Gardner's stereo camera captured the condemned hanging in the air, still alive, suffering their death struggles. In a rare

surviving example of that stereo card, the swinging bodies have created a blur during the exposure of the negative. The *Evening Star* spared no detail:

At twenty-six minutes past one o'clock the signal was given by a wave of the hand, the large blocks supporting the uprights were knocked out, the drops fell with a heavy slam, and the four bodies hung suspended. Payne's limbs were drawn up several times, and for a moment or two his whole frame quivered violently, but within five minutes all was still. Herold struggled some, and some emissions of water took place from his body, such as is frequently the case with persons dying a violent death. There was no perceptible movement of the body of Atzerodt and he apparently died easy. There was only a slight movement of the limbs of Mrs. Surratt observed. There was breathless silence for several minutes after the drop fell, but in a short time persons commenced to move about as usual.

The bodies were allowed to hang about 20 minutes when Surgeon Otis . . . Assistant Surgeons Woodward and Porter . . . examined them and pronounced them all dead. In about 10 minutes more a ladder was placed against the scaffold preparatory to cutting the bodies down. An over zealous soldier on the platform reached over severed the cord, letting the body fall with a heavy thump when he was immediately ordered down and reprimanded.

The bodies were laid on white pine boxes, their necks were inspected for signs of breaks or strangulation, and they were buried in unmarked graves beside the gallows.

The next day, the morning papers in Washington and across the country followed the *Star*'s lead and offered the kind of details that their readers demanded. Many newspapers copied their stories verbatim from the Washington papers, an accepted custom of the day. The *National Intelligencer*'s account, excerpted here, remains a piece of classic reporting:

The day of the execution was bright and clear . . . at the main entrance a strong guard was posted, and no one was allowed admission except such persons as carried passes signed by Gen.

Hancock. . . . The scaffold was erected during the night of Thursday by workmen detailed by Colonel Benton, of the Arsenal, under the direction of Captain Rath, of General Hartranft's staff. It was erected in the south yard of the building, and was twenty feet long, fifteen feet wide, ten feet high to the floor, and twenty feet to the beam. A beam ran through the centre of the platform of the scaffold, east and west, and upon each side of this beam and on the west side of the platform was a drop. Each drop was six feet long by four feet wide, and over each drop and suspended from the top beam hung two ropes, made of strong hemp, tarred, the slip of the noose of each rope being formed of nine twists and a knot.

The drops were supported by uprights, which being knocked away by two pieces of scantling, made to serve as rams, would allow the drops to fall. The steps leading to the platform of the scaffold were on the east side, and it was intended that the condemned prisoners should face to the west. The scaffold was about fourteen yards from the east wall of the enclosure. A few feet southeast of the scaffold, four graves, each one four feet deep, seven feet long, and three feet wide, had been dug, and were intended for the reception of the remains of the condemned prisoners. Beside these graves the coffins, made of plain pine boards, had been placed.

At half-past 12 o'clock Herold's sisters, seven in number, passed from the cell of their brother, after having bid him a farewell until eternity. They were weeping bitterly and then tears and moans told sensibly upon the stoutest hearts present. . . . Fathers Wiget and Walter were exceedingly earnest with regard to Mrs. Surratt, and prayed with her the entire morning. Her daughter was with her up to 12 o'clock, and Mrs. Surratt gave directions as to the disposition of her property after her death. . . . Atzerodt was counselled by Rev. Dr. Butler. He was visited during the morning by his mother and his wife. . . . Payne sat upright in his cell, but listened attentively to all that was said to him in reference to his soul's salvation.

At one o'clock, General Hancock emerged

from the building and contracted the lines of the guards. Four chairs were then placed on the scaffold, two on each side, whilst the windows of the Penitentiary building overlooking the enclosure where the execution was to take place thronged with human countenances. The top of a building in the Arsenal grounds, overlooking the scene, was also densely packed with human beings. . . . Gardner was on hand at the windows of the building looking from the west upon the scaffold, and took a number of photographs of the scene in its various stages of progress.

Two minutes after one o'clock the prisoners appeared at the door. . . . Mrs. Surratt was brought out first, supported by an officer and a non-commissioned officer. She wore a black alpaca dress, and had a veil over her face. She was also attended by Fathers Walter and Wiget, one of whom held a crucifix before her. She walked with a comparatively steady step leading to the platform of the scaffold, when she faltered a little. Upon being conducted to the platform she was placed in the chair on the right-hand side facing west, and her spiritual advisers commenced at once to direct her thoughts to eternity. Atzerodt followed next, supported as was Mrs. Surratt and attended by Rev. Dr. Butler. He wore the same clothes which he had on while the trial was in progress. He was bare headed, and was the only one of the party who was so. He was seated in the chair left of the platform facing west, and in order to protect him from the rays of the sun a white handkerchief was placed over his head.

The third in the solemn procession was Herold, who advanced with halting steps. He wore the same rusty black coat and checkered pants in which he was arrayed during the trial. His black slouch hat was turned all around, and altogether he looked the most miserable of the party. He was given a seat on the right of Atzerodt. Payne was brought out last, and he was accompanied by Rev. Dr. Gillette. He wore a straw hat, and shirt and pants of sailor blue. He walked with his head erect, and looked as though he fully understood the predicament in which he was placed, but was ready to meet the consequences of his guilt. He was seated by the side

and to the left of Mrs. Surratt, and upon the same drop with her. All of the prisoners were manacled hand and foot, and consequently walked with some difficulty. As soon as the prisoners were seated they seemed to be muttering prayers. Payne looked upward, and never once took his eyes from the heavens, except when listening to or replying to Dr. Gillette. Mrs. Surratt was attentive to her spiritual advisors, and while Father Wiget held the cross before her, Father Walter read the preparatory prayers for death. Herold hung his head so that his face was scarcely visible for a time, but when he raised his head he seemed to be engaged in earnest prayer. Atzerodt was attentive to all that Dr. Butler said to him, and appeared to feel very sensibly that he was upon the brink of eternity.

General Hartranft, accompanied by members of the staff, ascended the scaffold at five minutes past two [sic] o'clock and in a clear voice read the order for the execution. Herold and Atzerodt were affected to tears while the reading was in progress. Payne still gazed toward the heavens and Mrs. Surratt's face was not visible, her spiritual advisers engaged at the time administering the sacrament.

As soon as the reading was completed Dr. Gillette stepped forward and said that the prisoner, Louis Payne Powell, known as Payne, desired him thus publicly to thank General Hartranft and all the officers and soldiers under his command for the kind manner in which he had been treated during his imprisonment, and for their uniform and disinterested kindness and attention to him . . . during the prayer Mrs. Surratt groaned audibly.

At seventeen minutes after one o'clock the work of adjusting the nooses over the heads of the condemned was commenced. Each prisoner was bound about the arms with a strip of linen; while two strips, one about the ankles and the other above the knees, held the legs secure. Atzerodt trembled slightly as he stood up, as did also Herold. Payne stood like a statue, apparently determined to brave it to the last. Mrs. Surratt wavered a little, and at one time it was feared she would give way. Indeed, she was not without that

fear herself, for at one time she said to those standing by, "Please don't let me fall" . . . Atzerodt was the only one who spoke aloud. While his arms were being tied he said, "Gentlemen, take ware," evidently meaning they should take warning. While the white cap was being adjusted over his head, he spoke again and said, "Good-bye, gentlemen who is before me. May we all meet in the other world."

It was now twenty-one minutes after one o'clock. The prisoners had all been securely bound; the fatal nooses had been adjusted; the white caps had been placed over the heads of the condemned; Captain Serath [sic], of the 17th Michigan Infantry, who had charge of the detail for the execution, waved the crowd back from the prisoners; he clapped his hands three times; four soldiers, Wm. Coxwell, Daniel Sharpe, George F. Taylor, and Joseph Hazlett, all of company F, 14th V.R.C., knocked the supports from under the drops, and four human beings were left dangling between heaven and earth.

A shudder passed through the frame of Mrs. Surratt; but there was no other motion, except a nervous twitching of the hands, and in a moment all was quiet with her. Atzerodt struggled once, and then all was over. Payne and Herold died hardest. It was at least seven minutes before the muscular contractions of the former ceased. At one time he drew himself up so far as to assume the position one would take in sitting down. Herold gave evidence of life for about five minutes after swinging off.

After the bodies had hung for some time, Surgeon Otis, United States Volunteers; Assistant Surgeon Woodward, United States Army; and Assistant Surgeon Porter, United States Army, examined them, and pronounced each one dead. At seven minutes to two o'clock an order was given to cut the bodies down. An over-zealous corporal ran upon the scaffold, and with one cut severed the rope which held the body of Atzerodt suspended to the beam, and it fell to the ground below. The corporal was at once ordered from the scaffold and reprimanded. The other bodies were taken down more carefully, and, after an examination by

the surgeons, were placed in the coffins. Although the fall was nearly five feet, not a neck was broken, so far as the surgeons could ascertain. All of the nooses except that placed around the neck of Herold slipped to the back part of the head. Herold's body was taken down at four minutes of two o'clock; Payne's at three minutes of two; and Mrs. Surratt's at two minutes of two.

As each body was taken down the irons were removed from their ankles and arms, and the bands binding them were cut and removed. When Mrs. Surratt was being taken down, as the rope was cut, her head of course fell over upon her breast, and an individual standing by made the heartless remark, "She makes a good bow." He was properly rebuked by an officer standing by.

All of the deceased were placed in the coffins just as they were dressed when executed. The white caps were not even removed from their heads. The coffins were placed in the graves prepared for them, but friends can reclaim the bodies whenever they see fit so to do. The arrangements for the solemn tragedy were most perfect, and reflected unbounded credit upon Major General Hartranft and his efficient assistants.

The curtain has fallen upon the most solemn tragedy of the nineteenth century. God grant that our country may never again witness such another one.

It was not to be. Almost a hundred years later, Lincoln's death and funeral lingered so strongly in the national memory that when asked her wishes for her husband's funeral, Jacqueline Kennedy said, "Make it like Lincoln's."

His work done, although not perfectly as at least two conspirators did not have their necks broken but strangled to death slowly, Christian Rath cut down the ropes and divided them into pieces as souvenirs of the day. Even before the execution, reported one newspaper, "The relic hunters were about and despite the strong cordon of guards one man soon appeared with a handful of chips from the gallows and another with an inch bit of the rope."[34]

After the witnesses had departed, the bodies were buried, and Alexander Gardner toted off his cameras, it was open season on the gallows. According to the *Evening Star*: "The gallows remain in the same condition as when the bodies were cut down, although it has been somewhat hacked for relics by the soldiers on duty there. No directions have been given yet for its removal."[35]

Other trophy hunters rushed to Mary Surratt's boardinghouse. The *Star* reported: "Yesterday afternoon and last night hundreds of persons visited the vicinity of the Surratt house . . . in anticipation of getting a view of Mrs. Surratt's body, which many supposed would be brought to her late residence, but in this they were disappointed. At one time in the evening the crowd became so great around the house that it was found necessary to dispatch a detail of policemen to the spot to prevent intrusion upon the inmates. Before the arrival of the police some of the relic-hunters went so far as to cut chips from the portico in front of the residence. To-day the house is closed and draped in mourning."[36]

Inside that house, Mary Surratt's daughter wept. According to the *Star*: "Miss Annie E. Surratt, after bidding a final farewell to her mother a few moments before the execution, was conveyed to her residence on H street, where she gave vent to her feelings in such a manner as to attract the attention of passersby. Later in the day she broke down under the effects of the trying ordeal through which she had passed, and at a late hour last night it was reported that she was dead, but this proved to be incorrect. This morning, however, she is completely prostrated."[37]

The next day, July 9, she summoned her strength to compose a heartbreaking letter to General Hartranft. The general and his staff had been kind to Mary Surratt during her imprisonment, and they bore her no personal animus. Her inconsolable daughter sought to thank him and to make a small request: Might she have the precious pillow on which her beloved mother's head rested during her last night on earth?

The surviving conspirators were sent to the Florida Keys—to Fort Jefferson at Dry Tortugas—to serve out their sentences. Two years later the Lincoln assassination was back in the news when Mary Surratt's son John was captured abroad and brought back to the United States to stand trial as a conspirator in the great crime. Tried in 1867 in a civil court, Surratt was freed when the jury could not reach a verdict. Soon President Johnson released the surviving conspirators. It was too late for Michael O'Laughlin, who had died in prison, but Dr. Mudd, Samuel Arnold, and Edman Spangler were set free.

The memoirs of the chief executioner, Captain Christian Rath, were published nearly half a century after the trial. He recalled the night Powell tried to kill himself in his cell by banging his head against the wall, and how he was found "bathed in blood" but was revived. Rath also remembered the notorious hoods—which he euphemistically called "caps"—and the handcuffs connected by the straight iron bar. He recalled the hurried construction of the gallows and the reluctant carpenter who said, "I have made everything out of wood except a gallows." From their cells, the condemned had heard the hammering and the testing of the trap.

Rath made four nooses from thirty-one strand, two-thirds-inch Boston hemp, taken from the navy yard. Thinking that Mrs. Surratt would not hang, and being tired at the end of the day, he wound her noose with only five knots of the rope, not the customary seven as he did with the others. Rath tested the nooses by taking a length out to a tree behind the prison, filling a sturdy bag with shot, and climbing out on a limb. Securing the rope, he threw the bag off. The limb broke, and Rath was "precipitated to the ground . . . but the rope held."

Superstitious workmen didn't want to dig the graves, so Rath asked for volunteers from among the soldiers. "I could not command them to take part in the gruesome work," he recalled. "[But] I was simply overrun with volunteers," for they regarded it as "an honor to serve . . . in avenging the death of Lincoln."

On the platform, Rath placed Mary Surratt on the far right, considered the "place of honor" during an execution. He remembered that Powell walked to his death "like a king about to be crowned."And he remembered the drop: "I gave the signal, the two drops fell with a sickening thud, and, as one, the four bodies shot downward and hung in mid-air."[38]

Forty-eight years after the execution, one of Rath's men also remembered that day. Corporal William Coxshall was one of four chosen to knock the posts from under the drop. He reported that earlier in the morning a rehearsal had taken place: "One of the grimmest events I ever participated in. Four 140-pound shells were attached to the ropes with chains. For two hours, we were drilled in dropping these exactly as though the prisoners were in their place." The soldiers were promised a canteen of whiskey for doing a good job, but "we never got that drink," he groused.

In Gardner's photos, Coxshall is visible below the platform, leaning against the far left timber. He explained what he was doing: "Then the clergy took over, talking what seemed to me interminably. The strain was getting worse. I became nauseated, what with the heat and the waiting, and taking hold of the supporting post, I hung on and vomited."

Coxshall got a vivid image of how Mary Surratt died. Standing almost directly below her, he heard her last words as she complained that she was being bound to tightly: "'It hurts,' she said. 'Well,' was the consoling reply, 'It won't hurt long.'" Moments later, Coxshall watched as "three of the bodies shot straight down. Mrs. Surratt, who had barely stepped beyond the break, lurched forward, slid off, and fell, her body gathering momentum and swinging to and fro at the end of the rope like a pendulum."[39]

⸻

Scholars and others continue to debate the trial and execution of the Lincoln conspirators. Did they get a fair trial? Was the military commission unconstitutional? If the eight defendants had been tried by a civil criminal court would they, like John Surratt two

years later, have been released? Fair trial or not, were the defendants guilty? Lewis Powell and David Herold were, and they would surely have been convicted anyway. But would they have been hanged? George Atzerodt, who refused to kill the vice president, was guilty of failing to withdraw from the conspiracy, thereby sealing Lincoln's fate. Would the others have been convicted at all? Perhaps Samuel Arnold and Michael O'Laughlin, who were not involved in the plot to kill Lincoln and could prove it, might have been acquitted. Perhaps Edman Spangler, who was part of no plot to kidnap or kill, would never have been prosecuted.

And what of Dr. Samuel Mudd and Mary Surratt? The modern image of the innocent and kindly country doctor honoring his Hippocratic oath by rendering aid to an injured stranger is a myth. Evidence shows conclusively that Mudd was cruel to slaves, had met Booth on three previous occasions, was tied to a network of Confederate operatives, had introduced Booth to John Surratt, had recognized his patient as Booth, and had lied to cover Booth's trail, even after he learned that Booth was the assassin. Even if Mudd was not part of the murder plot, he was not the man that his family has spent more than a century trying to rehabilitate. The complete extent of his involvement with Booth will never be known.[40]

The same is true of Mary Surratt. Her country tavern was a Confederate safe house during the Civil War, her son was a rebel operative, John Wilkes Booth frequented her city boardinghouse, where she saw the comings and goings of the conspirators, and when Lewis Powell was in trouble he came to her door. Then there was the testimony against her, possibly perjured, about shooting irons, whispered confidences, and more. It is impossible to say whether Mary Surratt was part of the conspiracy to assassinate the president; it is easier to believe that she was part of—or at least aware of—the conspiracy to kidnap him.

Many of the Lincoln assassination sites still stand, mute witnesses to the events of the spring and summer of 1865. Ford's Theatre survives on Tenth Street despite many threats—and at least one documented attempt—to burn it down in the aftermath of the assassination. Several blocks away, Mary Surratt's boardinghouse lives on as a Chinese restaurant. Altered in several ways since the night of July 7, when hundreds gathered in the street in hopes of taking a gander at the corpse of a freshly hanged woman, the sad dwelling is still instantly recognizable from period photographs. The Surratt Tavern in Maryland, where John Wilkes Booth and David Herold paused on the night of April 14 and thereby doomed Mrs. Surratt, thrives as a museum, as does Dr. Mudd's home. Little remains of the Old Arsenal Penitentiary where the conspirators were tried and executed. It is still an army post, now called Fort Leslie McNair, but the tall brick wall made famous by Gardner's photographs is long gone, as are all the old buildings but one. The site of the scaffold is now a tennis court. These places continue to beckon the curious but provide no clues. The complete history of the assassination of Abraham Lincoln and the answers to many questions about the trial and execution of the conspirators remain shrouded, as Walt Whitman prophesied, in "eternal darkness."

—James L. Swanson

NOTES

[1] Lewis Payne, sometimes spelled Paine, was an alias. It is the name by which Lewis Powell was known most commonly from his arrest through much of the trial. He also used the names Hall and Reverend Wood. In our own text, we use his legal name. When quoting original sources we preserve whatever name and spelling was used therein.

[2] Noah Brooks, *Washington D.C. in Lincoln's Time.* ed. Herbert Mitgang (1895; reprint, Athens: University of Georgia Press, 1989), 218, 219, 221.

[3] Brooks, *Washington D.C.*, 223.

[4] Brooks, *Washington D.C.*, 225, 226.

[5] The literature of the Lincoln assassination is vast, and it is impossible to rehearse it here. Several titles remain standard references. For the best modern account see Edward Steers Jr., *Blood on the Moon: John Wilkes Booth, Samuel A. Mudd and the Assassination of Abraham Lincoln* (Lexington: University Press of Kentucky, 2001). The best vintage account, and one that holds up well today, is George S. Bryan, *The Great American Myth* (New York: Carrick and Evans, 1940). Other excellent studies include Roy Z. Chamlee, *Lincoln's Assassins: A Complete History of Their Capture, Trial, and Punishment* (Jefferson, N.C.: McFarland & Company, 1990) and William F. Hanchett, *The Lincoln Murder Conspiracies.* (Urbana: University of Illinois Press, 1983). A classic history, nearly a century old but still worth reading, is Clara E. Laughlin, *The Death of Lincoln: The Story of Booth's Plot, His Deed and the Penalty* (New York: Doubleday, Page, 1909).

[6] Strangely, despite Booth's prominence in American history and folklore, there is no modern biography of him. Until one is written, the high spots of the Booth bibliography include John Rhodehamel and Louise Taper, *"Right or Wrong, God Judge Me": The Writings of John Wilkes Booth* (Urbana: University of Illinois Press, 1997); Stanley Kimmel, *The Mad Booths of Maryland* (Indianapolis: Bobbs-Merrill, 1940); and Francis Wilson, *John Wilkes Booth: Fact and Fiction of Lincoln's Assassination* (Boston: Houghton Mifflin, 1929).

[7] For excellent accounts of the mourning and national funeral pageant, see Thomas Reed Turner, *Beware the People Weeping: Public Opinion and the Assassination of Abraham Lincoln* (Baton Rouge: Louisiana State University Press, 1982); Ralph Borreson, *When Lincoln Died* (New York: Appleton-Century, 1965); Dorothy Meserve Kunhardt and Philip B. Kunhardt Jr., *Twenty Days* (New York: Harper & Row, 1965); and Victor Searcher, *The Farewell to Lincoln* (New York: Abingdon Press, 1965). The best insights into the mourning, memories, and myths that followed the assassination appear in Lloyd Lewis, *Myths After Lincoln* (New York: Harcourt, Brace and Company, 1929).

[8] *Sunday Morning Chronicle* (Washington, D.C.), 16 April 1865.

[9] Testimony of Major H. W. Smith in Benn Pitman, *The Assassination of President Lincoln and the Trial of the Conspirators* (Cincinnati: Moore, Wilstach & Baldwin, 1865), 122.

[10] *Evening Star*, 7 July 1865.

[11] Ben Perley Poore, *The Conspiracy Trial for the Murder of the President* (Boston: J. E. Tilton and Company, 1865), 11, 12.

[12] Brooks, *Washington D.C.*, 239.

[13] Poore, *The Conspiracy Trial*, 13.

[14] Poore, *The Conspiracy Trial*, 12.

[15] Brooks, *Washington D.C.*, 238.

[16] Samuel Bland Arnold, *Defense of a Lincoln Conspirator, Statements and Biographical Notes* (Hattiesburg, Miss.: The Book Farm, 1943), 58–60. Arnold's memoir was serialized in the *Baltimore American* in 1902, while he was still alive. It did not appear in book form until 1943.

[17] Abott A. Abott, *The Assassination and Death of Abraham Lincoln* (New York: American News Company, 1865), 12.

[18] Howard K. Beale, ed., *The Diary of Gideon Welles*, vol. 2 (New York: W. W. Norton & Company, 1960), 303.

[19] Howard K. Beale, ed., *The Diary of Edward Bates, 1859–1866*. Vol. 4 of *The Report of the American Historical Association, 1930* (Washington: Government Printing Office, 1933), 481.

[20] George Templeton Strong, *Diary of the Civil War, 1860–1865: George Templeton Strong*. ed. Allan Nevins (New York: Macmillan, 1962), 596.

[21] James Speed, *Opinion on the Constitutional Power of the Military to Try and Execute the Assassins of the President* (Washington: Government Printing Office, 1865).

[22] Beale, *Edward Bates*, 483.

[23] Beale, *Gideon Welles*, 303, 305.

[24] National Archives. U.S. Army Continental Commands, 1821–1920. "Records of Brevet General John Frederick Hartranft as Special Provost Marshal for the Trial and Execution of the Assassins of President Lincoln." RG 393. National Archives Bureau of Archives and History, Harrisburg, Pa.

[25] Arnold, *Defense of a Lincoln Conspirator*, 59.

[26] *Testimony for Prosecution and Defence in the Case of Edward Spangler, Tried for Conspiracy to Murder the President, before a Military Commission, of Which Major General Hunter Was President, Washington, D.C., May and June, 1865. Thomas Ewing Jr., Counsel for the Accused.*

[27] Amator Justitiae [pseud.], *Trial of Mrs. Surratt; or, Contrasts of the Past and Present* (n.p., 1865), 3.

[28] Fifteen years after her execution, one of Mary Surratt's attorneys, John W. Clampitt, published an article in her defense, "The Trial of Mrs. Surratt" (*North American Review* 131, 1880). The first book about her case, although controversial, occupies a central place in the assassination bibliography. See David Miller DeWitt, *The Judicial Murder of Mary E. Surratt* (Baltimore: John Murphy & Co., 1895). For later works, see Helen J. Campbell, *The Case for*

Mrs. Surratt (New York: G. P. Putnam's Sons, 1943) and Guy W. Moore, *The Case of Mrs. Surratt* (Norman: University of Oklahoma Press, 1954).

[29] *Daily Morning Chronicle* (Washington, D.C.), 7 July 1865.

[30] *Evening Star*, 7 July 1865.

[31] Ibid.

[32] John A. Gray, "The Fate of the Lincoln Conspirators: The Account of the Hanging Given by Lieutenant-Colonel Christian Rath, The Executioner," *McClure's* 37 (1911), 636.

[33] Ibid.

[34] *Evening Star*, 7 July 1865.

[35] *Evening Star*, 8 July 1865.

[36] Ibid.

[37] Ibid.

[38] Gray, "The Fate of the Lincoln Conspirators," 626–636.

[39] Coxshall's recollections, published in two places and revised over the years, appear in *The Lincoln Ledger: A Publication of the Lincoln Fellowship of Wisconsin*, November 1995.

[40] The case of Dr. Mudd has inspired several books. See Edward Steers Jr., *His Name Is Still Mudd: The Case against Dr. Samuel Alexander Mudd* (Gettysburg: Thomas Publications, 1997); John Paul Jones, ed., *Dr. Mudd and the Lincoln Assassination: The Case Reopened* (Conshohocken, Penn.: Combined Books, 1995); Elden C. Weckesser, *His Name Was Mudd* (Jefferson, N.C.: McFarland and Company, 1991); Samuel Carter III, *The Riddle of Dr. Mudd* (New York: G. P. Putnam's Sons, 1974); Hal Higdon, *The Union vs. Doctor Mudd* (Chicago: Follett Publishing Company, 1964); and Nettie Mudd, *The Life of Dr. Samuel A. Mudd* (New York: Neale Publishing Company, 1906).

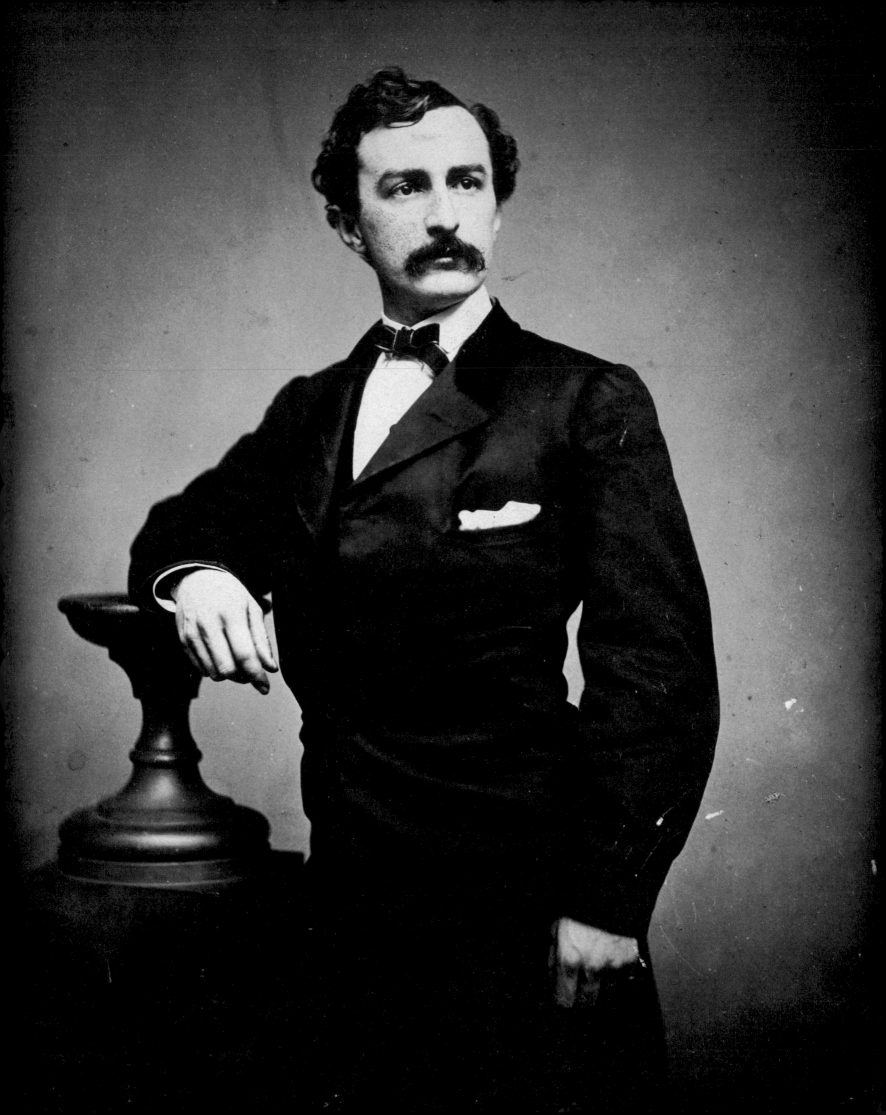

CHAPTER ONE

THE GREAT CRIME – THE ASSASSINATION OF THE PRESIDENT

O powerful western fallen star!
O shades of night—O moody, tearful night!

—Walt Whitman,
"When Lilacs Last in the Dooryard Bloom'd"

ON APRIL 14, 1865, THE PRESIDENT of the United States went to the theater. Five days earlier Lee had surrendered to Grant. The Civil War was over and the North held a jubilee. Cannons boomed, people sang in the streets of Washington, and bonfires flamed. On April 14, Good Friday, Abraham Lincoln sought relief from the exhilaration of victory by attending the play *Our American Cousin* at Ford's Theatre.

The afternoon papers, the *Evening Star* and the *Daily National Republican*, published notices that General Grant would be Lincoln's theater guest that night. Grant had spent most of the war at the front and was an unfamiliar sight in the capital. The promise of his appearance guaranteed a full house. But then the Grants decided to leave Washington on an early train to visit their children. The Lincolns had trouble replacing them; several people declined their invitation. Finally, Clara Harris, daughter of U.S. Senator Ira Harris, and her fiancé, Major Henry Rathbone, accepted the invitation.

When the curtain rose at 8:00 P.M., theatergoers who glanced up at the president's box were disappointed to find it empty. Perhaps Lincoln had changed his mind and was not coming. In fact, the president's carriage arrived late, at about 8:15. The Lincoln party entered Ford's, ascended the stairs, walked across the back of the theater, and stepped into their box, which was festooned with flags. The performance was suspended so that the orchestra could play "Hail to the Chief." As the audience cheered, the Lincolns took their seats.

During the performance, at about 10:15 P.M., a lone figure slipped into the box and fired a bullet into the back of the president's head. Simultaneously, several blocks away, a man forced his way into the home of Secretary of State William Seward and nearly stabbed him to death in his bed. At the theater, Lincoln slumped forward in his rocking chair. He lapsed into unconsciousness without uttering a sound. The assassin swung over the balustrade, ran across the stage, fled out a back door, and galloped away on a waiting horse. Several witnesses said the assassin looked just like John Wilkes Booth, the famous actor.

They were right. Booth, the twenty-six-year-old scion of America's most celebrated theatrical family, had just assassinated the president of the United States. One of the great actors of his day, Booth used his fame and wealth to support a conspiracy against Lincoln. A longtime Confederate sympathizer, he hated Lincoln and his polices. In 1864 he and his loosely organized band of followers plotted to kidnap the president and hold him as a hostage for the Confederacy. His scheme failed, the war ended, and the South lay in ruins. To avenge that defeat, Booth turned to assassination.

Surgeons at Ford's Theatre pronounced the president mortally wounded and warned that he could not be moved far. Soldiers carried him across the street to the Peterson house and laid him diagonally across a spindle bed that was too short for his tall frame. Mary Lincoln sobbed uncontrollably in the front parlor. At the back of the house, Secretary of War Edwin M. Stanton interviewed witnesses, sent telegrams to army posts, and commanded troops to hunt for the assassin. Abraham Lincoln lingered until morning, when he died at 7.22.

1. Perhaps the finest portrait of John Wilkes Booth ever made, this magnificent large-format albumen photograph remains vivid evidence of Booth's appeal. (Caption continues on page 147.)

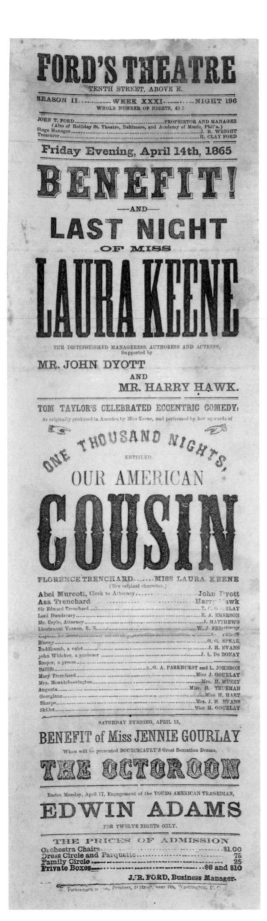

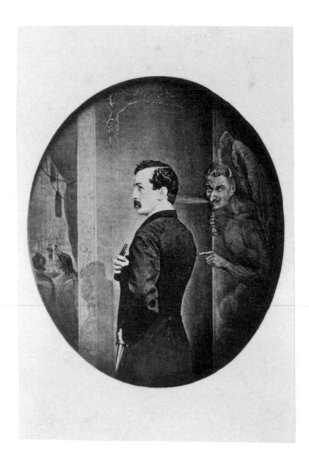

2. An outraged nation condemned John Wilkes Booth for his loathsome act. Artists demonized the assassin with lurid depictions of him as the devil's disciple. This imaginative carte-de-isite montage, based on an actual photograph of Booth, shows Satan whispering in Booth's ear to murder President Lincoln.

3. This carte-de-visite depicts a jaunty Booth, renowned for his luxurious wardrobe, in all his splendor.

4. An authentic Ford's Theatre playbill for the night of April 14, 1865. The public clamored for souvenirs of the assassination. The first reproductions of this playbill appeared within days and continued to be made for decades.

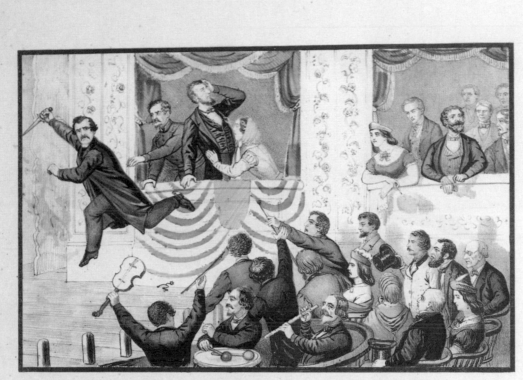

THE ASSASSINATION OF PRESIDENT LINCOLN

At Ford's Theatre, Washington, on the night of Friday, April 14, 1865.

PUBLISHED BY A. PHARAZYN, 229 SOUTH ST PHILAD'A

5. Rival publishers competed frantically to produce prints within days of the assassination. This color lithograph by A. Pharazyn was one of the most dramatic—albeit fanciful—depictions. The president's box was higher from the stage, Booth did not sail through the air, and Lincoln did not spring from his chair after being shot.

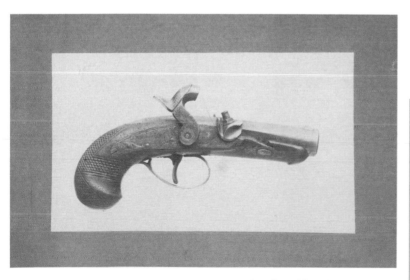

6. & 7. Booth's single-shot derringer became an iconic artifact of fascination, as this undated souvenir photo from the nineteenth century suggests.

This Photograph of Deringer Pistol was taken from the original Deringer Pistol which "Booth" shot & Killed President Lincoln with at Close of Civil War in Fords Theatre Washington D.C. is of exact size. the original is in the Attorney Generals Department in Washington and can only be seen by request.

Tudor Hall June 18th 1855

My Dear Friend

Excuse my neglect, in not writing to you before. but indeed I have been so taken up with the pastimes, and various amusements that have been going on in this month. that I can hardly find time to sleep. and you know that that is something new to me. being a very late risser. and used to long naps. there is nothing that I can put under the heading of news. but I will tell you what has been going on, what is going on and what will be going on if nothing happens, from the first to the last day of June. well the first week in June was taken up by a Fair held in Church Hill for the benifit of the Presbetaryan Church they made $600,00. I spent more time than mony at it. I promise you, for I was there night and day. and you must not think I am blowing when I say I cut quite a dash. I saw pretty girls home at ten O Clock at night some at the distance of four or five miles. after it was over it was very dull for a day or two, and then we. (meaning the young fellows that was doing the same as I) went visiting all the young ladies that we knew at the fair. asked them how they was. how they enjoyed themselves at the fair. and &c &c. then I was invited to two tea parties. I have visited the Travelers home. or home sweet home. the place I described on a rainy day in one of my letters to you. yesterday and to day it has been raining like the devil, and I wanting to do something

-40-

DAILY CITIZEN.
EXTRA.

ASSASSINATION
OF THE
PRESIDENT.

He was Shot at the THEATRE.

He Died at two minutes after 7, this morning.

THE NATION IN MOURNING

J. Wilkes BOOTH,
The Actor.

THE ASSASSIN.

ESCAPE OF THE ASSASIN!

DEATH OF SEC. SEWARD.

From the gentlemanly telegraphic operator, Mr. Mundy, we are able to lay before the public the mournful news of the assassination of the President of the United States.

We obtain from Quartermaster General Meigs the following account of the assassination :

"About half-past ten o'clock, a man dressed in a dark suit and hat entered the private box, in which Mr. Lincoln and his party consisting of Mrs. Lincoln, Miss Harris, daughter of Senator Harris, and Capt. Rathbone, of Albany were seated.

Immediately upon opening the door, he advanced toward Mr. Lincoln with a six barreled revolver in his right hand and a Bowie knife in his left. The President, who was intent upon the play, did not notice his interruption, and the gentleman who was seated beside him rose to enquire the reason of his entry. Before he had time to ask the assassin what he wanted, he fired one charge from his revolver, which took effect in the back part of the President's head. The ball passed through and came out at the right temple. Capt Rathburn who was in the box with Mr. Lincoln attempted to arrest the murderer, and on so doing he received a shot in his arm. The assassin then leaped from the box to the stage. Before he disappeared behind the curtain he turned and with a tragic tone and flourish with his knife, shouted " Sye Semper Tyrannies."

So sudden was the affair, that for some moments after the occurrence, the audience supposed that it was part of the play, and were only uudeceived by the manager announcing from the stage that President of the United States had been shot. The shock fell upon the audience like a thunder bolt, and loud cries were immediately raised to " kill or capture assassin."

The murderous emissary of the Slave power escaped easily and rapidly from the Theatre, mounted a horse and rode off.

The mass of evidence to-night is that J. Wilkes Booth committed the crime. Whoever it was, there are reasons for thinking that the same bold and bloody hand attempted the life of Mr. Seward.

The person who fired the pistol was a man about thiry years of age, about five feet nine inches high, spare built, fair skin, dark hair, apparently with large mustache.

Laura Keene and the leader of the orchestra, declare that they recognize him as J. Wilkes Booth, the actor and a rabid secessionist. Who ever he was, it is plainly evident that he thoroughly understood the theatre, and also the approaches and modes of escaping on the stage. A person not familiar with the theatre could not possibly have made his peas well aud quickly.

The following dispatch, just received, brings the sad intelligence that the assassin's shot was fatal. The honored head of the nation is no more :

WASHINGTON, April 15.

To Gen Dix :

The President died at 2 minutes past 7 this a. m. (Signed,)

E. M. STANTON.

LATER.

Secretary Seward was assassinated last night. He died at 9:45 this A. M.

MIRROR EXTRA.

SATURDAY MORNING, APRIL 15.

TERRIBLE NEWS

ASSASSINATION
OF

Pres. Lincoln,
SEC'Y SEWARD,
AND
Mr. Fred'k Seward.

Booth, the Actor, the Assassin.

Washington, April 15. A most terrible assassination, unparalled in the history of the country, occurred a few moments before eleven o'clock to-night, at Ford's Theatre.

President Lincoln and Mrs. Lincoln were seated in a private box on the right hand side of the stage, witnessing the last act of the "American Cousin."

He went with apparent reluctance and urged Mr. Colfax to go with him, but that gentleman had made other arrangements and with Mr. Ashmun of Massachusetts, bid him Good bye.

At a moment when it was unusually quiet, the sharp, quick report of a pistol was heard and a man sprung out of a box to the stage some ten feet downward and with a knife gleaming in his hand run across the stage out into a side alley, mounted a horse and rode like lightening up Tenth street.

The audience for a moment seemed paralized, for glancing at the box the President had fallen back as if killed or badly wounded.

The pistol ball entered the back of the President's head and penetrated nearly thro' the head. The wound is mortal. He has been insensible ever since the wound was inflicted and is now dying.

About the same hour an assassin, whether the same or not is not known, entered Mr. Seward's apartment and under pretence of having a prescription was shown to the Secretary's sick chamber. The assassin immediately rushed to the bed and inflicted two or three stabs in the throat and two on the face.

It is hoped that the wounds may not prove mortal. My supposition is that they will prove mortal. The nurse alarmed Mr. Frederick Seward, who was in an adjoining room, and he hastened to the door of his father's room, where he met the assassin, who inflicted upon him one or more dangerous wounds.

The recovery of Frederick Seward is doutful. It is not probable that the President will live through the night.

Gen. Grant and wife were advertised to be at the theatre last evening, but he started for Burlington N. J. last evening. At a Cabinet meeting at which Gen. Grant was present, the subject of the state of the country and the prospect of a speedy peace was discussed. The President was very cheerful and hopeful, and spoke very kindly of Gen. Lee and others of the Confederacy and of the establishment fo a government in Virginia.

All the members of the Cabinet except Mr. Seward are now in attendance upon the President. I have seen Mr. Seward, but he and Frederick were both inconscious.

EDWIN M. STANTON,
Secretary of War.

Half past one, The President lingers insensible with his life blood ebbing away. It is a slight consolation to learn that Gen. Grant has reached Philadelphia unharmed, as fears have been entertained that a plot had been laid and that he might also have been a victim. So passeth away the champion of Liberty and Union, a devoted husband, an indulgent father, a sincere friend and exemplary man. May God in his mercy protect the United States.

WASHINGTON, April 15.

To Major-Gen. Dix :—Abraham Lincoln died this morning at 22 minutes after seven o'clock. E. M. STANTON,
Secretary of War.

Miss Laura Keene, who was coming on the stage at the time of the shooting, testifies that J. WILKES BOOTH, the actor, is the assassin.

The screams of Mrs. Lincoln first discovered the fact to the audience that the President had been shot, when all present rose, their feet rushing towards the stage many exclaiming Hang him! Hang him! The excitement was of the wildest possible discription and of course there was an abrupt termination of the theatrical performance.

There was a rush towards the President's box, when cries were heard, stand back to give him air! Has any one stimulants? On an hasty examination it was found that the President had been shot through the head above and back of the temporal bone, and that some of the brain was oozing out.

A common single barrelled pocket pistol was found on the carpet. The shock to the community is terrible.

The parting of his family with the dying President is too sad for description.

The President and Mrs. Lincoln did not start for the theatre until fifteen minutes after 8 o'clock. Speaker Colfax was at the White House at the time and the President stated to him that he was going, although Mrs. Lincoln had not been well, because the papers had announced that he and Gen. Grant were to be present, and as Gen. Grant had gone north he did not wish the audience to be disappointed.

Vice-President Johnson is in the city. His headquarters are guarded by troops.

9. & 10. In some cities, the newspapers did not wait for their regular editions to publish news of the assassination. Instead, they rushed into print with one-page broadside extras that announced the latest—and frequently erroneous—news. The *Daily Citizen Extra* contains many errors: It reports that Secretary of State Seward is dead (he was wounded in a knife attack); it states that Lincoln died at 7:02 A.M. (the time of death was approximately 7:22 A.M.); it says that one of Lincoln's theater companions, Rathbone, held the army rank of captain (he was a major); and it states that Rathbone was shot in the arm (Booth cut him with a knife). These incorrect statements, plus spelling and typographical errors, suggest that this broadside was printed in haste on the morning of April 15, 1865. This *Mirror Extra*, also from the fifteenth, was produced so quickly that the printer did not even bother to trim the sheet properly.

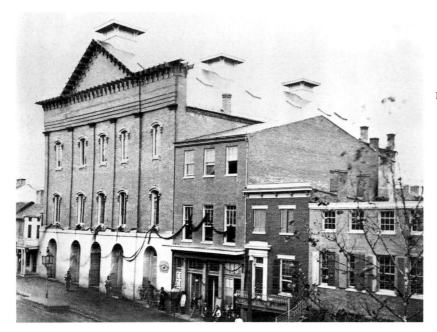

11. Ford's Theatre

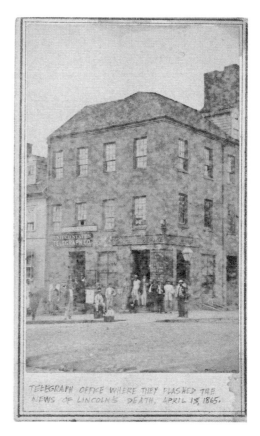

TELEGRAPH OFFICE WHERE THEY FLASHED THE NEWS OF LINCOLN'S DEATH, APRIL 15, 1865.

12. From the telegraph office pictured in this carte-de-visite, news of the assassination and death of the president was flashed to the nation.

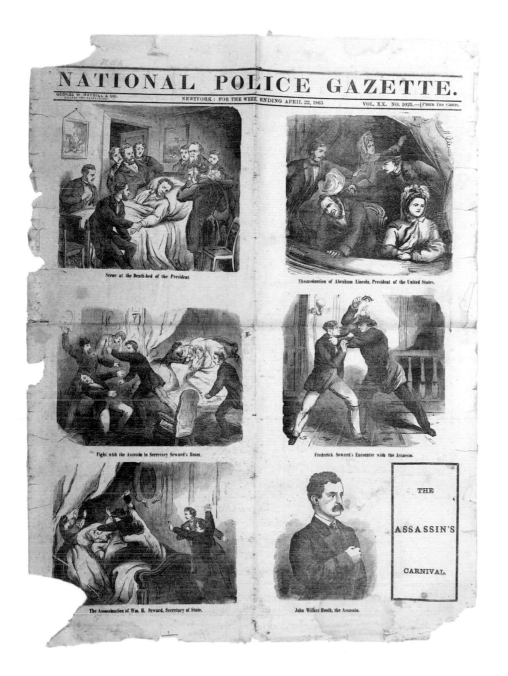

13. This action-packed April 22, 1865, issue of the *National Police Gazette* portrays scenes from what it calls "The Assassin's Carnival"— the assassination of Lincoln at Ford's Theatre, the attempted assassination of Secretary of State William H. Seward in his bed, and the deathbed of the president.

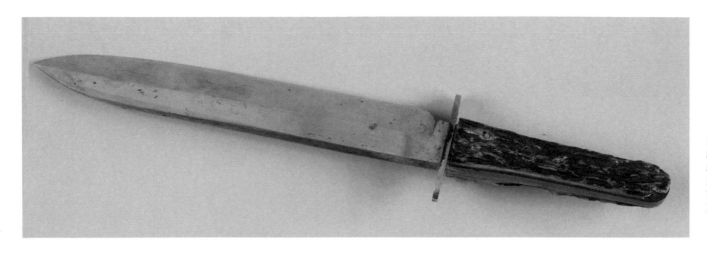

14. Lewis Powell's knife, used to attack Secretary of State Seward and his medical attendant, Private George Foster Robinson.

War Department,
Bureau of Military Justice,
Washington, D. C., July 10th, 1866.

Sir:

Your application for the Knife used by Payne, in his attempt to assassinate the Honorable William H. Seward, Secretary of State of the United States, at Washington D.C., on the night of the 14th of April 1865, having been referred to the Secretary of War, has been by him approved, and I am directed by him to comply with your request. Your conduct on the occasion mentioned is now a matter of history, and none will hereafter doubt but that by your self possession and courage in grappling with the assassin, you contributed largely to save the life of the Secretary of State, at the extreme hazard of your own — a most meritorious public service, nobly rendered, and of which the weapon now committed to your Keeping will be an enduring memento.

Very respectfully

Your Obedient Servt.
J. Holt
Judge Advocate General

To.
Sergeant George F. Robinson,
Present.

Bureau of Military Justice,
OFFICIAL BUSINESS.

Judge Advocate General.

To
Sergeant George F. Robinson
Present

15. Robinson saved Seward's life by fighting off the formidable Powell. For his heroism and the wounds he sustained, Congress gave him a gold medal and a reward of five thousand dollars. Robinson asked for Powell's knife as a souvenir, and in this letter dated July 10, 1866, Joseph Holt, judge advocate of the United States Army and a prominent figure at the trial of the conspirators, presented the knife to Robinson.

16. Replica of Robinson's medal.

17. In Washington, D.C., the *Sunday Morning Chronicle* of April 16 (right) provided a much more detailed account than the issue rushed into print the previous day.

SECRETARY SEWARD'S ATTEMPTED ASSASSINATION, APRIL 14, 1865—THE ASSASSIN TURNING UPON MR. FREDERICK SEWARD AT THE DOOR OF THE SICK-ROOM.

18. In this *Harper's Weekly* woodcut, Lewis Powell launches his attack on the household of Secretary of State Seward.

19. & 20.
Within hours of the assassination, the *New York Herald,* receiving the latest news by telegraph, reported to its readers early on the morning of April 15. The April 16 issue confirmed the death of the president.

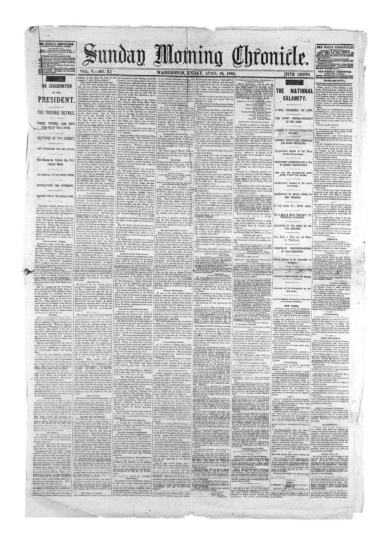

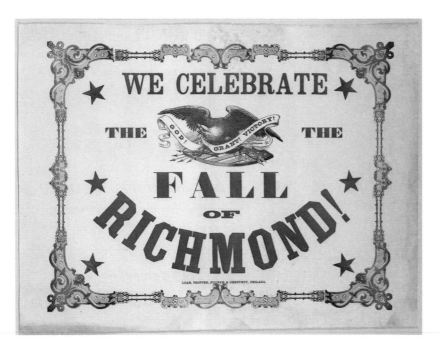

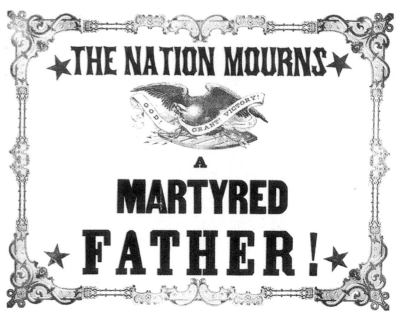

21. & 22. The North rejoiced when the citadel of the Confederacy, Richmond, fell on April 3, 1865. This rare large-format broadside, printed by Loag in Philadelphia, celebrated the news but became obsolete less than two weeks later when Lincoln was assassinated. The printer immediately reset the type, abandoned the festive red, white, and blue color scheme, and produced a somber tribute to Lincoln. Paired, these broadsides show vividly how the mood of the country changed overnight.

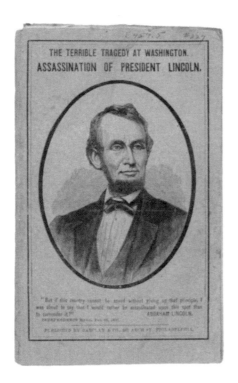

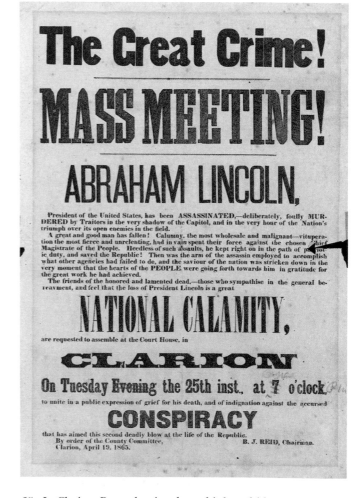

23. & 24. Soon after the nation's newspapers published the first accounts of the assassination and death of Lincoln, other publishers followed with pamphlets. Abott A. Abott's *The Assassination and Death of Abraham Lincoln*, a twelve-page pamphlet from the American News Company in New York, is thought to be the first separately printed account of the assassination. Barclay & Company of Philadelphia published a series of pamphlets about the assassination and the trial of the conspirators, including *The Terrible Tragedy at Washington. Assassination of President Lincoln.*

25. In Clarion, Pennsylvania, where this broadside was published, loyal Union men issued resolutions mourning Lincoln and calling patriotic meetings to demonstrate their grief. Similar broadsides were published in many other cities.

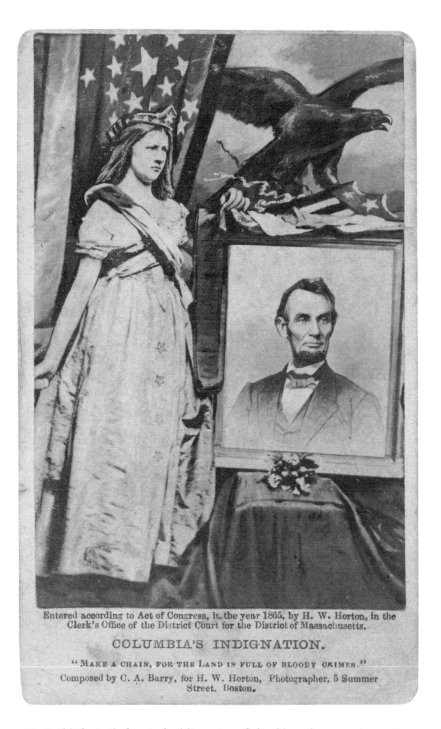

Entered according to Act of Congress, in the year 1865, by H. W. Horton, in the
Clerk's Office of the District Court for the District of Massachusetts.

COLUMBIA'S INDIGNATION.

"MAKE A CHAIN, FOR THE LAND IS FULL OF BLOODY CRIMES."

Composed by C. A. Barry, for H. W. Horton, Photographer, 5 Summer
Street, Boston.

26. In this fantastical carte-de-visite, a stern Columbia and a screaming eagle
keep a vigil over the memory of the martyr president and proclaim a
warning: "Make a chain, for the land is full of bloody crimes." Soon chains
and manacles would become symbols of the trial of the conspirators.

28. & 29. People expressed their grief by purchasing
and wearing white silk ribbons printed in black (above
right). Dozens of different versions were produced,
and even today hitherto unknown designs continue to
be discovered.

27. One of many carte-de-visite-size
memorial cards printed in the days
following the assassination.

The Nation Mourns a Martyred Father.

WE MOURN OUR CHIEF HAS FALLEN.

GOD'S Illustrious Servant FAITHFUL TO THE END

30. 31. 32. & 33. Small, colorful paper flags were popular symbols of mourning.

Mourning Badges.

WE MOURN

THE

NATION'S LOSS.

ABRAHAM LINCOLN.

April 15, 1865.

This beautiful badge, printed on white satin, draped in mourning, with splendid gilt pin attached (with likeness), will be sent by mail, postage paid, for 50 cents. Price, by the 100, postpaid, $25. Badges without pins, $12 50 per 100. Address B. W. HITCHCOCK, No. 14 Chambers Street, New York.

34. & 35. Manufacturers of mourning memorabilia, an instant cottage industry, took out newspaper ads, like this one from *Harper's Weekly*, to hawk their wares. A typical badge combined a Lincoln photograph, an American flag, and a black ribbon.

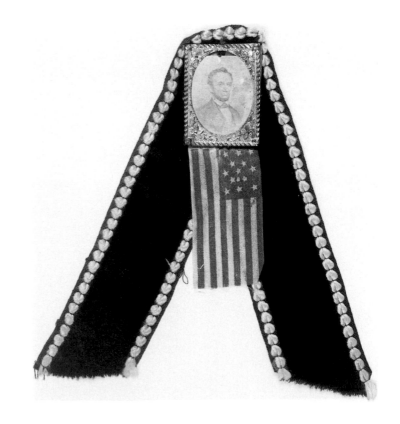

WE MOURN

LINCOLN

OUR LOVED AND MARTYRED GUIDE!

36. & 37. These large-format mourning broadsides, intended for display on a wall or in a window facing the street, are rare. The portrait broadside, with its primitive woodcut, is not a very good likeness of Lincoln, but it speaks with touching simplicity. The black American flag and its demand for vengeance suggest what is to come for those involved in the president's murder.

GOD WILL AVENGE OUR SLAUGHTERED LEADER!

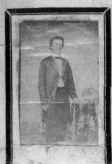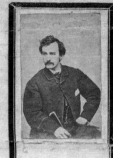

SURRAT. BOOTH. HAROLD.

War Department, Washington, April 20, 1865,

 # $100,000 REWARD!

THE MURDERER

Of our late beloved President, Abraham Lincoln,

IS STILL AT LARGE.

$50,000 REWARD

Will be paid by this Department for his apprehension, in addition to any reward offered by Municipal Authorities or State Executives.

$25,000 REWARD

Will be paid for the apprehension of JOHN H. SURRATT, one of Booth's Accomplices.

$25,000 REWARD

Will be paid for the apprehension of David C. Harold, another of Booth's accomplices.

LIBERAL REWARDS will be paid for any information that shall conduce to the arrest of either of the above-named criminals, or their accomplices.

All persons harboring or secreting the said persons, or either of them, or aiding or assisting their concealment or escape, will be treated as accomplices in the murder of the President and the attempted assassination of the Secretary of State, and shall be subject to trial before a Military Commission and the punishment of DEATH.

Let the stain of innocent blood be removed from the land by the arrest and punishment of the murderers.

All good citizens are exhorted to aid public justice on this occasion. Every man should consider his own conscience charged with this solemn duty, and rest neither night nor day until it be accomplished.

EDWIN M. STANTON, Secretary of War.

DESCRIPTIONS.—BOOTH is Five Feet 7 or 8 inches high, slender build, high forehead, black hair, black eyes, and wears a heavy black moustache.

JOHN H. SURRAT is about 5 feet, 9 inches. Hair rather thin and dark; eyes rather light; no beard. Would weigh 145 or 150 pounds. Complexion rather pale and clear, with color in his cheeks. Wore light clothes of fine quality. Shoulders square; cheek bones rather prominent; chin narrow; ears projecting at the top; forehead rather low and square, but broad. Parts his hair on the right side; neck rather long. His lips are firmly set. A slim man.

DAVID C. HAROLD is five feet six inches high, hair dark, eyebrows rather heavy, full face, nose short, hand short and fleshy, feet small, instep high, round bodied, naturally quick and active, slightly closes his eyes when looking at a person.

NOTICE.—In addition to the above, State and other authorities have offered rewards amounting to almost one hundred thousand dollars, making an aggregate of about TWO HUNDRED THOUSAND DOLLARS.

38. Six days after the assassination, John Wilkes Booth and his alleged accomplices, John H. Surratt and David Herold, were still on the loose. To speed their arrests, on April 20, 1865, Secretary of War Edwin M. Stanton offered a reward of $100,000 for their apprehension—and threatened with death anyone who gave them aid. Several different types of broadsides were printed in Washington, D.C., to publicize the reward.

CHAPTER TWO

THE HUNT FOR THE ASSASSINS

THE MURDERER OF our late beloved President, Abraham Lincoln, IS STILL AT LARGE.

—Secretary of War Edwin M. Stanton, April 20, 1865

JOHN WILKES BOOTH ESCAPED from Washington, D.C., on horseback, rendezvoused with his scout David Herold, and fled into Maryland. Together, the assassin and his accomplice rode to Mary Surratt's tavern, where they picked up weapons and supplies that were waiting for them. After lingering for just a few minutes, they rode on to Dr. Samuel A. Mudd's farm. Mudd treated Booth's leg, injured when he jumped from the president's theater box to the stage. Pursued by army patrols, Booth and Herold continued south to Virginia, where Confederate soldiers, agents, and sympathizers provided food, shelter, and newspapers. Without the help of these men, Booth and Herold could never have eluded their pursuers for so long. Curiously, none of these accomplices was ever put on trial.

Booth's escape incensed—and thrilled—the nation. To ensure his capture, the government put a $50,000 bounty on his head. Booth and Herold spent the night of April 25 at the farm of Richard Garrett, where they slept in his tobacco barn. Disillusioned at the South's failure to celebrate him as a hero, Booth scribbled words of his despair in his pocket date book:

After being hunted like a dog through swamps, woods, and last night being chased by gun boats . . . wet cold and starving, with every mans hand against me, I am here in despair. And why; For doing what Brutus was honored for. . . . And yet I for striking down a greater tyrant. . . am looked upon as a common cutthroat A country groaned beneath this tyranny and prayed for this end.

Yet now behold the cold hand they extend to me. . . . I am abandoned, with the Curse of Cain upon me. To night I will try to escape these blood hounds once more. Who can read his fate. God's will be done. I have too great a soul to die like a criminal. Oh may he, may he spare me that and let me die bravely.

Federal troops caught up with Booth and Herold after midnight on April 26. Dramatist to the end, Booth called out to the officer in charge and offered to fight the entire patrol in formal combat. The soldiers could hear arguing inside the barn. After insulting his accomplice as a coward, Booth announced that a man wanted to come out and surrender. Herold gave up, while Booth, armed with a carbine and revolver, resolved to fight. The government wanted him alive, so soldiers set the barn afire to force him to surrender.

As the flames rose and revealed Booth's position through cracks between the barn boards, a single shot rang out. Booth fell, mortally wounded. Soldiers carried him to the front porch of the Garrett farmhouse and gave him water. After suffering for several hours he whispered his last words: "Tell mother . . . I die for my country . . . Useless, useless."

As the sun rose on April 26, 1865, twelve days after he had assassinated President Lincoln, John Wilkes Booth died. Newspapers and printmakers exulted at the shocking news and spread the historic word to the nation—the assassin was dead.

War Department Washington, April 20, 1865,

$100,000 REWARD

THE MURDERER

Of our late beloved President, Abraham Lincoln,

IS STILL AT LARGE.

$50,000 REWARD

Will be paid by this Department for his apprehension, in addition to any reward offered by Municipal Authorities or State Executives.

$25,000 REWARD

Will be paid for the apprehension of JOHN H. SURRATT, one of Booth's Accomplices.

$25,000 REWARD

Will be paid for the apprehension of David C. Harold, another of Booth's accomplices.

LIBERAL REWARDS will be paid for any information that shall conduce to the arrest of either of the above-named criminals, or their accomplices.

All persons harboring or secreting the said persons, or either of them, or aiding or assisting their concealment or escape, will be treated as accomplices in the murder of the President and the attempted assassination of the Secretary of State, and shall be subject to trial before a Military Commission and the punishment of DEATH.

Let the stain of innocent blood be removed from the land by the arrest and punishment of the murderers.

All good citizens are exhorted to aid public justice on this occasion. Every man should consider his own conscience charged with this solemn duty, and rest neither night nor day until it be accomplished.

EDWIN M. STANTON, Secretary of War.

DESCRIPTIONS.—BOOTH is Five Feet 7 or 8 inches high, slender build, high forehead, black hair, black eyes, and wears a heavy black moustache.

JOHN H. SURRAT is about 5 feet, 9 inches. Hair rather thin and dark; eyes rather light; no beard. Would weigh 145 or 150 pounds. Complexion rather pale and clear, with color in his cheeks. Wore light clothes of fine quality. Shoulders square; cheek bones rather prominent; chin narrow; ears projecting at the top; forehead rather low and square, but broad. Parts his hair on the right side; neck rather long. His lips are firmly set. A slim man.

HAROLD is a little chunky man, quite a youth, and wears a very thin moustache.

39. Another version of the broadside printed in Washington, D.C., offering a $100,000 reward for Booth and his accomplices.

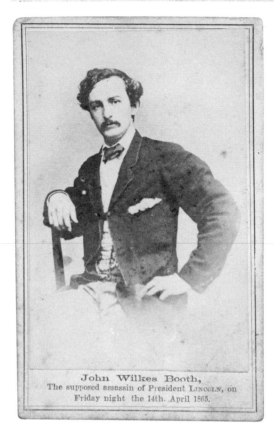

John Wilkes Booth,
The supposed assassin of President LINCOLN, on Friday night the 14th. April 1865.

40. & 41. The public clamored not only for Lincoln memorabilia— mourning ribbons, badges, portraits, and flags—but also for images of the assassin. Demand for Booth photos surged, and photographers across the nation copied the work of other photographers, selling those images as their own. This carte-de-visite of the "supposed assassin" was made while Booth was still at large. Trade in these pirated images was brisk. Disturbed by the unseemly demand for assassin photos, the government banned their sale on May 2, 1865. Secretary of War Stanton rescinded that order on May 26, 1865.

44. Another pamphlet published by Barclay & Company of Philadelphia. The image of John Wilkes Booth riding into the night, haunted by ghosts and hunted by soldiers, became a popular theme.

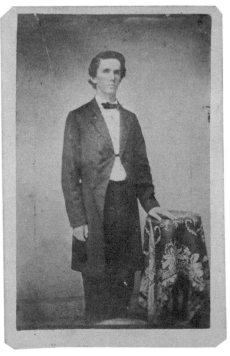

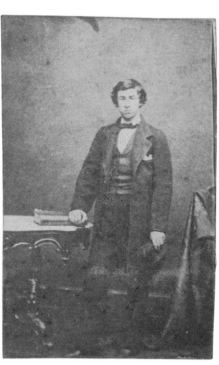

42. & 43. The War Department distributed these photographs of John H. Surratt and David Herold during the hunt for Booth's accomplices.

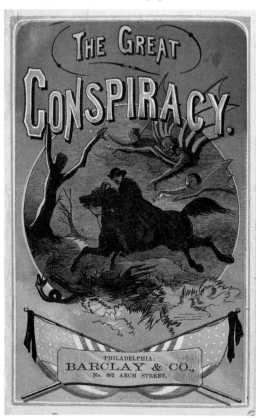

THE GREAT CONSPIRACY.

PHILADELPHIA:
BARCLAY & CO.,
No. 602. ARCH STREET.

War Department, Washington, April 20, 1865.

$100,000 REWARD!

THE MURDERER

Of our late beloved President, ABRAHAM LINCOLN,

IS STILL AT LARGE.

$50,000 REWARD!

will be paid by this Department for his apprehension, in addition to any reward offered by Municipal Authorities or State Executives.

$25,000 REWARD!

will be paid for the apprehension of JOHN H. SURRATT, one of Booth's accomplices.

$25,000 REWARD!

will be paid for the apprehension of DANIEL C. HARROLD, another of Booth's accomplices.

LIBERAL REWARDS will be paid for any information that shall conduce to the arrest of either of the above-named criminals, or their accomplices.

All persons harboring or secreting the said persons, or either of them, or aiding or assisting their concealment or escape, will be treated as accomplices in the murder of the President and the attempted assassination of the Secretary of State, and shall be subject to trial before a Military Commission and the punishment of DEATH.

Let the stain of innocent blood be removed from the land by the arrest and punishment of the murderers.

All good citizens are exhorted to aid public justice on this occasion. Every man should consider his own conscience charged with this solemn duty, and rest neither night nor day until it be accomplished.

EDWIN M. STANTON, Secretary of War.

DESCRIPTIONS.—BOOTH is 5 feet 7 or 8 inches high, slender build, high forehead, black hair, black eyes, and wears a heavy black moustache.
JOHN H. SURRATT is about 5 feet 9 inches. Hair rather thin and dark; eyes rather light; no beard. Would weigh 145 or 150 pounds. Complexion rather pale and clear, with color in his cheeks. Wore light clothes of fine quality. Shoulders square; cheek bones rather prominent; chin narrow; ears projecting at the top; forehead rather low and square, but broad. Parts his hair on the right side; neck rather long. His lips are firmly set. A slim man.
DANIEL C. HARROLD is 23 years of age, 5 feet 6 or 7 inches high, rather broad shouldered, otherwise light built; dark hair, little (if any) moustache; dark eyes; weighs about 140 pounds.

GEO. F. NESBITT & CO., Printers and Stationers, cor. Pearl and Pine Streets, N. Y.

45. The War Department telegraphed news of the reward to Major General John A. Dix in New York, who had this rare broadside printed by Geo. F. Nesbitt & Co., Printers and Stationers at the corner of Pearl and Pine Streets.

THE ASSASSIN'S VISION

46. The fate of the damned. As he rides in darkness, Booth cannot escape "The Assassin's Vision"—the ghost of Lincoln, who stands before him and floats above him in all the trees of the forest. This incredible carte-de-visite montage by Francis Hacker of Providence, Rhode Island, is perhaps the most bizarre image inspired by the assassination.

47. & 48. Contemporary artists dramatized the pursuit of Booth and his conspirators. Here, Colonel LaFayette C. Baker and aides are depicted by *Harper's Weekly* and *Frank Leslie's Illustrated Newspaper* taking charge. Both images are based on a Gardner photograph. In fact, although Baker had the trust of the secretary of war, he was a dubious character who thwarted others hunting for Booth, claimed more credit than he deserved, and sought a large share of the reward money.

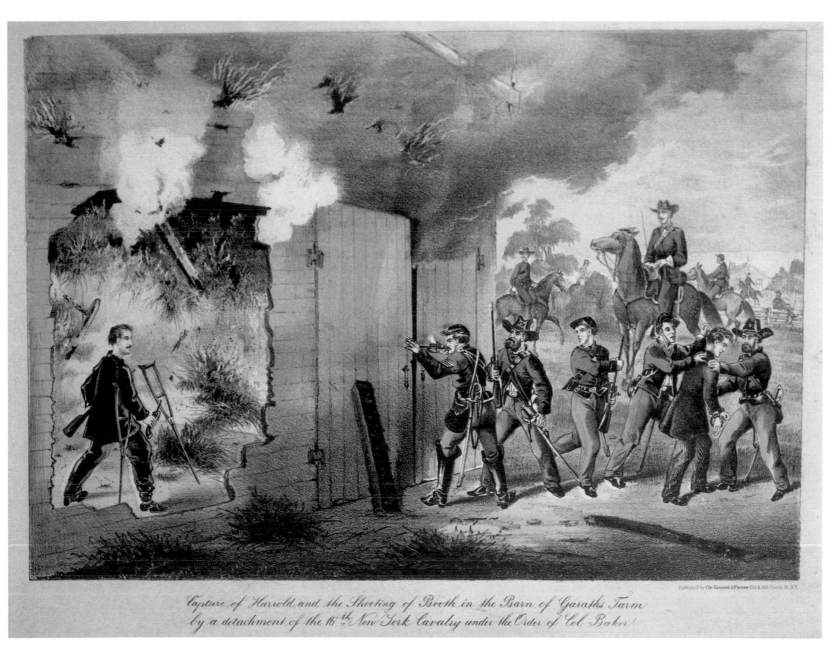

Capture of Harrold, and the Shooting of Booth in the Barn of Garaths Farm by a detachment of the 16th New York Cavalry under the Order of Col Baker

49. Printmakers hurried to publish prints depicting the historic events at Garrett's farm. This color lithograph by Kimmel & Forster was the most popular image of the death of the assassin.

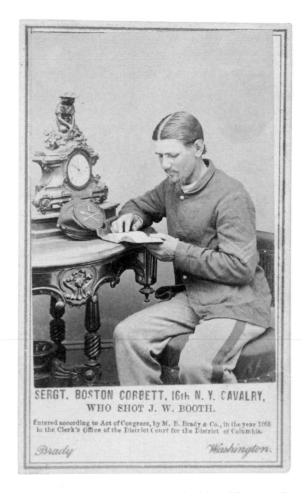

50. 51. 52. & 53. Inscribed cartes-de-visite of Sergeant Boston Corbett. Corbett, a religious fanatic who castrated himself when tempted by fallen women, claimed to have killed Booth. The War Department wanted the assassin alive and considered court-martialing Corbett, but then allowed him to play the role of hero. For a brief time he enjoyed his celebrity, signing photographs and writing letters to fans. Then he vanished and was lost to history.

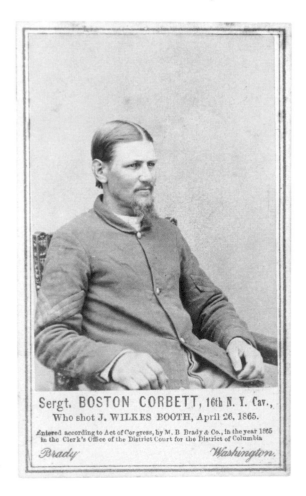

54. Francis Hacker of Providence, Rhode Island, who published the eerie carte-de-visite of Lincoln's ghost haunting Booth, also produced this image depicting Booth at the moment the fatal shot was fired.

55. & 56. Through the summer of 1865, during the trial of the conspirators, John Wilkes Booth, even in death, continued to dominate the popular imagery of the assassination. Dion Haco novelized the life of the man he dubbed "the assassinator" in *Booth: The Assassin*, here in its original and fragile paper wrappers, one of the rarest publications from the time. Booth also dominates the front wrapper of journalist George Alfred Townsend's book about the assassination and trial, *The Life, Crime, and Capture of John Wilkes Booth: And the Pursuit, Trial and Execution of His Accomplices.*

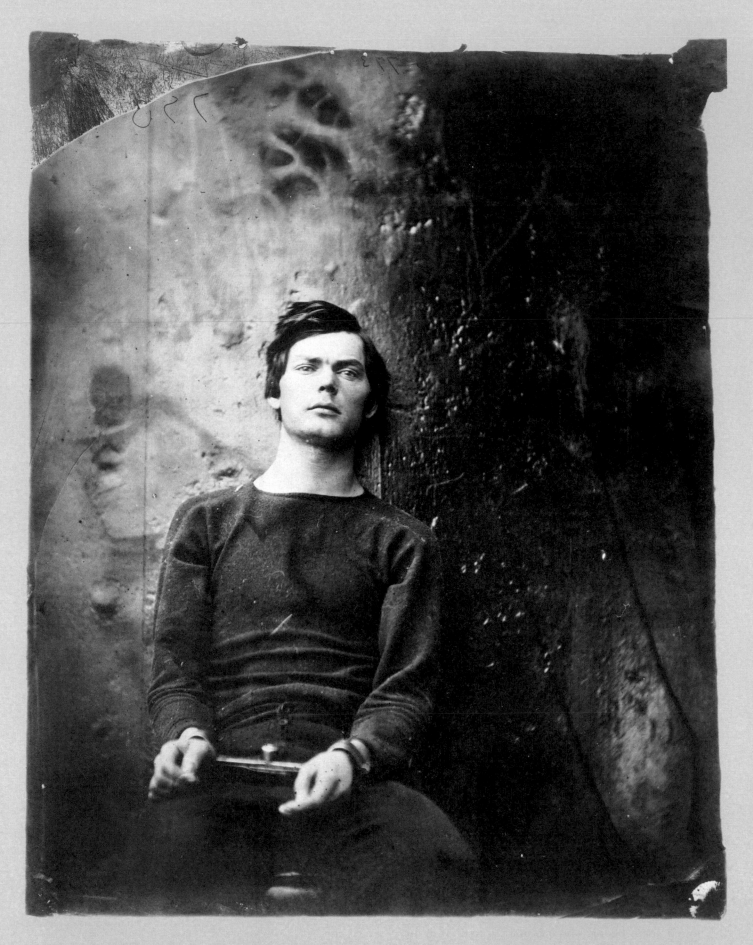

57. Vintage silver print of Lewis Powell, from the original glass-plate negative. Powell sits against the battle-scarred turret of the ironclad *Montauk* or *Saugus*, where he and other male conspirators were held prior to their confinement in the Old Arsenal Prison. Powell's wrist irons are clearly visible.

CHAPTER THREE

ARRESTS

MAKE A CHAIN, FOR THE LAND IS FULL OF BLOODY CRIMES.
—carte-de-visite, 1865

SOLDIERS, POLICEMEN, AND private detectives fanned out over Washington, Maryland, and Virginia in pursuit of John Wilkes Booth and his accomplices. Named on the night of the assassination as one of Booth's intimates, John H. Surratt was the initial suspect in the knife attack on Secretary of State William H. Seward. The authorities also sought the author of the mysterious and incriminating "Sam Letter" discovered in Booth's hotel room. Booth seemed to have vanished. The newspapers spread contradictory rumors that he had been spotted aboard a train to Philadelphia, that he would be arrested within twenty-four hours, and that he was still in hiding in Washington. Nearly a week after the assassination, one of the most famous and recognizable men in America was still on the loose.

The $100,000 reward offered for Booth, John Surratt, and David Herold drove their pursuers into a frenzy of greed, but the three men continued to elude the authorities. Surratt fled to Canada, and Booth and Herold were spirited along their way by Confederate sympathizers.

The government had better luck arresting some of Booth's alleged accomplices. Edman Spangler, the Ford's Theatre stagehand who had held the reins of Booth's horse, was seized. Many other people connected to the theater were rounded up, including the Fords. In the opinion of the secretary of war, Ford's Theatre was a lair to which Lincoln had been lured, and surely those connected with it had conspired with the assassin. How else could Booth have shot Lincoln so easily and escaped so smoothly? The theater itself was "arrested" by the government—it was ordered closed and was eventually confiscated from the Fords. In the days of rage, fear, and high emotions that followed, many people who had nothing to do with the crime were arrested and questioned. It was assumed that the assassination of the president and the attack on the secretary of state were part of a widespread conspiracy plotted by the leaders of the Confederacy.

The government struck gold on the night of April 17. For the second time after the assassination, soldiers went to Mary Surratt's boardinghouse, located a few blocks from Ford's Theatre, to investigate the disappearance of her son John. While they questioned Mary and the residents of the house, a man toting a pickax appeared at the door. He claimed to be a laborer calling on Mrs. Surratt about digging a gutter. Suspicious, an officer asked her if she knew the man. She swore she did not, which prompted the arrest of the strange caller and everyone in her house. Lewis Thornton Powell, the would-be assassin of Secretary of State Seward, had just blundered into the government's arms. Soldiers searched the house and made an ominous discovery—a photograph of John Wilkes Booth, secreted from view.

Samuel Arnold, a boyhood friend of Booth's, was identified as the author of the "Sam Letter" found in the actor's trunk. He was taken into custody and confessed his involvement in an earlier conspiracy to kidnap the president and hold him hostage for the benefit of the Confederacy. Arnold swore that he had no part in the murder plot and that the "Sam Letter" was actually evidence of his withdrawal from the conspiracy. Also arrested was Michael O'Laughlin, another boyhood associate of Booth's and a fellow participant in the abduction scheme. Dr. Samuel Mudd turned out to be more than a simple Good Samaritan who treated an anonymous, injured traveler. He knew Booth and Surratt before the assassination, and his suspicious behavior afterward led to his arrest.

George Atzerodt, a German wagon painter, was taken by surprise in bed at the house of his cousin. Atzerodt had taken a room at Andrew Johnson's hotel, where weapons and Booth materials were found. He was charged with plotting to assassinate the vice president. David Herold, Booth's guide, surrendered at the Garrett farm.

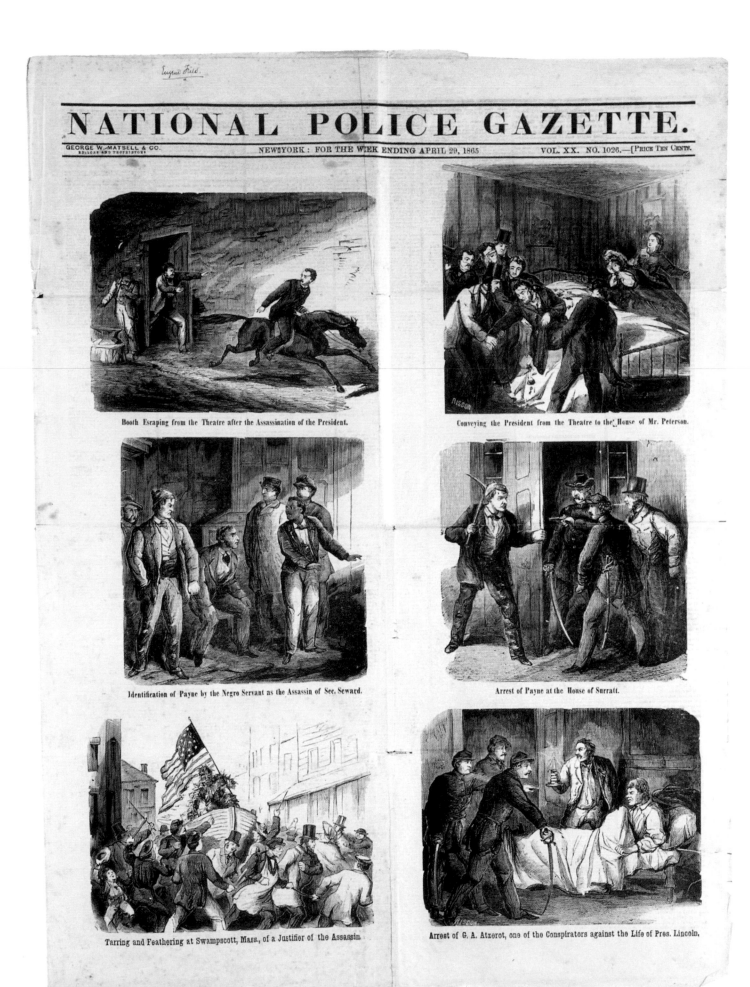

58. The capture of Lewis Powell at Mary Surratt's boardinghouse and the arrest of George Atzerodt, as depicted in woodcuts from the *National Police Gazette*.

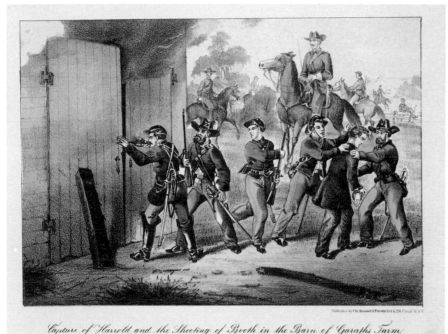

Capture of Harrold and the Shooting of Booth in the Barn of Garaths Farm by a detachment of the 16th New York Cavalry under the Order of Col. Baker

59. The surrender of David Herold at the Garrett farm in another print by Kimmel and Forster.

Majr Jas. R. Obourne
Proost Marshall of the
District of Columbia
Dear Sir

Having on or about the 15th of April, given information to the Detectives then on duty guarding Mr Johnsons room, of one suspicious character in Room 126 of the Hotel which on being searched proved to be Atzerodts, and from the things found in the Room he was caught. I would like you to give this due consideration and if it is worth any thing I hope to receive it. his Statement I can prove by two or three Detectives now in the service of the Government

Yours Most Respectfully
Michael Henry
Bartender

60. Vice President Andrew Johnson resided at the Kirkwood Hotel, where Atzerodt was supposed to murder him. Bartender Michael Henry here explains that it was he who informed the detectives guarding Johnson that there had been a "suspicious character in Room 126 . . . which on being searched proved to be Atzerodt's, and from the things found in the room he was caught." Henry wrote this letter hoping to obtain a share of the reward money.

61. Mary Surratt's Washington, D.C., boardinghouse, of which President Andrew Johnson said, "She kept the nest in which the egg was hatched."

HAROLD'S HOUSE, NEAR THE WASHINGTON NAVY-YARD.—[Sketched by McCallum.]

62. A newspaper woodcut of David Herold's house. He lived here with his mother and sisters after his father died and had been working as a pharmacist's apprentice in Washington.

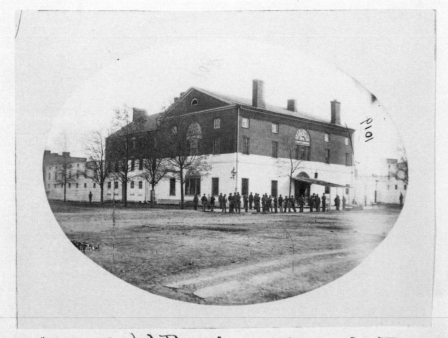

"Old Capitol Prison" Washington D.C.
where the conspirators where confined
and executed.

63. The Old Capitol Prison, where some suspects in the conspiracy were jailed in the days immediately following the assassination, including Dr. Samuel Mudd. Theater owner John T. Ford, Booth's brother Junius Jr., and dozens of others were arrested and held there. All those who by word or deed failed to show proper respect for the "late, beloved President" also came under suspicion. The prison annex, also known as Carroll Row, held female prisoners, including Mary Surratt and Confederate spy Rose Greenhow.

THE

OLD CAPITOL AND ITS INMATES,

BY A LADY,

WHO ENJOYED THE HOSPITALITIES OF THE GOVERNMENT
FOR A "SEASON."

NEW YORK:
E. J. HALE & SON,
16 MURRAY STREET.
1867.

64. Two years after the assassination, an anonymous woman, imprisoned with Mary Surratt, wrote about life with her in the Old Capitol Prison.

65. & 66. The alleged key to the Old Capitol Prison, from the collection of U.S. Detective A. E. L. Kerse, and a brick from the same building. Souvenir hunters coveted relics connected to the historic events unfolding before them.

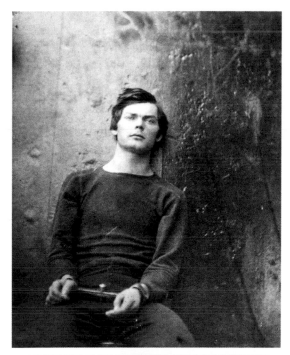

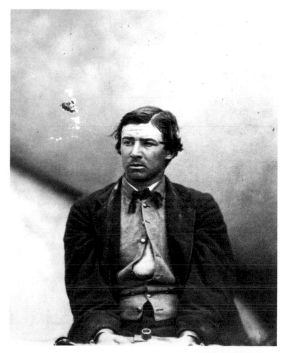

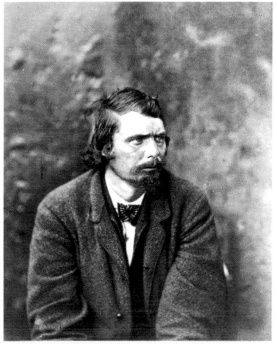

Alexander Gardner photographed the six alleged conspirators confined aboard the ironclads *Montauk* or *Saugus* on April 27, 1865. One by one, they were brought up to the deck, seated before the gun turret, and presented to the photographer. *Clockwise from top left:* Lewis Thornton Powell, David E. Herold, Samuel Arnold, Michael O'Laughlin, Edman Spangler, George A. Atzerodt.

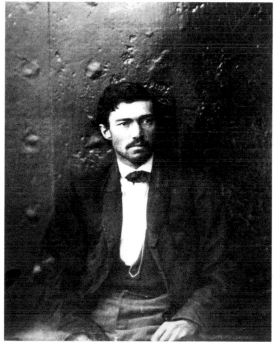

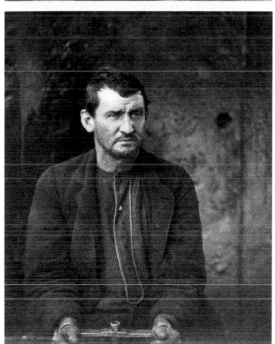

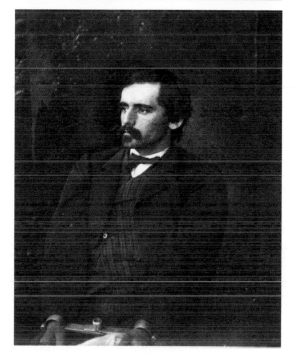

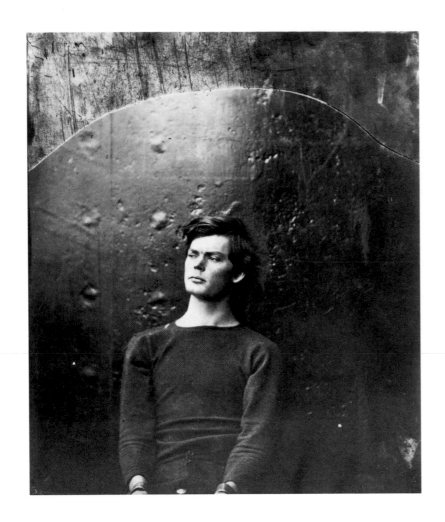

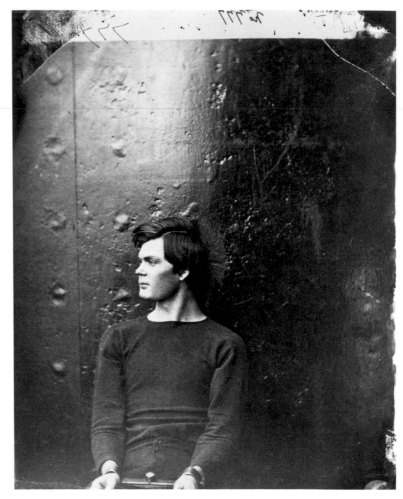

67. 68. & 69. Lewis Thornton Powell

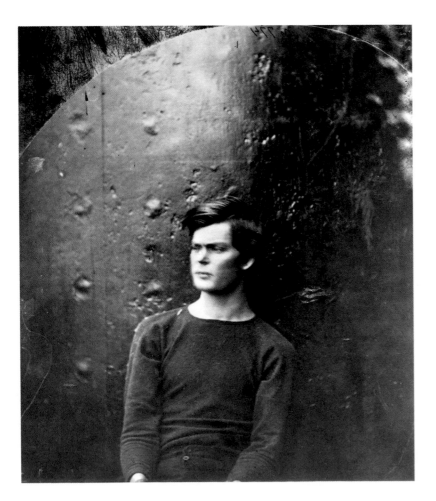

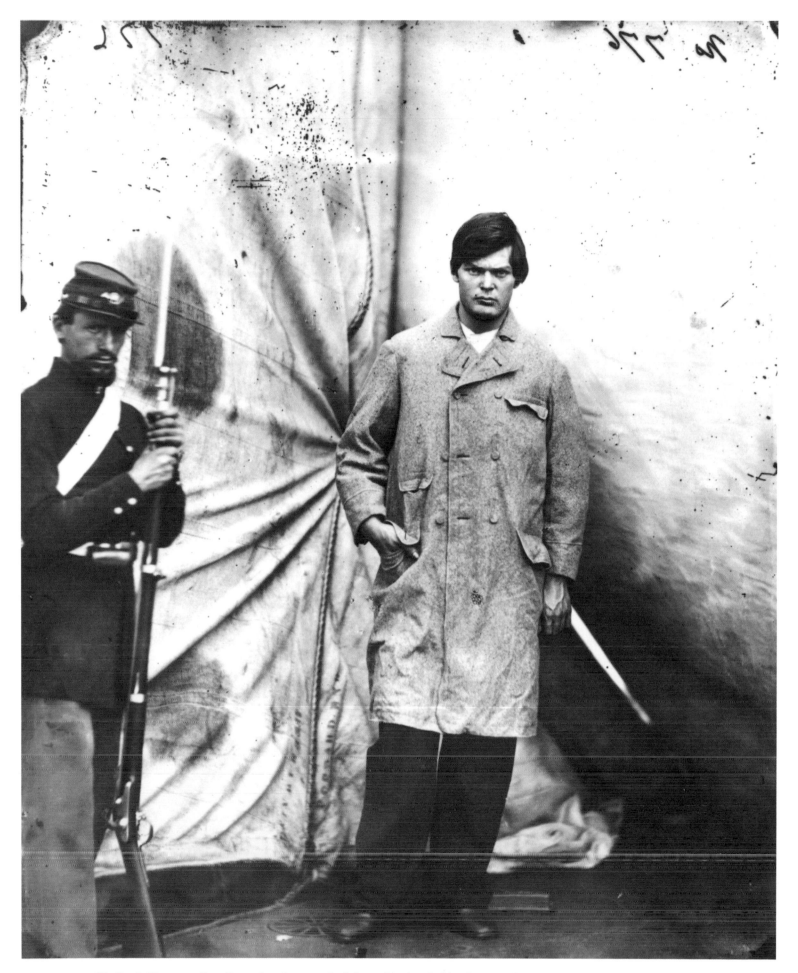

70. Lewis Thornton Powell was also photographed dressed in the clothing he wore the night he attacked William Seward.

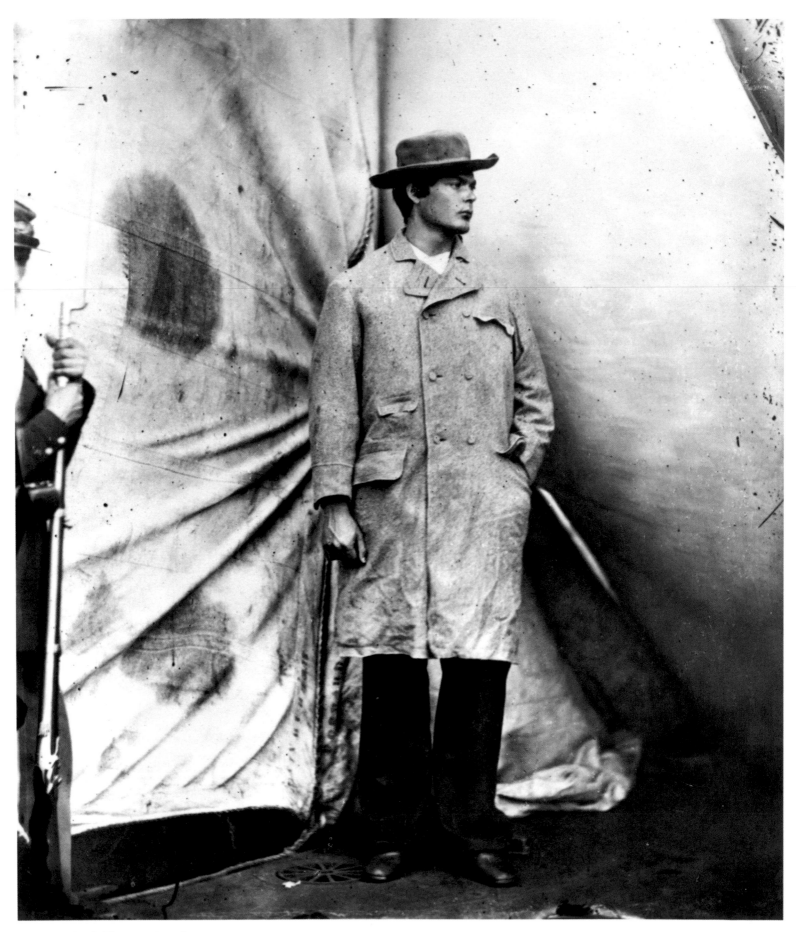

71. Lewis Thornton Powell

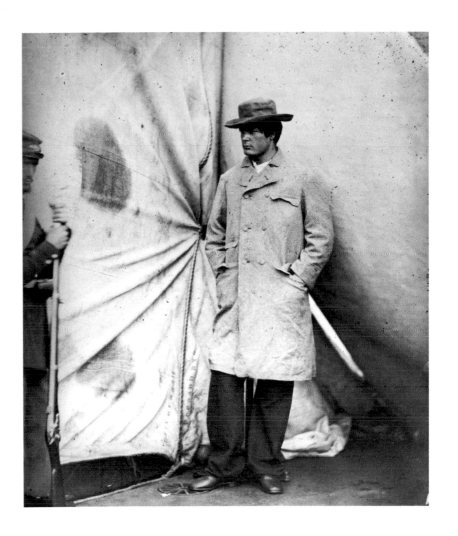

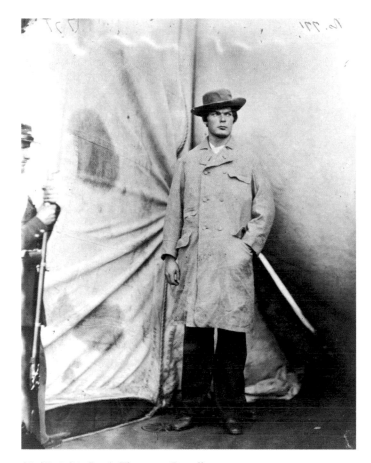

72. 73. & 74. Lewis Thornton Powell

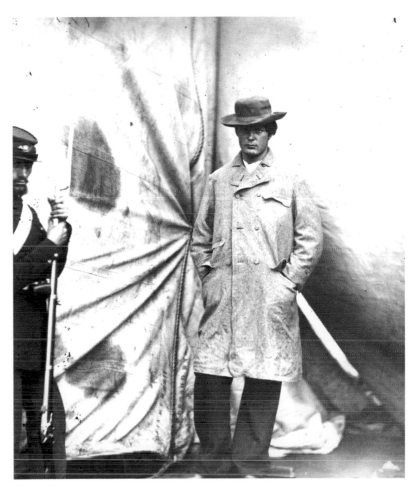

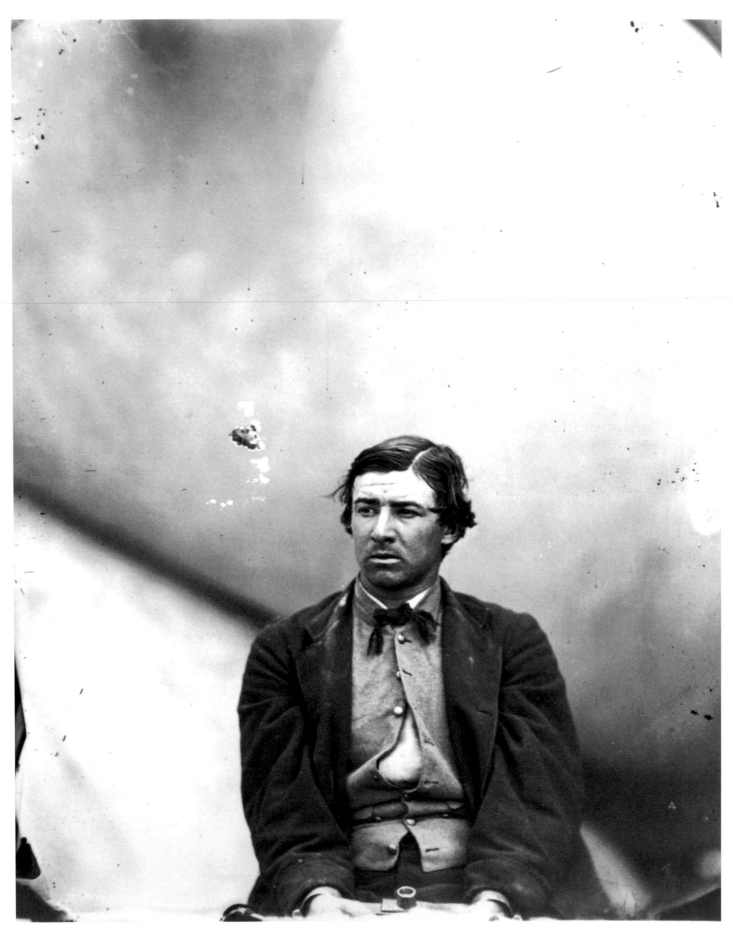

75. David E. Herold

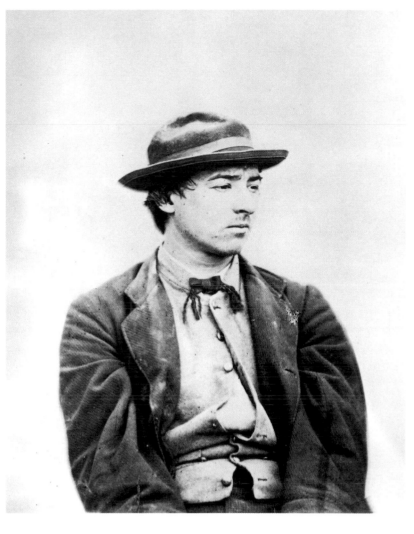

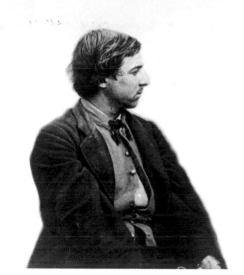

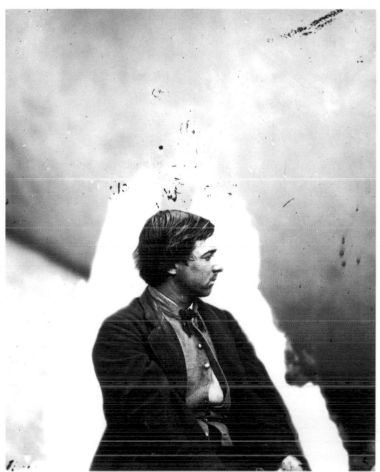

76. 77. & 78. David E. Herold

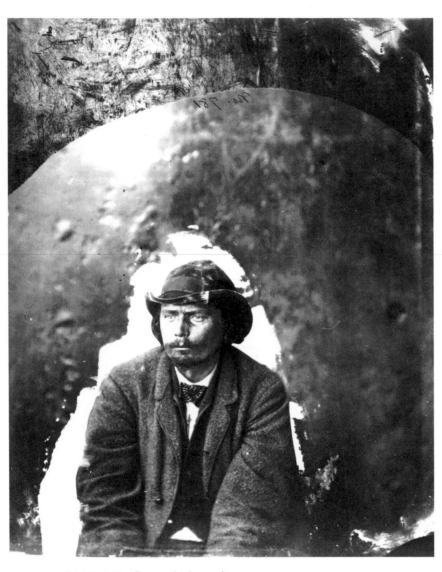

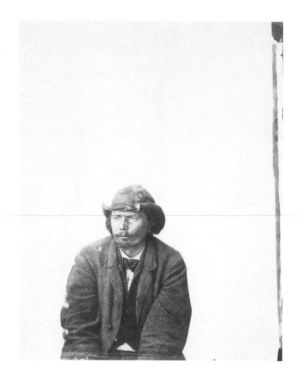

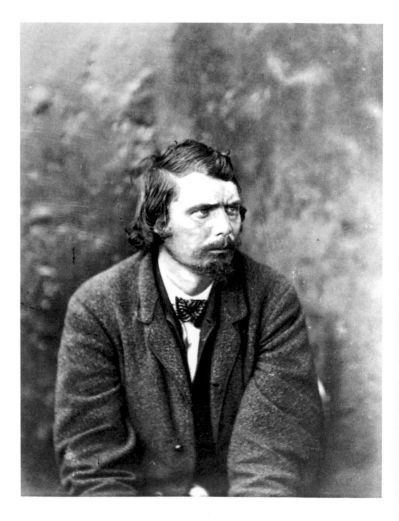

79. 80. & 81. George A. Atzerodt

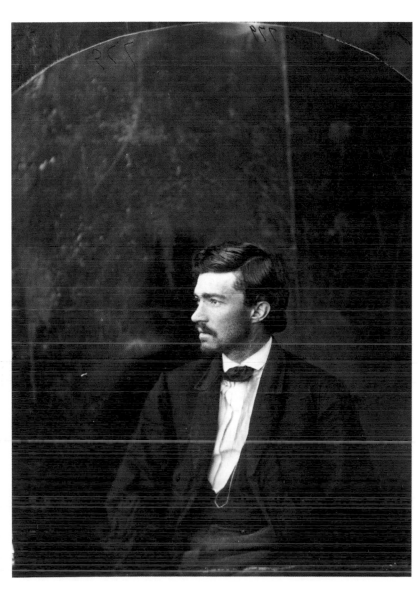

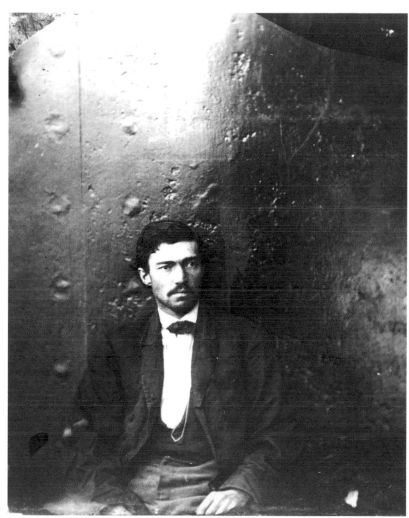

82. & 83. Samuel Arnold

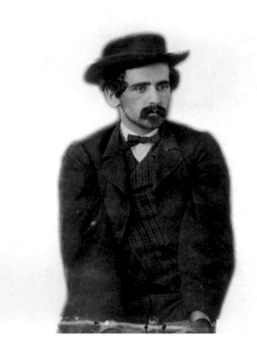

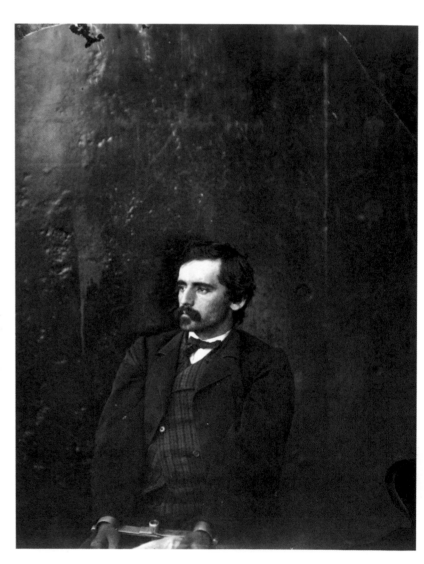

84. & 85. Michael O'Laughlin

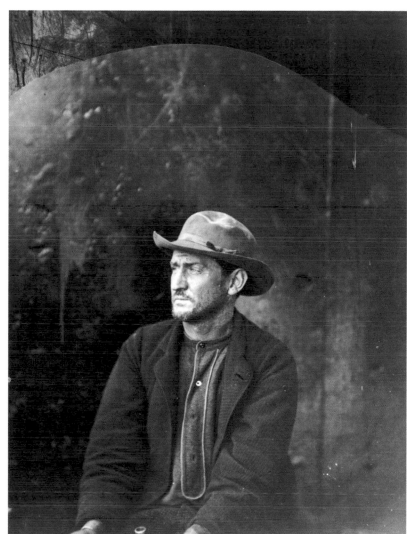

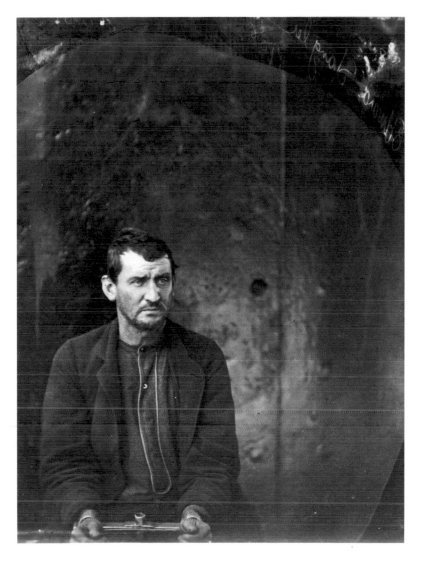

86. & 87. Edman Spangler

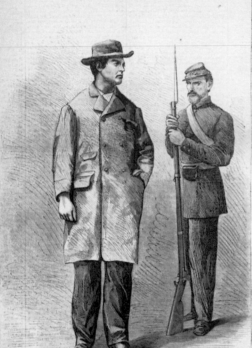

88.

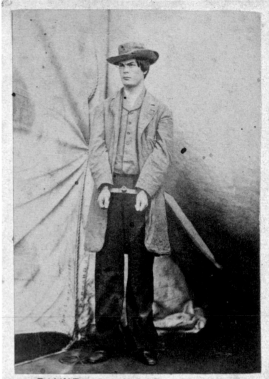

PAYNE, *alias* **WOOD,** *alias* **HALL,**
Arrested as one of the Associates of Booth in the Conspiracy.

Entered according to Act of Congress, by Alex. Gardner, in the year 1865, in the Clerk's Office of the District Court for the District of Columbia

89.

88. – 102. Gardner soon exploited the images taken on the ironclads by selling cartes-de-visite. In the case of Powell, one image became a prized front-page woodcut in *Harper's Weekly.*

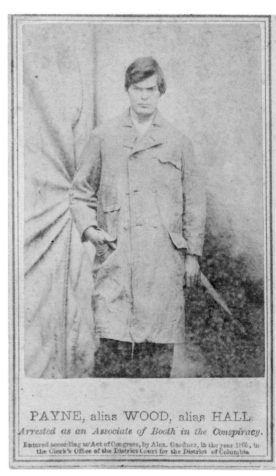

PAYNE, alias **WOOD,** alias **HALL.**
Arrested as an Associate of Booth in the Conspiracy.

Entered according to Act of Congress, by Alex. Gardner, in the year 1865, in the Clerk's Office of the District Court for the District of Columbia

90.

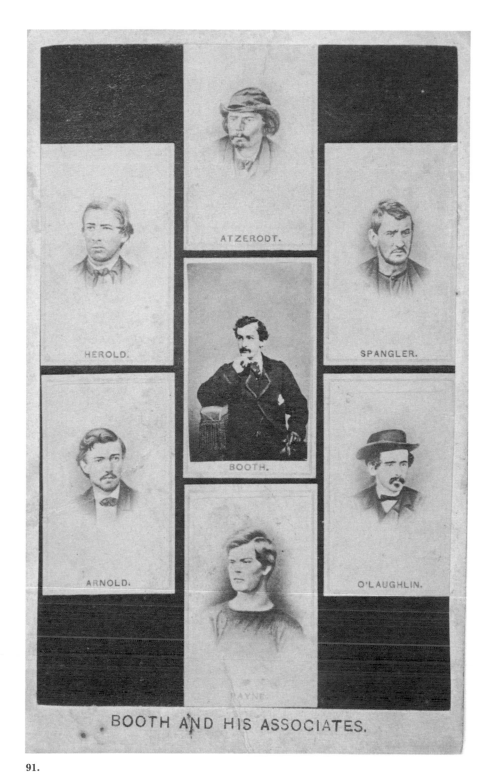

91.

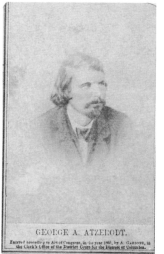

92.

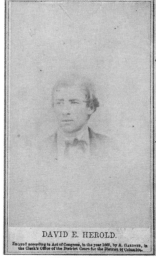

93.

94.

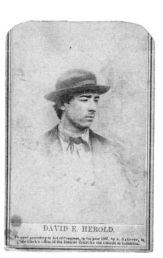

95.

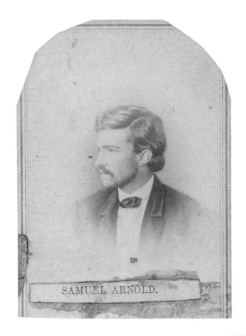

SAMUEL ARNOLD.

96.

ALEX. GARDNER.
Photographer to the Army of the Potomac.

GALLERIES
511 SEVENTH STREET AND 332 PENNSYLVANIA AV.
PUBLISHED BY
PHILP & SOLOMONS,
WASHINGTON D.C.

773

97.

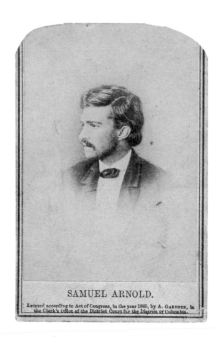

SAMUEL ARNOLD.
Entered according to Act of Congress, in the year 1865, by A. GARDNER, in the Clerk's Office of the District Court for the District of Columbia.

98.

99.

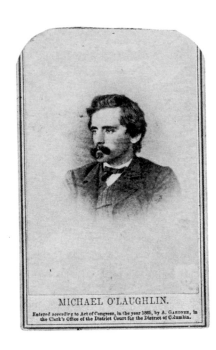

MICHAEL O'LAUGHLIN.
Entered according to Act of Congress, in the year 1865, by A. GARDNER, in the Clerk's Office of the District Court for the District of Columbia.

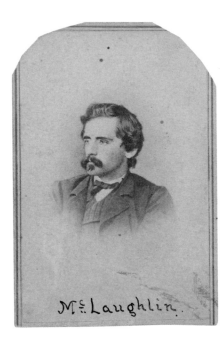

McLaughlin.

100.

101.

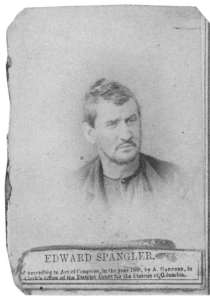

EDWARD SPANGLER.
according to Act of Congress, in the year 1865, by A. GARDNER, in Clerk's Office of the District Court for the District of Columbia.

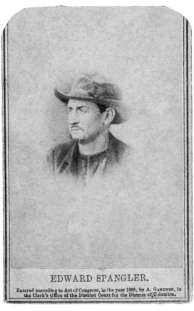

EDWARD SPANGLER.
Entered according to Act of Congress, in the year 1865, by A. GARDNER, in the Clerk's Office of the District Court for the District of Columbia.

102.

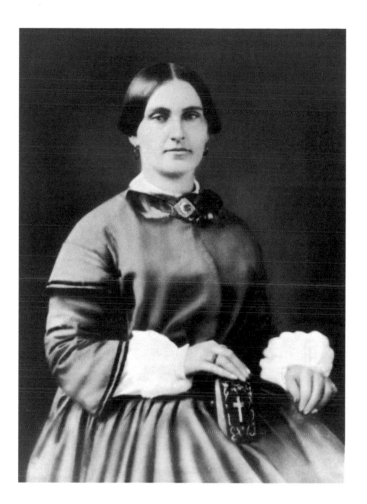

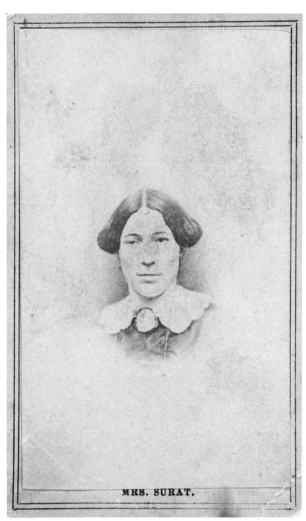

MRS. SURAT.

103. Gardner never photographed Mary Surratt. She was not on board the ironclads when he photographed the other conspirators, and he never took photographs of her or Dr. Mudd at the Old Capitol Prison. Why Gardner never photographed Surratt and Mudd remains a mystery. In one case, that did not stop an enterprising photographer from contriving a spurious portrait of Mary Surratt. The subject looks nothing like her, and her name is even misspelled.

104. & 105. The real Mary Surratt in family photographs at age twenty-eight and about forty. The latter was copied in an engraving of the conspirators (see Fig. 119 in Chapter 4).

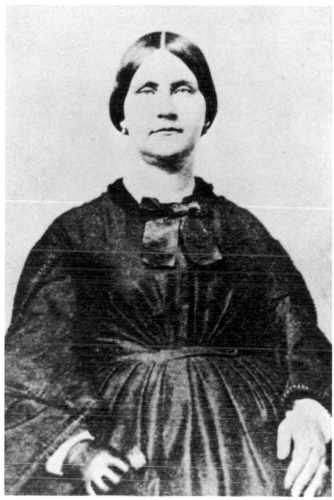

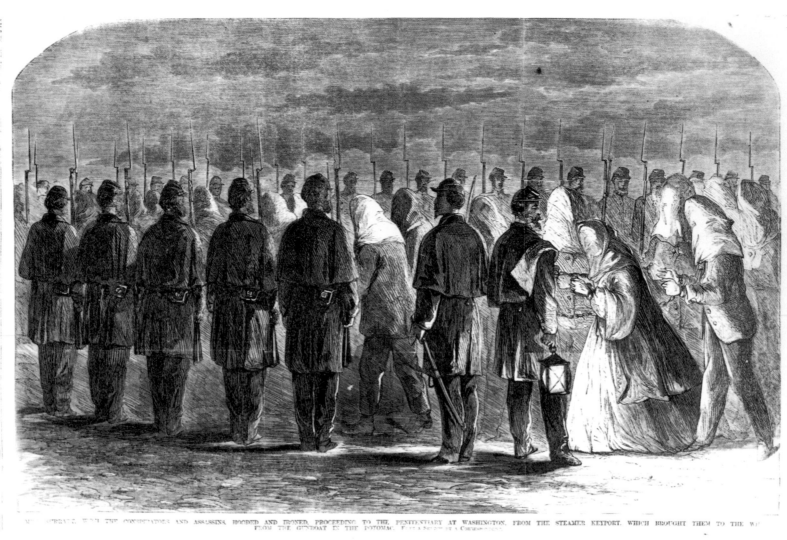

106. *Mrs. Surratt with the Conspirators and Assassins, Hooded and Ironed, Proceeding to the Penitentiary . . . from the Steamer Keyport . . . from a Sketch by a Correspondent.* The woodcut is imaginary. In fact, Mary Surratt and the male prisoners on the ironclads were transported to the Old Arsenal separately.

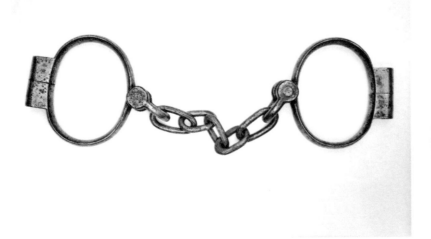

107. & 108. Original handcuffs and wrist irons worn by the conspirators from their arrest to their execution. The solid bar kept the hands apart.

FRANK LESLIE'S ILLUSTRATED NEWSPAPER

Entered according to the Act of Congress in the year 1864, by FRANK LESLIE, in the Clerk's Office of the District Court for the Southern District of New York.

No. 504 Vol. XX.] NEW YORK, MAY 27, 1865. [PRICE 10 CENTS. $4 00 YEARLY. 13 WEEKS $1 00.

Failure of the Conspiracy against Republicanism.

THE Spaniards, after an ineffectual struggle of four years, during which they expended many thousands of lives and millions of money, have been compelled to evacuate Santo Domingo. The last of their forces left the island on the 30th of March, a Provisional Republican Government having meantime been organised. So ends the first attempt to reduce the American Republics again under European rule. So end the hopes inspired by the outbreak of our great civil war, which it was supposed and believed would break up the whole Republican System on this continent, and leave all the American States an easy prey to European cupidity and rapacity. There is something like poetical justice in the fact that it was the weakest of all the republics assailed that was first to repel the attack. The Dominican Republic has an area of only about 18,000 square miles, and had a population little, if any, exceeding 150,000 inhabitants, mostly negroes and mulattos. Yet this handful, animated by an unconquerable spirit of independence, have not only been able to resist the whole power of Spain, but to drive Spanish authority from the island, even after it had been fully installed there through the treason of Santana and his accomplices. As observed by a daily contemporary: "For the future of the American continent and its position among the civilized nations of the world, the issue of the Dominican war of independence can have no consequences like those which will follow the restoration of the Union of these States. Still the triumph of the Dominicans will be hailed with cordial sympathy in this country. It is the most mortifying rebuke which has yet been administered to the European schemes of conquest on this continent, and both here and in Europe it will be regarded as foreshadowing the final issue of all similar attempts."

Simultaneously with the news from Santo Domingo, we get advices of the death of the tyrant of Central America, the ignorant and brutal Carrera, of Guatemala, the tool of the reactionary faction of that country, and the instrument relied on by the French to bring Central America within the farcical Mexican Empire. His death will ensure a speedy revindication of the Liberal party in Central America, which Carrera only kept down through his influence with the ignorant and bigotted Indians, of whom he was a fair type, and with

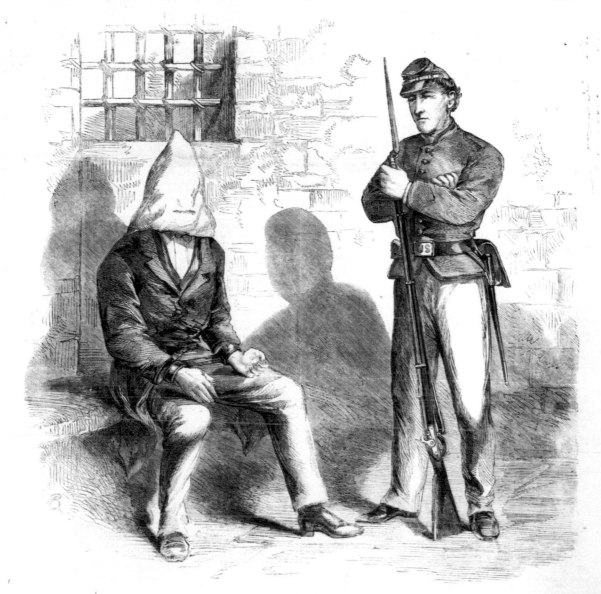

LEWIS PAYNE, THE ASSASSIN OF MR. SEWARD, AWAITING HIS TRIAL IN THE PENITENTIARY AT WASHINGTON, GUARDED BY A SENTRY OF THE 3D RESERVE CORPS.—SKETCHED BY A CORRESPONDENT.

109. Lewis Powell in his cell at the Old Arsenal, hooded and restrained by wrist irons

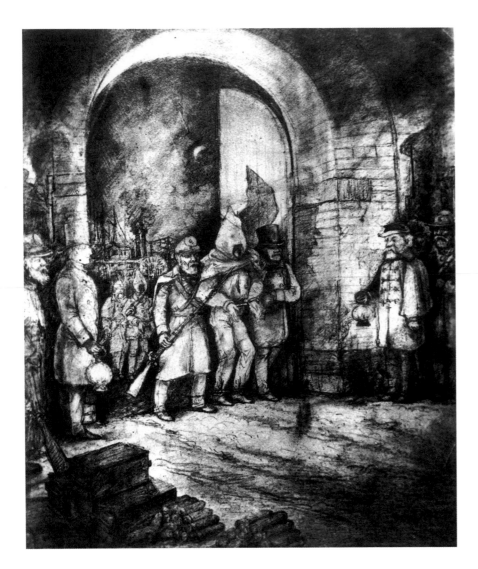

110. *Prisoners Being Transferred from Ironclads*, a sketch by Colonel James G. Benton of the Ordnance Corps, shows the prisoners entering the gate to the Old Arsenal.

Depot of Army Clothing and Equipage,

Washington, D. C. May 3rd 1865

Strictly Confidential

Mr Wm. Brearley

Chief Clerk

Sir

Please report immediately to Maj. Genl. Hartranft. with the enclosed letter from Maj. Genl Hancock - obtain Genl. Hartranfts' directions as to what work is to be done and have them carried out with secrecy and dispatch

Very Resp &c

Daniel G. Thomas

M. S. K. U. S. Army

In reference to lining Caps made for the assassins of President Lincoln to keep them from knocking their brains out against the prison walls

111. This mysterious letter of May 3 ordered William Brearley, chief clerk of the Depot of Army Clothing and Equipage, to report to the Old Arsenal and "obtain Genl. Hartranft's directions as to what work is to be done and have them carried out with secrecy and dispatch." The depot was the most likely source for the hoods.

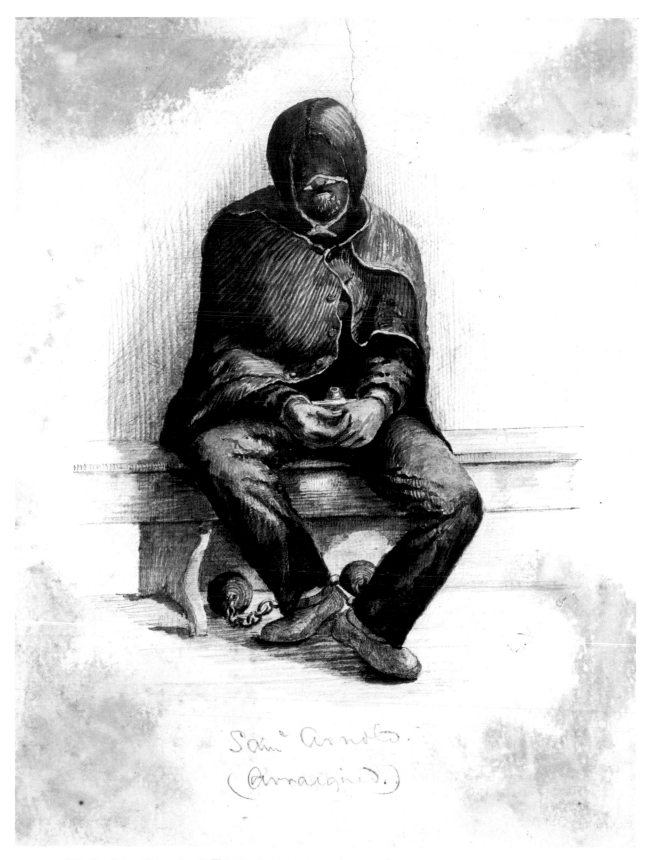

Sam'l Arnold.
(Arraigned.)

112. *Sam'l Arnold (Arraigned).* This life sketch by General Lew Wallace, one of the judges at the trial, is the only known contemporary image of a padded hood in use.

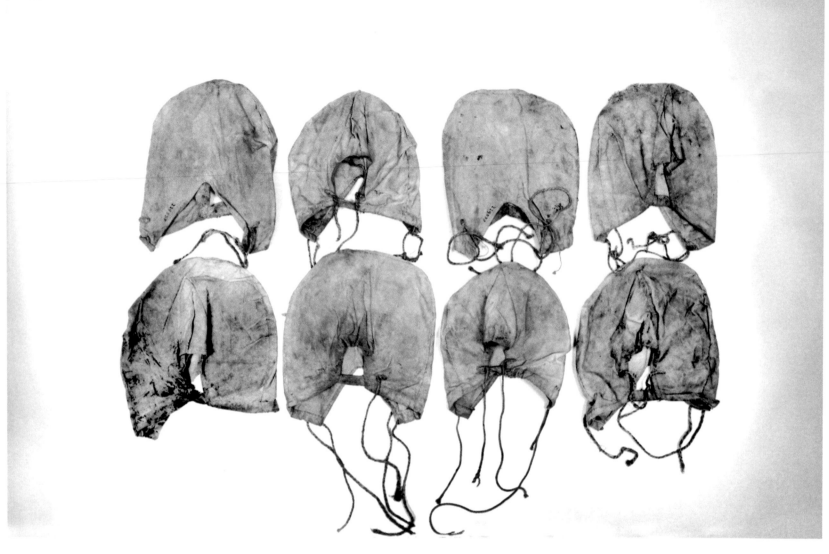

113. The eight lightweight canvas hoods transferred by the War Department to the Smithsonian Institution. Secretary of War Edwin Stanton ordered that the conspirators were to wear hoods at all times. Several different styles of hoods were used. Contemporary woodcuts indicate that the conspirators wore long hoods covering their heads and shoulders while they were transferred from the ironclads to the Old Arsenal. No examples of these "shoulder transfer hoods" have been discovered. Contemporary accounts state that, once imprisoned at the Old Arsenal, the prisoners were forced to wear padded hoods, which kept them from injuring themselves by banging their heads against the cell walls. At least one padded hood is extant. In addition, eight shorter, lightweight cloth hoods (above) repose at the Smithsonian Institution. It is possible that these replaced the padded hoods when the latter caused the prisoners to suffer terribly in the summer heat. It is also possible that the conspirators wore these hoods only when they were transferred to and from their cells and the courtroom. The final hoods were the "hanging caps" worn on the gallows and in which the conspirators were buried.

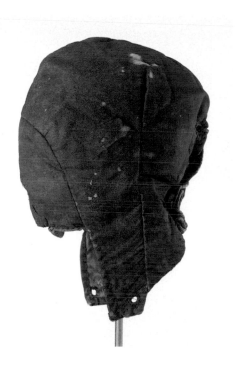
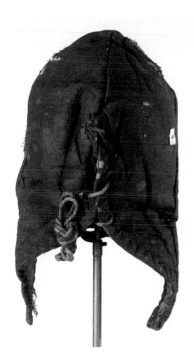

114. & 115. Lewis Powell's padded hood, kept by William Brearley, chief clerk of the Depot of Army Clothing and Equipage. The cotton lining of the hood is stained with sweat, and other substances not inconsistent with blood.

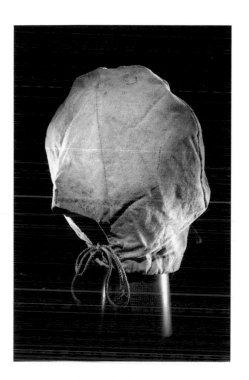
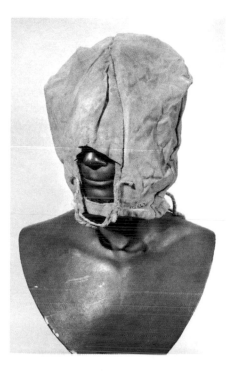
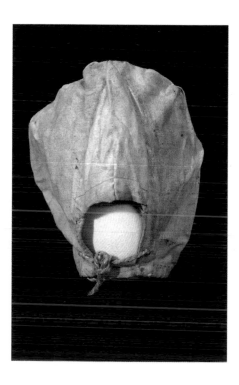

116. 117. & 118. Front and rear views of the Smithsonian hoods.

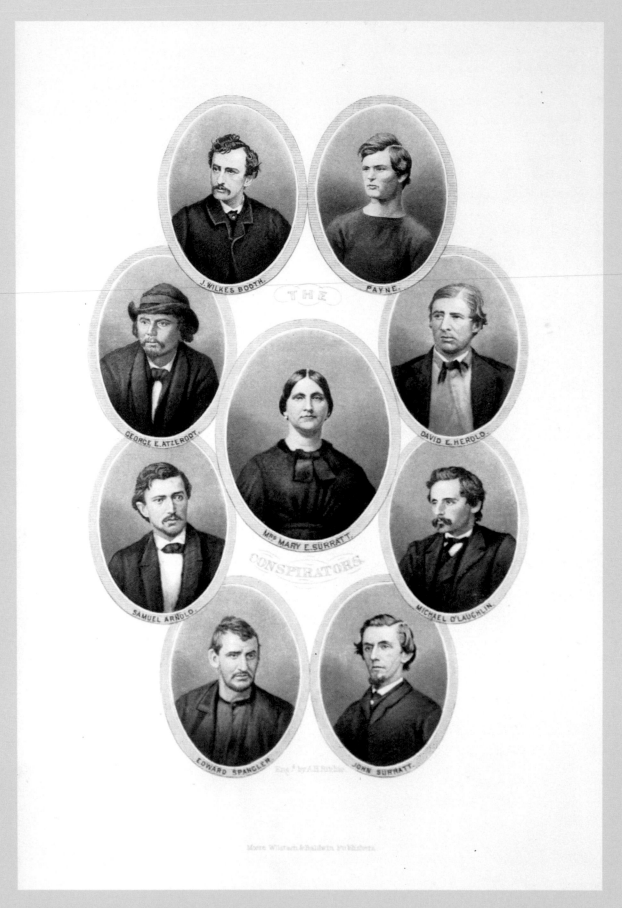

119. After the trial was over, Benn Pitman, the official court reporter, published his transcript in a hardbound book, *The Assassination of Abraham Lincoln and the Trial of the Conspirators*. This engraving, the frontispiece of the book, reflects the government's contention that Mary Surratt was at the center of the conspiracy. Oddly, the engraving omits one of the defendants, Dr. Samuel Mudd, but it does depict John H. Surratt, who evaded arrest and trial by fleeing the country.

CHAPTER FOUR

THE CONSPIRACY TRIAL

Beware the People weeping
When they bare the iron hand.

—Herman Melville, "The Martyr"

B Y THE END OF APRIL, the eight individuals who would become defendants at the great conspiracy trial of the spring and summer of 1865 were all in custody. Six conspirators, Lewis Powell (known at the time of his arrest and through much of the trial by his aliases Lewis Payne and Lewis Paine), David Herold, George Azterodt, Samuel Arnold, Michael O'Laughlin, and Edman Spangler were confined below deck in harsh conditions on the ironclad vessels *Montauk* and *Saugus*. Mary Surratt and Dr. Samuel A. Mudd, perhaps because of her sex and his professional status, were held at the Old Capitol Prison. Aboard the ironclads, the prisoners were separated from each other, shackled, chained, and forced to wear cloth hoods over their heads. All eight conspirators were transferred to the Old Arsenal Penitentiary in preparation for their trial, which would be held at that military post.

President Andrew Johnson ordered a trial by a military commission. The assassination of the president was deemed an act of war—an assault on the commander-in-chief before the cessation of hostilities, during a time of armed rebellion against the lawful authority of the government of the United States. The War Department, under the command of Edwin M. Stanton, would manage the proceedings. The judge advocate general of the U.S. Army would prosecute the conspirators, and a military commission of nine army officers acting as judges would hear the case, render verdicts, and impose sentences. The defendants would be allowed to engage counsel, but under prevailing legal customs of the time they would not be allowed to testify in their defense. The trial would be secret. Although transcripts would be made by official court reporters, the press and the public would be barred from the courtroom.

Trying the defendants by military commission was not uncontroversial. Some newspapers and govern-

ment officials objected. Defense counsel argued that the process was unconstitutional and that the conspirators should be tried by a civil criminal court. The commission swept aside all objections and held its first session on May 9. Under pressure, the commission did retract its secrecy order and allow newspaper reporters and chosen citizens to attend the trial.

The great conspiracy trial was the high point of the spring and summer of 1865. The newspapers covered it daily and published transcripts of the testimony and proceedings. The trial was a popular entertainment, and tickets for admission were in high demand. The army doled out passes to those it determined to be respectable persons. Men and women were allowed to attend, but as far as can be determined children were not admitted as spectators. After an initial blush of excitement, the trial settled into a predictable routine, punctuated occasionally by dramatic moments or the appearance of prominent witnesses. The trial seemed not only a prosecution of eight individuals but also a case against the leaders of the Confederacy, the poor treatment of Union prisoners, the outrages of guerrilla warfare, and alleged Confederate plots to spread infectious diseases in the North.

Hundreds of witnesses appeared. Contemporary observers described the atmosphere of the courtroom as nonchalant and unhurried. The commission held its last session on June 29 and retired to deliberate. The judges finished their work quickly and presented their findings and sentences to President Andrew Johnson, who approved them on July 5. On July 6 the sentences were revealed to the conspirators and reported in the afternoon Washington newspapers.

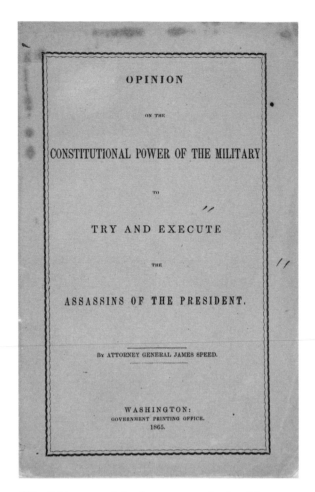

OPINION

ON THE

CONSTITUTIONAL POWER OF THE MILITARY

TO

TRY AND EXECUTE

THE

ASSASSINS OF THE PRESIDENT.

By ATTORNEY GENERAL JAMES SPEED.

WASHINGTON:
GOVERNMENT PRINTING OFFICE.
1865.

120. Critics argued that it was unconstitutional for a military commission to try civilians. To settle the matter, the attorney general of the United States issued a controversial written opinion supporting the legality of the trial.

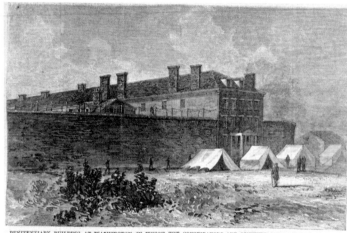

THE ARSENAL BUILDING, WASHINGTON, D. C., WHERE THE ASSASSINS AND CONSPIRATORS WERE TRIED.

121.

PENITENTIARY BUILDING AT WASHINGTON, IN WHICH THE CONSPIRATORS ARE CONFINED AND UNDERGOING TRIAL.
[SKETCHED BY JOSEPH HASHEW.]

122.

Harper's Weekly, as well as other illustrated newspapers and pamphlets, took readers to the Old Arsenal where the defendants were jailed and tried (figs.121, 122), to the cells of the accused (figs. 123, 124, 125), and inside the courtroom (figs. 126, 127, 128, 129, 130).

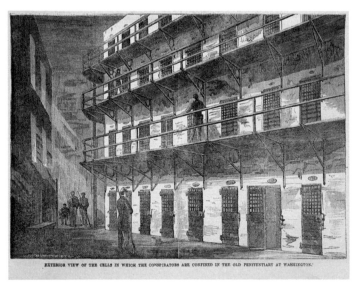

EXTERIOR VIEW OF THE CELLS IN WHICH THE CONSPIRATORS ARE CONFINED IN THE OLD PENITENTIARY AT WASHINGTON.

123.

Key of prison that, locked in the conspirators of President Lincoln one ¼ the size

124. & 125.

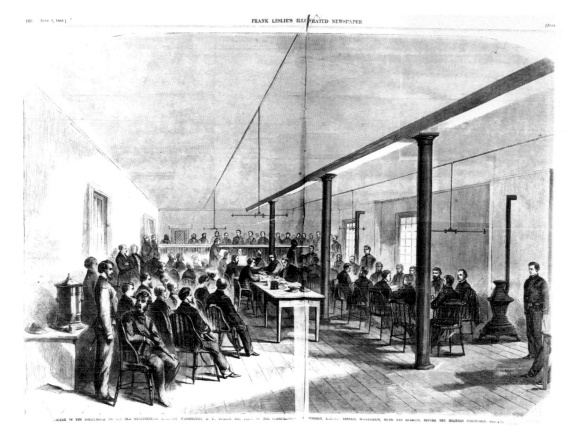

126.

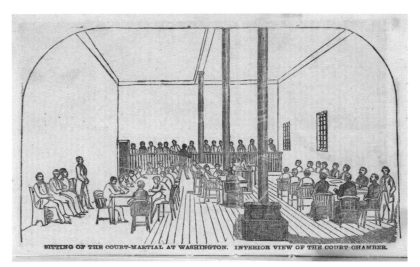

SITTING OF THE COURT-MARTIAL AT WASHINGTON. INTERIOR VIEW OF THE COURT CHAMBER.

127.

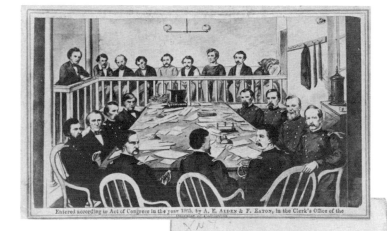

Entered according to Act of Congress in the year 1865, by A. E. ALDEN & F. EATON, in the Clerk's Office of the

128. & 129.

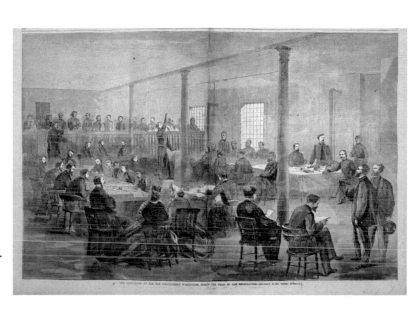

130.

This Picture is a correct Photograph from life, of Conspirators on trial, and the only original one. Taken June 5th, 1865, by special permission of Maj. Gens. Hunter and Hartrauft, at the Court Room in Arsenal Building, Washington, D. C.

In the foreground may be seen Judges Holt and Bigelow, Maj. Gens. Hunter and Hartrauft, and other members of the Military Commission. Also, on the table of manuscripts, may be distinctly seen the identical hat worn by President Lincoln on the night of his assassination, and near it on the same table, the basket of pistols and bowie knives which were furnished Booth and his companions by Mrs. Surratt.

NAMES OF CONSPIRATORS.

No. 1. Surratt, Mrs. Mary E.	No. 2. Harrold, David E.
No. 3. Payne Lewis.	No. 4. Atzeroth George A.
No. 5. O'Laughlin Michael.	No. 6. Spangler Edward.
No. 7. Mudd, Dr. Samuel A.	No. 8. Arnold Samuel

Duplicates furnished by the hundred or thousand.

A. E. ALDEN, Photographer.

No. 95 Arcade, Providence, R. I.

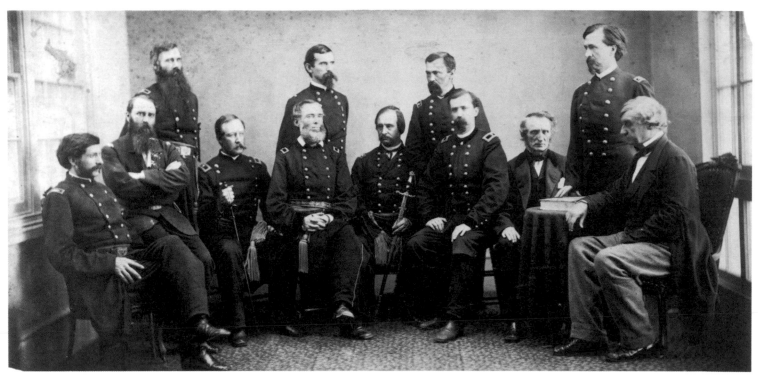

131. The military commission.

132. 133. & 134. Carte-de-visite photographs and newspaper woodcuts introduced the officers and judges of the military commission to the public. Later, glass slides were made to tell the story of the assassination.

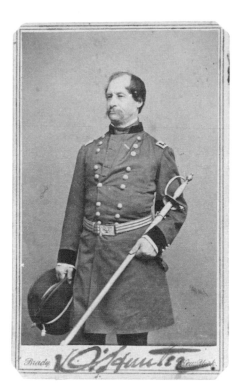

135. The president of the military commission, Major General David Hunter, in a signed carte-de-visite photograph.

136. & 137. Admission to the trial, a popular entertainment in the spring and summer of 1865, required a pass signed by General Hunter. Long after the event, souvenir seekers besieged Hunter with requests for relics. In this letter he complies by sending an unused pass left over from the trial.

138. A receipt for shaving the conspirators. The smallest details of life in the Old Arsenal were recorded.

139. This diagram of the courtroom, along with an illustration of the famous wrist irons, appears in a transcript of the trial published after the executions

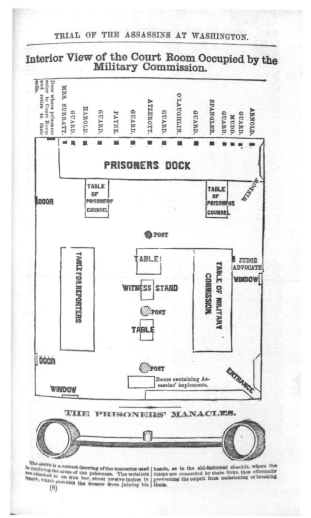

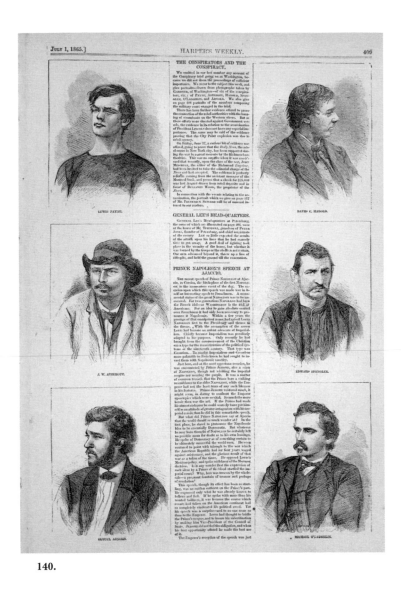

140.

During and after the trial, newspapers, periodicals, pamphlets, and books published images of the conspirators. Some, like these woodcuts from *Harper's Weekly* (fig. 140), were fine copies of Gardner photographs. Others were cruder copies (figs. 143, 144) and were perhaps based on personal observations of the conspirators (fig.141), or in some cases, bear no resemblance to the conspirators and appear concocted from fantasy (fig. 142).

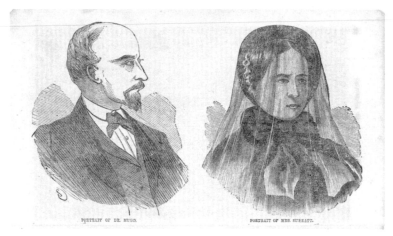

141.

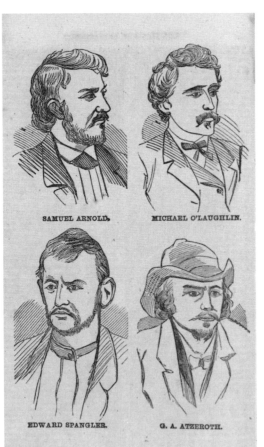

143.

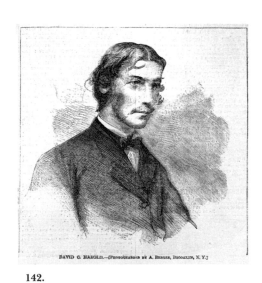

142.

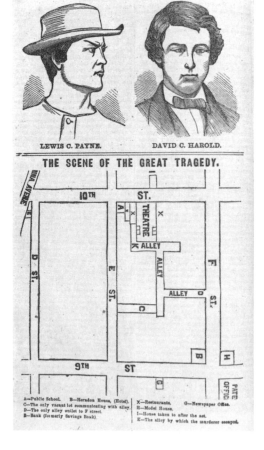

144.

The Philadelphia Inquirer.

PRICE TWO CENTS. PHILADELPHIA, FRIDAY, MAY 19, 1865. PRICE TWO CENTS.

THE ASSASSINS!

Trial of Booth's Accomplices!

YESTERDAY'S TESTIMONY.

Unraveling of the Mystery!

EVIDENCE AGAINST J. H. SURRATT.

His Hopes Gone and Prospects Blighted!

JUDGE OLIN'S EXAMINATION OF FORD'S THEATRE.

Plan to Capture Mr. Lincoln!

"SAM" ARNOLD'S LETTER TO "JOHN."

He Wants "John" to Go to Richmond!

DAVIS TO BE CONSULTED BEFORE ATTEMPTING MURDER!

The Plot to Burn Northern Cities and Steamers.

OFFICIAL REBEL EVIDENCE SHOWN!

Prof. McCullogh's Infernal Scheme

GENERAL HARRIS, OF MISSOURI, IMPLICATED!

J. D. Endorses the Diabolical Design!

EVIDENCE OF IMPORTANT WITNESSES

The Assassins Begin to Realize Their Proximity to the Gallows.

THE TRIAL OF THE CONSPIRATORS.

WASHINGTON, May 18—The Court, after the evidence taken on Wednesday had been read, proceeded to the examination of witnesses.

DAVID C. HAROLD,
The Accomplice of Booth in the Murder of President Lincoln.

THE PRISONERS' MANACLES.

160 50

145. The major newspapers gave comprehensive coverage to the trial and in many cases printed daily transcripts of the testimony. The *Philadelphia Inquirer* of May 19, 1865, reports the latest from the trial and also gives its own views on the character of defendant David Herold. By now the wrist irons have become a symbol of the trial in the public mind.

TESTIMONY FOR PROSECUTION AND DEFENCE

IN THE CASE OF

EDWARD SPANGLER,

Tried for Conspiracy to Murder the President,

BEFORE A

MILITARY COMMISSION, OF WHICH MAJOR-GENERAL HUNTER WAS
PRESIDENT, WASHINGTON, D. C., MAY AND JUNE, 1865.

THOMAS EWING, JR., COUNSEL FOR THE ACCUSED.

MAY 17.
—

SERGEANT JOSEPH M. DYE,

a witness called for the prosecution, being duly sworn, testified as follows:

By the JUDGE ADVOCATE:

Q. State whether or not, on the evening of the 14th of April last, you were in front of Ford's Theatre, and at what hour you were there.

A. I was sitting in front of Ford's Theatre about half-past nine o'clock.

Q. Did you observe several persons, whose appearance excited your suspicions, conferring together upon the pavement in front of the theatre?

A. Yes, sir.

Q. Describe their appearance, and what they did.

A. The first appearance was an elegantly dressed gentleman, who came out of the passage, and commenced conversing with a ruffianly-looking fellow. Then there was another one appeared, and the three conversed together. After they had conversed together, it was drawing near the second act. The one that appeared to be the leader of them, the well-dressed one, said, "I think he will come out now," referring to the President, I supposed.

Q. Was the President's carriage standing there?

A. Yes, sir. One of them had been standing out, looking at the carriage on the curbstone, while I was sitting there, and then went back. They watched a while, and the rush came down; many gentlemen came out and went in and had a drink in the saloon below. Then, after they went up, the best-dressed gentleman stepped into the saloon himself; remained there long enough to get a drink, and came out in a style as if he was becoming intoxicated. He stepped up and whispered to this ruffian, (that is, the miserablest-looking one of the three,) and stepped into the passage—the passage that leads to the stage there from the street. Then the smallest one stepped up and called the time, just as the best dressed gentleman appeared again, from the clock in the vestibule. Then he started up the street, and remained there a while, and came down again, and called the time again. Then I began to think there was something going on, and looked towards this man as he called the time. Presently he went up again, and came down then and called the time again. Then I began to think there was something going on, and I looked towards the man as he called the time. Presently he went up again, and then came down and called the time louder. I think it was ten minutes after ten that he called out then.

Q. Was he announcing it to the other two?

A. Yes, sir; then he started on a fast walk up the street, and the best-dressed one among them started into the theatre, and went inside; I was invited by Sergeant Cooper to have some oysters, and we had barely time to get in the saloon and get seated, and order the oysters, when a man came running in and said the President was shot.

Q. Would you recognize that well-dressed person from his photograph, if you were to see it now?

A. Yes, sir.

Q. [Exhibiting Booth's photograph, Exhibit No. 1.] Look at that photograph.

A. That was the man; but his moustache was heavier and his hair longer than in this picture.

Q. But do you recognize the features?

A. Yes, sir; this is the man; these are his features exactly.

This part of the "GREAT CONSPIRACY TRIAL" contains all the evidence which in any and every way relates to my Theatre, and to the acts of "EDWARD SPANGLER," the only person connected with it upon trial,—it is published from the OFFICIAL COURT RECORD for the use of friends and for the sake of truth.

Much exaggeration incidental to the charges upon which this trial was founded was indulged in at a time of great public excitement. The offer of rewards for information brought many ambitious detectives to the surface, who were manifestly more ambitious to convict than to learn truth—willing and florid newspaper correspondents caught up their tales and attractively placed them before the public, and through such means "PUBLIC OPINION" was created, condemning the accused before trial. How much wrong has been done in this way, the patience and fairness of the reader must now judge.

Respectfully,

Jno. T. Ford

BALTIMORE, June 24th, 1865.

146. & 147. During the trial, John T. Ford, owner of Ford's Theatre, published this transcript of testimony to muster support for his stagehand Edman Spangler. Helping Spangler was risky for Ford, who had also been arrested and imprisoned briefly in the hysteria that followed the assassination. Nonetheless, Ford, who could have published this pamphlet under the safety of anonymity, glued a defiant note to the front page.

TESTIMONY

FOR THE

PROSECUTION AND THE DEFENCE

IN THE CASE OF

DR. SAMUEL A. MUDD,

CHARGED WITH

CONSPIRACY TO ASSASSINATE

THE

President of the United States, &c.

Tried before a Military Commission, of which Major-General DAVID HUNTER is President, May and June, 1865.

PUBLISHED FOR THE ACCUSED, FROM THE VERBATIM OFFICIAL REPORT OF THE "NATIONAL INTELLIGENCER,"

By POLKINHORN & SON, PRINTERS.

WASHINGTON.
1865.

148. Supporters of Dr. Samuel A. Mudd arranged to publish testimony related to his case in their effort to prove his innocence.

AN ARGUMENT

TO ESTABLISH THE ILLEGALITY OF

MILITARY COMMISSIONS

IN THE

UNITED STATES,

AND ESPECIALLY OF THE ONE ORGANIZED FOR THE TRIAL OF THE PARTIES CHARGED WITH

Conspiring to Assassinate the Late President,

And Others,

PRESENTED TO THAT COMMISSION,

On Monday, the 19th of June, 1865,

AND PREPARED BY

REVERDY JOHNSON,

One of the Counsel of Mrs. Surratt.

BALTIMORE....PRINTED BY JOHN MURPHY & CO.

PUBLISHERS, BOOKSELLERS, PRINTERS AND STATIONERS,

182 BALTIMORE STREET.

1865.

149. Reverdy Johnson, a former United States senator from Maryland and one of Mary Surratt's attorneys, argued in this pamphlet that the trial by military commission was unconstitutional.

150. An anonymous supporter of Mary Surratt, "Amator Justitiae," printed this rare four-page pamphlet in her defense on June 14, 1865, two weeks before the trial was over.

TRIAL OF MRS. SURRATT;
Or, contrasts of the past and present.

People of our day are apt to look pityingly on their forefathers, and stigmatize the times in which they lived as "the Dark Ages." Is the charge just?

Whatever may have been their original barbarism, the nations of Europe emerged, under the enlightening and refining influence of Christianity, into a robust and generous civilization. To this, succeeding generations are indebted for their noblest usages and institutions. Certainly, among them we may number the deference paid to woman and the safeguards thrown around her person, name, liberty, honor, life.

In the demoralization of mankind, woman, robbed of the status which the Almighty had assigned her, became a slave and object of contempt; but restored to pristine honors by the pure and gentle teachings of the Gospel, she was in the times of Feudalism, the type of dignity, grace, and purity, as Christian maid, wife, and mother.

Guizot, Balmes, Hallam, and other eminent publicists warm with an honest enthusiasm when they record this exaltation of the female sex in the minds of men and in the social scale. There is something surprisingly grand and beautiful in the attitude which woman then held in court, and camp, and tourney, in bower and hall, in banquet-room, as in the chamber of disease and prison-cell. Everywhere she was greeted as the paragon and benefactress of her race, the inspirer of chivalric sentiments, the rewarder of heroic deeds, the patroness of gentle pursuits, the reformer of vicious customs, the recipient of queenly homage. Noble and serf bowed to her beneficent sway, statesmen smoothed their ruffled brows under the charm of her presence; warriors drew sword and couched lance in her honor; champions of goodly name and estate periled limb and life to vindicate her rights and redress her grievances. It mattered not, "by the faith which knights to knighthood bore," if the gauntlet were thrown down in the cause of the old or young, the comely or deformed, the high-born or lowly. She was a *woman;* weak, defenceless, beset with dangers; and her champion deemed himself a recreant knight, a poltroon with dishonored manhood, if he shunned the combat or forgot the motto: "God and his Lady."

Walter Scott, though a fiction writer, traces with historic truthfulness this spirit and character of the Feudal ages. We barely allude to a brilliant and touching picture in Ivanhoe: The daughter of a proscribed and odious race is denounced and arraigned as a sorceress and misleader of a distinguished knight-templar. Good and guiltless of offence, but alone and deserted amid the *suspicions of circumstances* and the prejudices of the crowd, she trembles on the verge of destruction. To what does she owe her hopes of safety? To the manly spirit of the age; to the reverence due her sex. She appeals to the mailed warriors around her; she demands their protection in the trial of arms. Not a voice questions her right of appeal, nor a hand refuses succor in her distress. Norman and Saxon are ready to do battle in her service. A valiant knight confronts her enemy, hurls him to the earth, and amid hearty acclamations, proclaims the innocence and deliverance of the lorn and persecuted Jewess.

The reader of this preface perceives, no doubt, our purpose. After presenting the obverse of the medal, we venture to give them the reverse. What will they conclude? That our own times are infinitely wiser, purer, nobler than the past; that the civilization of the nineteenth century casts into shade all previous ameliorations of the condition of our forefathers? that society is high-toned, brave, and just beyond compare? that men are not deficient in moral courage, nor woman bereft of counsel and support in her exigencies? that the weak are protected by the laws, the friendless are sustained by public opinion, and even the accused are not outcasts from honor and compassion?

A few facts will guide our judgment.

An enormous crime is committed. It is patent as the sun. That crime deserves condign punishment; all men of sense and probity admit, demand it. Let justice pronounce and execute her award. How?

In an open, fair, legal, authorized manner, beyond cavil, suspicion, and distrust. No violent process against the statute, no departure from established forms, no disregard of venerable precedents, no cramping of evidence, no intimidation and cruelties—this ought to be the cry of the national heart, and what is more, the claim of the public conscience.

Let it be added: *Expedients are not law: asserted necessities are not justice; man's passions are not the vindicators of the rights of society. "Fiat justitia; ruat coelum."*

Well, the law with its Briarean hands clutches a number of reputed conspirators, incarcerates, tries them. If with the ordinary tests they be proven guilty, let them undergo the penalty. We seek no shield for iniquity.

Among these prisoners is a woman. We turn towards her with unbidden interest, for she is an alien among her own people, torn from her home, separated from her children,

TRIAL OF THE CONSPIRATORS FOR THE ASSASSINATION OF PRESIDENT LINCOLN, &c.

ARGUMENT

OF

JOHN A. BINGHAM,

SPECIAL JUDGE ADVOCATE,

IN REPLY TO THE

ARGUMENTS OF THE SEVERAL COUNSEL FOR MARY E. SURRATT, DAVID E. HEROLD, LEWIS PAYNE, GEORGE A. ATZERODT, MICHAEL O'LAUGHLIN, SAMUEL A. MUDD, EDWARD SPANGLER, AND SAMUEL ARNOLD, CHARGED WITH CONSPIRACY AND THE MURDER OF ABRAHAM LINCOLN, LATE PRESIDENT OF THE UNITED STATES.

Delivered June 27 and 28, 1865, before the Military Commission, Washington, D. C.

WASHINGTON:
GOVERNMENT PRINTING OFFICE.
1865.

151. The prosecution did not remain silent. Here, Special Judge Advocate John A. Bingham responds on June 27 and 28 to arguments by lawyers for Lewis Powell, George Atzerodt, Michael O'Laughlin, Edman Spangler, Dr. Samuel A. Mudd, and Samuel Arnold.

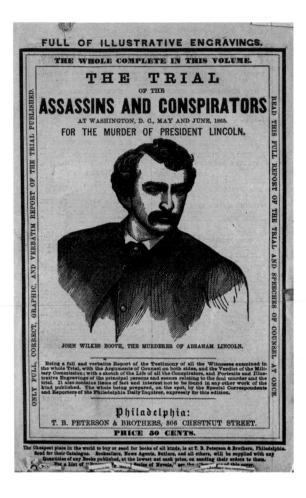

152. & 153. After the trial was over and four conspirators were executed and the rest confined in prison, rival publishers issued several different versions of the transcript that varied in accuracy and completeness. T. B. Peterson & Brothers of Philadelphia published a hardbound edition and also this eye-catching version bound in illustrated paper wrappers. Booth was dead and had not even been a defendant at the trial, but that did not stop publishers from exploiting his image to sell books. A recurring advertisement in the *Philadelphia Inquirer* drummed up advance sales for this edition.

154. In Boston, J. E. Tilton and Company published Ben:Perley Poore's version of the transcript, *The Conspiracy Trial for the Murder of the President, and the Attempt to Overthrow the Government by the Assassination of Its Principal Officers*, in parts and bound in paper wrappers, while the trial was still in progress. Tilton filed for copyright on June 12, 1865, and deposited a copy on July 5, 1865. He followed up the pamphlet edition with a three-volume hardbound set.

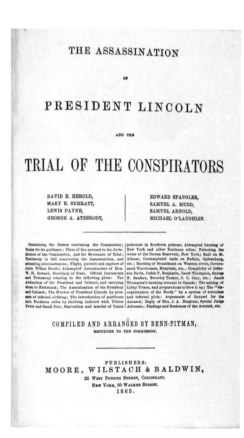

155. Moore, Wilstach, and Baldwin of Cincinnati published *The Assassination of President Lincoln and the Trial of the Conspirators*, the transcript by Benn Pitman, the official "recorder to the commission."

156. & 157. Not all post-trial publications were transcripts of testimony. J. R. Hawley & Co. of New York and Cincinnati published *The Assassination and History of the Conspiracy* and bound it in handsomely printed wrappers. Barclay & Company of Philadelphia published another pamphlet, *Trial of the Assassins and Conspirators for the Murder of President Lincoln.* The front wrapper illustration of a veiled Mary Surratt enhanced the drama of the story.

158. It did not help the conspirators that the national day of mourning for President Lincoln, June 1, 1865, fell in the middle of their trial. In Providence, Rhode Island, the famed abolitionist and editor of *The Liberator*, William Lloyd Garrison, addressed the public.

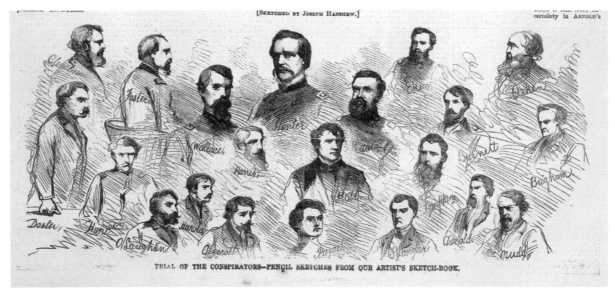

159. *Harper's Weekly* published this collection of vignettes of conspirators, attorneys, and judges.

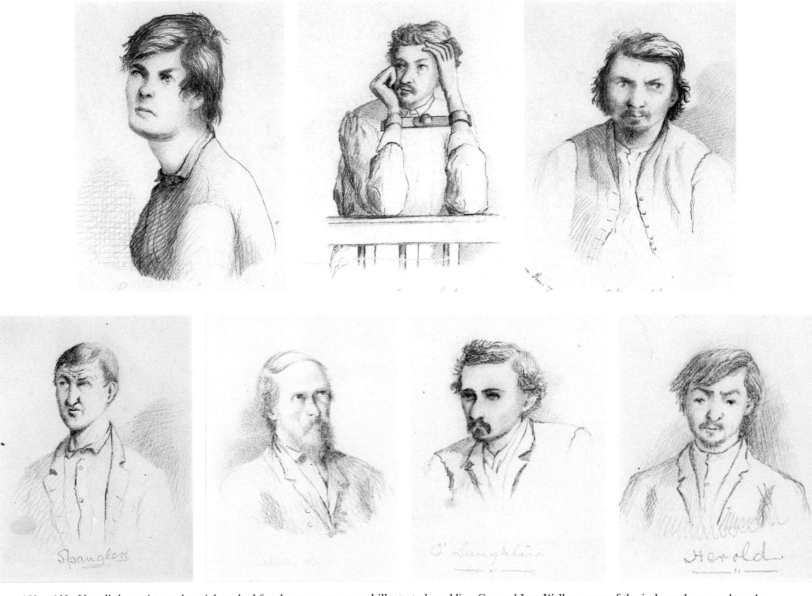

160. – 166. Not all the artists at the trial worked for the newspapers and illustrated weeklies. General Lew Wallace, one of the judges who served on the military commission, amused himself by sketching the conspirators from life while he observed them.

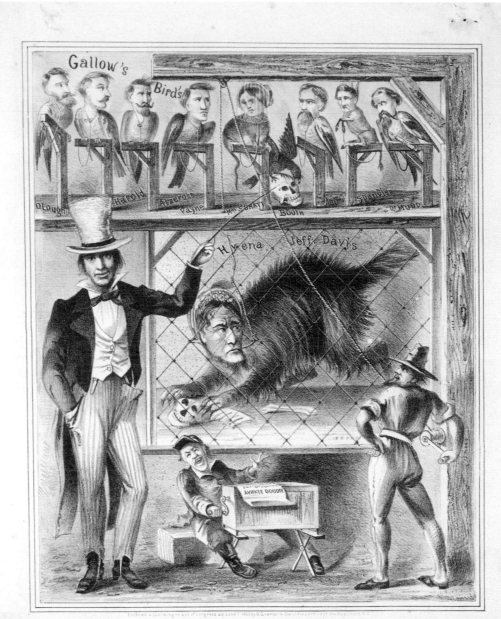

UNCLE SAM'S MENAGERIE

167. & 168. Disturbing imagery that claimed to foreshadow the fate of the conspirators began to appear. The print *Uncle Sam's Menagerie*, copyrighted on June 7, 1865, had already sentenced all eight defendants to the gallows a full month before the execution of four of them. In a mockery of her name, Mary Surratt appears with a rattail, and Dr. Samuel Mudd clutches a tool of his trade, a glass syringe. The carte, based on an almost impossibly detailed painting, depicts the "grand hanging" of rebels, including Dr. Mudd.

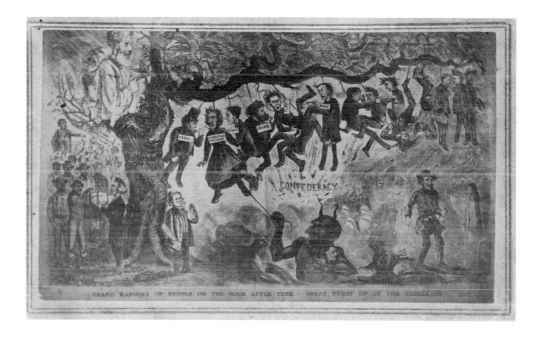

FRANK LESLIE'S
ILLUSTRATED
NEWSPAPER

Entered according to the Act of Congress in the year 1864, by Frank Leslie, in the Clerk's Office of the District Court for the Southern District of New York.

No. 512.—Vol. XX.] NEW YORK, JULY 22, 1865. [Price 10 Cents. $4 00 Yearly.

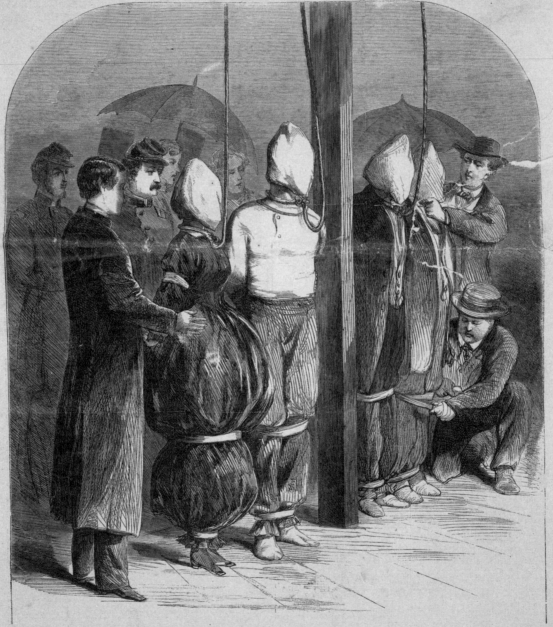

EXECUTION OF THE CONSPIRATORS IN WASHINGTON, D. C.—THE FINAL PREPARATIONS—APPEARANCE OF THE CRIMINALS ON THE SCAFFOLD.—FROM A SKETCH BY OUR SPECIAL ARTIST, D. B. GULICK.

169. The last moments, as depicted by sketch artist D. B. Gulick, in *Frank Leslie's Illustrated Newspaper*, July 22.

CHAPTER FIVE

THE EXECUTION

She was cut down and placed in a square wooden box or coffin, in the clothes in which she died. . . the rope made a clean cut around her neck fully an inch in diameter, which was black and discolored with bruised blood. The cap was not taken off her face, and she was laid in the coffin with it on, and thus passed away from the earth Mary E. Surratt. —*The Trial of the Assassins and Conspirators,* T. B. Peterson & Brothers

THE END CAME QUICKLY. On July 6, 1865, the day after President Johnson approved the verdicts and sentences of the commission, they were copied out by hand and carried to the prison by Major General Winfield Scott Hancock. It was the duty of Major General John Hartranft, commander of the Old Arsenal Penitentiary, to inform the prisoners of their fates. At around noon, Hartranft walked from cell to cell and read aloud the sentences to Lewis Powell, Mary Surratt, David Herold, and George Atzerodt: They had been found guilty and would be hanged the next day between the hours of 10 A.M. and 2 P.M. Then Hartranft handed each of the condemned an envelope containing a copy of the death warrant. The other defendants had been found guilty, too, but they would be spared: Samuel A. Mudd, Samuel Arnold, and Michael O'Laughlin were sentenced to life in prison; Edman Spangler to six years.

The conspirators were shocked to learn how quickly they had been convicted and that they would be executed the next day. There would be little time to summon family and ministers and to prepare for death. Mary Surratt's lawyers did not even learn of her death sentence until early in the evening, when a newsboy's cry hawking the afternoon edition alerted them. Although word spread through Washington on the night of July 6, the nation did not know that the conspirators had been found guilty and that four of them would hang that day until the morning of July 7.

The front pages of the morning newspapers were filled with information on the conspirators, how they had spent their last night, and the preparations for the execution. Many people did not believe that Mary Surratt would be hanged. Her daughter, Anna, rushed to the White House to plead for her mother's life. Her lawyers filed a last minute petition for a writ of habeas corpus to free her from the military prison and to turn her over to civil authorities.

On execution day, a rumor spread that the president, out of consideration for Mary Surratt's age and sex, had commuted her sentence to life.

That rumor was dispelled when four conspirators, with Surratt at their head, were led into the prison courtyard, marched within sight of their coffins and freshly dug graves, and taken up to the scaffold. As Alexander Gardner's camera recorded the scene, the condemned were seated while the death sentence was read aloud. Then they were ordered to stand. They were bound, nooses were placed around their necks, and cloth hoods were pulled over their heads. At Lewis Powell's request, his minister thanked the assembled officers and soldiers for their kind treatment during his imprisonment. George Atzerodt spoke up nervously and muttered something about meeting in another world. The signal was given, the trap fell, and, in the words of one witness, "four human beings were left dangling between heaven and earth."

That afternoon, just hours after the execution, the Washington *Evening Star* hit the street, and the public savored the first reports of the hanging. The gentlemen of the press did their jobs well. Little escaped their attention. They reported on who had visited the conspirators, the names of their ministers, how they had spent their last nights alive, which conspirators had acted cowardly and which had behaved bravely, how they had walked to the scaffold, the words spoken on the scaffold, and how the order to drop the trap had been given. The reporters had even timed how long it took each conspirator to die and described every bodily convulsion of their death struggles. After the bodies were cut down, the reporters checked to see which conspirators had broken necks and which ones had strangled to death. The next day, newspapers across the country told their readers how the Lincoln assassination conspirators had died.

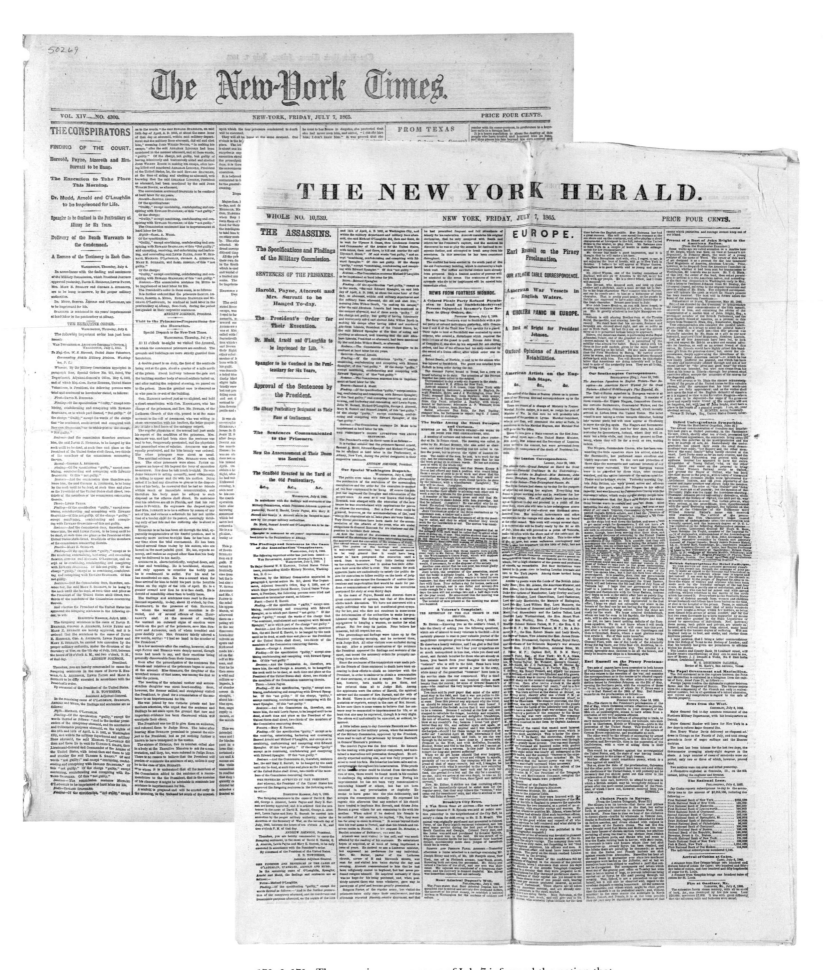

170. & 171. The morning newspapers of July 7 informed the nation that four of the conspirators would hang that day.

War Department,
Adjutant General's Office.
Washington, July 5, 1865

Extract.

To/ Major General W. S. Hancock,
 U. S. Volunteers,
 Commanding Middle Military Division
 Washington, D.C.

Whereas, by the Military Commission appointed in paragraph 4, Special Orders, No. 211, dated War Department, Adjutant General's Office, Washington, May 6, 1865, and of which Major General David Hunter, U. S. Volunteers, is President, the following named persons were tried, and after mature consideration of the evidence adduced in their cases were found and sentenced as hereinafter stated, as follows:

 x x x x

 3d Lewis Payne.
 Finding.
"Of the Specification - Guilty except combining

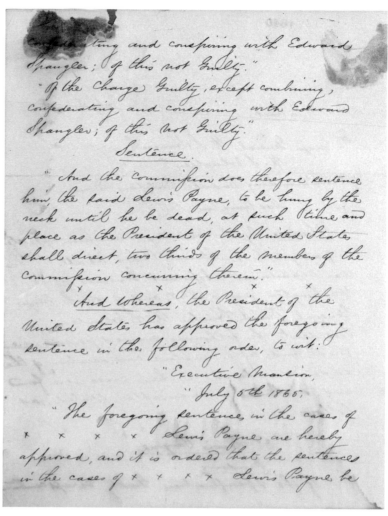

...binating and conspiring with Edward Spangler; of this not Guilty."

"Of the Charge Guilty, except combining, confederating and conspiring with Edward Spangler; of this not Guilty."

 Sentence.

"And the Commission does therefore sentence him the said Lewis Payne, to be hung by the neck until he be dead, at such time and place as the President of the United States shall direct, two thirds of the members of the Commission concurring therein."

And whereas, the President of the United States has approved the foregoing sentence in the following order, to wit:

 "Executive Mansion,
 "July 5th 1865.

"The foregoing sentence in the cases of x x x x Lewis Payne are hereby approved, and it is ordered that the sentences in the cases of x x x x Lewis Payne be

carried into execution by the proper military authority, under the direction of the Secretary of War, on the Seventh day of July 1865, between the hours of ten o'clock A.m. and two o'clock P. m. of that day x x x

 Andrew Johnson,
 "Presd."

Therefore, You are hereby commanded to cause the foregoing sentence in the case of Lewis Payne to be duly executed in accordance with the President's order.

By command of the President of the United States.
 E D Townsend
 Asst. Adjt Genl

172. & 173. Lewis Powell's death warrant. Powell gave the order to his minister, the Reverend Dr. A. D. Gillette, who wrote a pencil endorsement on the flap: "This death warrant was given me by Payne less than an hour before his execution. I was in his cell & with him the last moments of his life. A. D. Gillette."

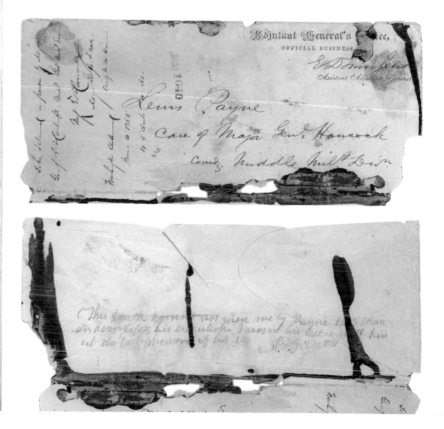

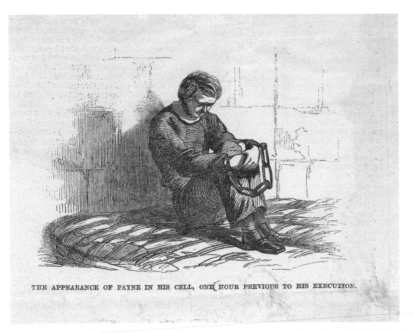

THE APPEARANCE OF PAYNE IN HIS CELL, ONE HOUR PREVIOUS TO HIS EXECUTION.

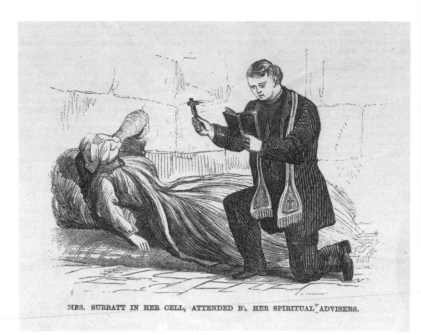

MRS. SURRATT IN HER CELL, ATTENDED BY HER SPIRITUAL ADVISERS.

174. – 178. The public was fascinated by the last hours of the condemned. *Harper's Weekly* and other newspapers gave details of their emotions, visitors, and spiritual advisers.

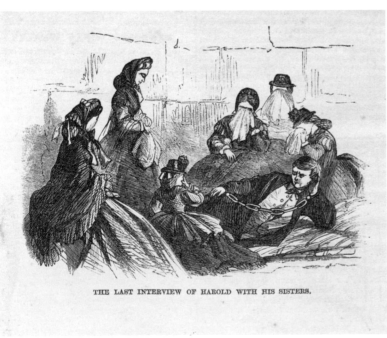

THE LAST INTERVIEW OF HAROLD WITH HIS SISTERS.

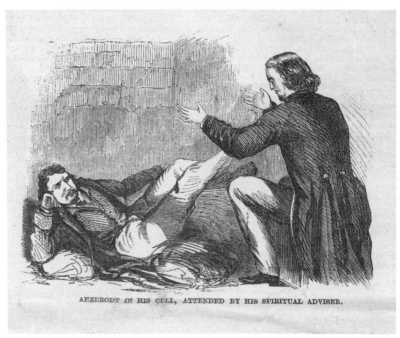

ARZERODT IN HIS CELL, ATTENDED BY HIS SPIRITUAL ADVISER.

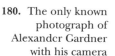

Head Quarters Mid Mily Division.
Washington D C July 6. 1865

In accordance with the directions of
the President of the United States, the
foregoing sentences, in the cases of
David E Herold. G. A Atzerodt & Lewis
Payne, and Mary E. Surratt. will be duly
executed. at the Military Prison
near the Washington Arsenal, between
the hours of 10 o'clock A M. and two
o'clock P M. July 7. 1865.
Brevet Major General John F Hartranft
U S V. Commandant of the Military Prison
is charged with, the Execution of this
order

Wm S. Hancock
Major General Commanding

179. General Winfield Scott Hancock's order to General Hartranft to hang the conspirators.

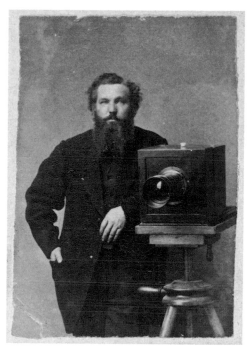

180. The only known photograph of Alexander Gardner with his camera

181. Alexander Gardner's pass to enter the Old Arsenal two days before the hanging. Before the public—or even the condemned—was informed of the forthcoming execution, the War Department alerted Gardner to prepare.

MILITARY COMMISSION
Washington, July 5th 1865.

ADMIT Alexander Gardner

C. P. Hunter
President of the Commission.

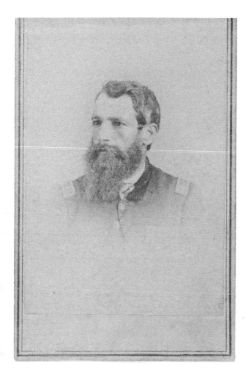

182. Chief executioner Captain Christian Rath, Seventeenth Michigan Infantry, First Division, Ninth Corps.

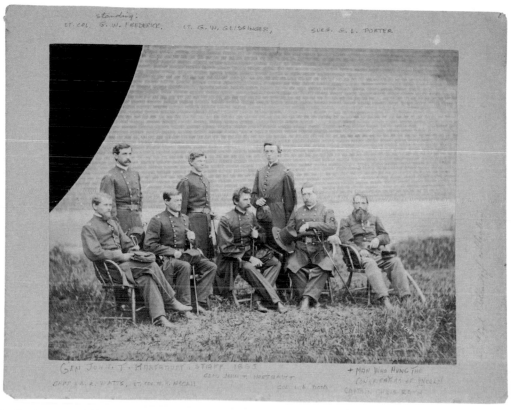

183. Gardner posed General Hartranft and his staff in the very chairs used by the condemned on the scaffold. *Seated, left to right:* Capt. A. R. Watts, Lt. Col. W. H. McCall, Gen. John T. Hartranft, Col. L. A. Dodd, Capt. Christian Rath. *Standing, left to right:* Lt. Col. G. W. Frederick, Lt. G. W. Geissinger, Surgeon G. L. Porter.

War Department.
Adjutant Generals Office.
Washington, July 5, 1865.

To/
Major General W. S. Hancock,
 U. S. Volunteers,
 Commanding Middle Military Division,
 Washington, D.C.

Whereas, by the Military Commission appointed in paragraph 4, Special Orders. No. 211, dated War Department, Adjutant General's Office, Washington, May 6, 1865, and in paragraph 91, Special Order. No. 216. dated War Department, Adjutant General's Office, Washington May 9. 1865, and of which Major General David Hunter. U.S. Volunteers, is President, the following named persons were tried, and after mature consideration of the evidence adduced in their cases were found and sentenced as hereinafter stated, as follows:

1st David E. Herold.

 Finding.
"Of the Specification. Guilty except combining,

confederating, and conspiring with Edward Spangler; as to which part thereof, Not Guilty."
"Of the charge — Guilty, except the words of the charge that he combined, confederated, and conspired with Edward Spangler; as to which part of said charge, not Guilty.

 Sentence.
"And the Commission does therefore, sentence him the said David E. Herold, to be hanged by the neck until he be dead, at such time and place as the President of the United States shall direct, two thirds of the members of the Commission concurring therein."

2d. George A. Atzerodt.

 Finding.
"Of the Specification, Guilty, except combining, confederating, and conspiring with Edward Spangler; of this not Guilty."
"Of the charge, Guilty, except combining, confederating and conspiring with Edward Spangler; of this Not Guilty."

 Sentence.
"And the Commission does therefore sentence

entertaining, harbouring, and concealing Samuel Arnold, and Michael OLaughlin, and except as to combining, confederating, and conspiring with Edward Spangler; of this not guilty."
"Of the charge, Guilty, except as to combining, confederating, and conspiring with Edward Spangler; of this not guilty."

 Sentence.
"And the Commission does therefore sentence her the said Mary E. Surratt, to be hung by the neck until she be dead, at such time and place as the President of the United States shall direct, two thirds of the members of the Commission concurring therein."

 And whereas, the President of the United States has approved the foregoing sentence in the following order, to wit:
 "Executive Mansion,
 "July 5th 1865.
"The foregoing sentence, in the cases of David E. Herold, G. A. Atzerodt, Lewis Payne, x x, x x, x x, Mary E. Surratt, x x x, are hereby approved, and it is ordered that the sentences in the

cases of David E. Herold, G. A. Atzerodt, Lewis Payne, and Mary E. Surratt, be carried into execution by the proper Military authority under the direction of the Secretary of War, on the seventh day of July 1865, between the hours of ten o'clock A.M. and two o'clock P.M. of that day. x x x x x x x x x"
 "Andrew Johnson,
 "Presd."

 Therefore, You are hereby commanded to cause the foregoing sentence, in the cases of David E. Herold, G. A. Atzerodt, Lewis Payne, and Mary E. Surratt, to be duly executed in accordance with the President's order.

 By command of the President of the United States.
 E D Townsend
 Asst. Adjt. Genl.

him, the said George A. Atzerodt, to be hung by the neck until he be dead at such time and place as the President of the United States shall direct, two thirds of the members of the commission concurring therein."

3rd Lewis Payne.

Finding.

"Of the Specification, Guilty, except combining, confederating, and conspiring with Edward Spangler; of this not Guilty."

"Of the Charge Guilty, except combining, confederating and conspiring with Edward Spangler; of this not Guilty."

Sentence.

"And the Commission does therefore sentence him, the said Lewis Payne, to be hung by the neck until he be dead, at such time and place as the President of the United States shall direct, two thirds of the members of the Commission concurring therein."

4th Mary E. Surratt,

Finding

"Of the Specification, Guilty, except as to receiving

184. The original Order of Execution (reading across from top left). General Hartranft read this order to the condemned on the scaffold.

185. A signed carte-de-visite photograph of Edward D. Townsend, assistant adjutant general of the army. Townsend wrote in his own hand the execution order read on the scaffold and the four individual death warrants given to each conspirator in his or her cell the day before the hanging.

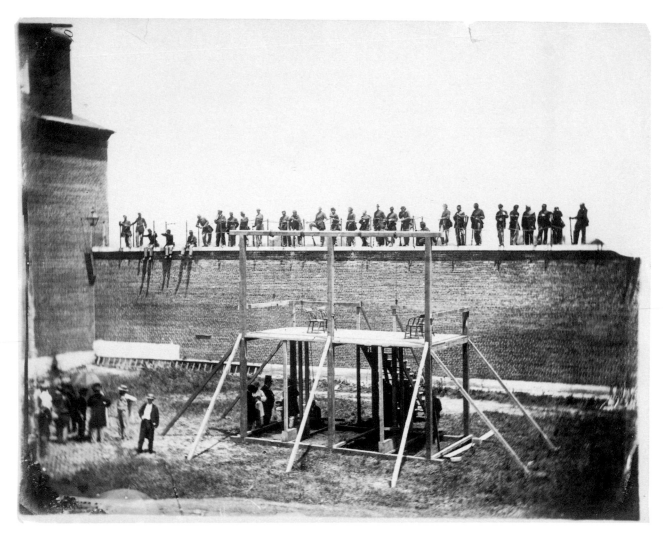

186. The empty scaffold awaits, while the reporters and witnesses gather.

187. *Arrival on Scaffold.* Large-format view, taken a few minutes after the arrival. The execution party carries umbrellas to shield themselves and Mary Surratt from the sun. The gentlemen of the press write and sketch in their notebooks.

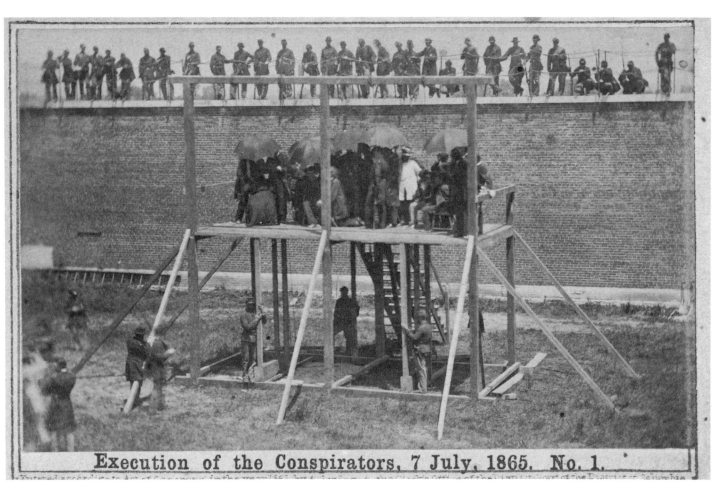

Execution of the Conspirators, 7 July, 1865. No. 1.

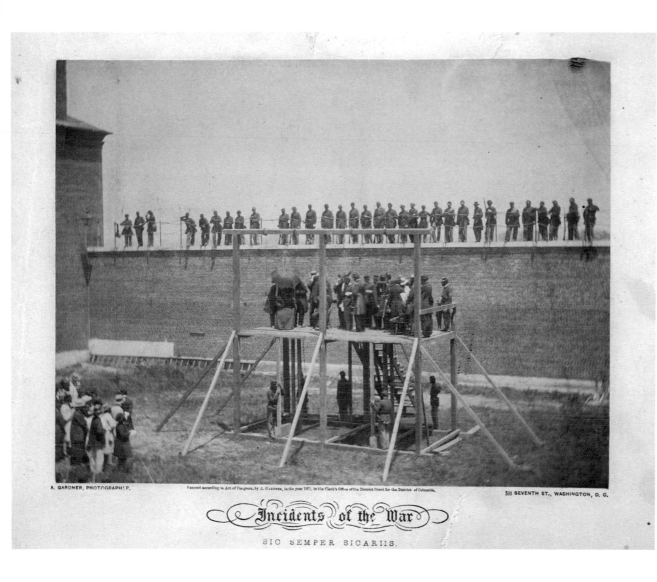

A. GARDNER, PHOTOGRAPHER. Entered according to Act of Congress, by A. Gardner, in the year 1865, in the Clerk's Office of the District Court for the District of Columbia. 511 SEVENTH ST., WASHINGTON, D. C.

Incidents of the War

SIC SEMPER SICARIIS.

188. The prisoners, their guards, the ministers, and the official execution party arrive on the scaffold. The condemned, *left to right:* Mary Surratt, Lewis Powell, David Herold, George Atzerodt. Surratt was placed on the right, the place of honor according to executioner Rath.

189. *Reading the Death Warrant.* General Hartranft reads the execution order to the conspirators. Colonel Dodd, holding his sword, and Captain Rath, in his white coat and hat, listen attentively. Seated on the right, Atzerodt covers his head with a white handkerchief.

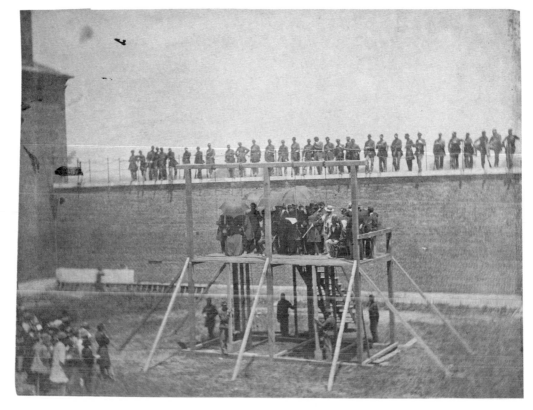

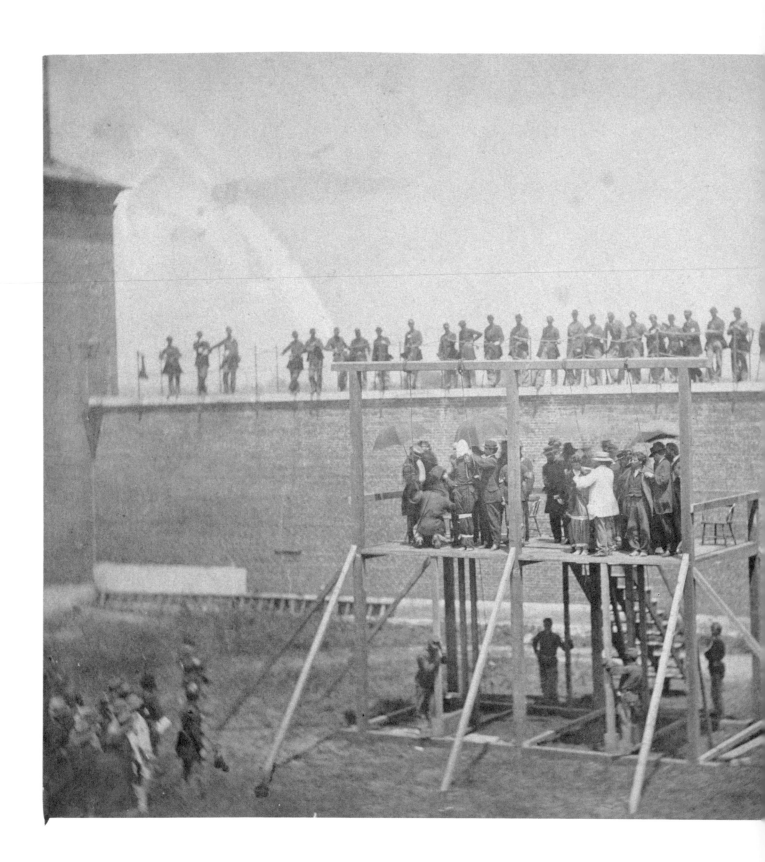

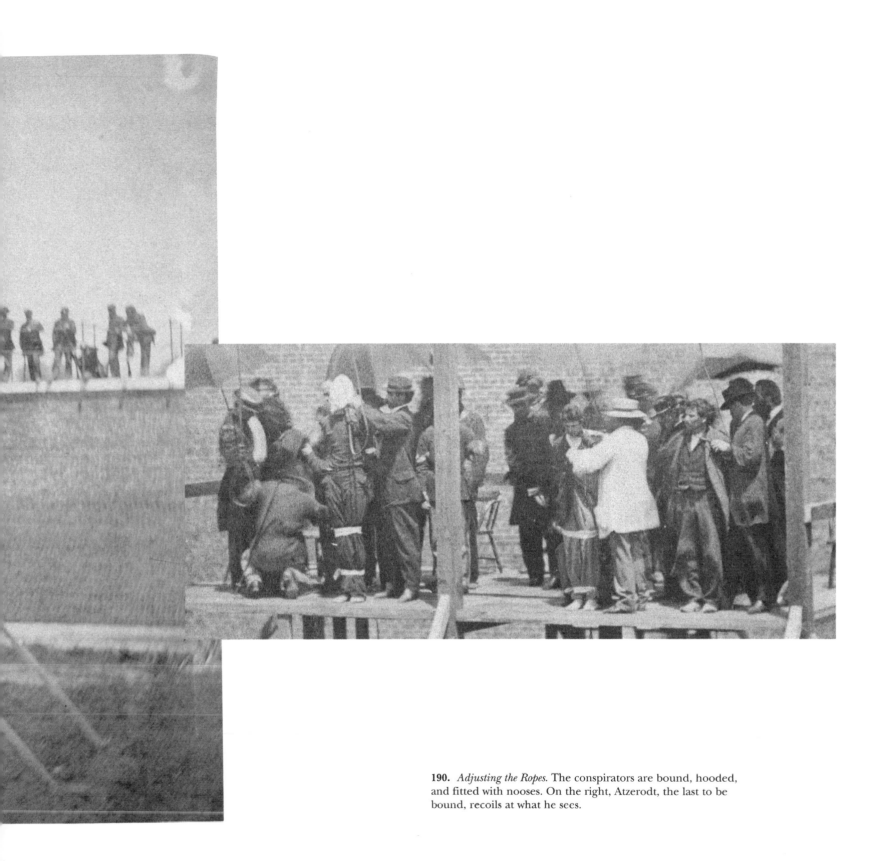

190. *Adjusting the Ropes.* The conspirators are bound, hooded, and fitted with nooses. On the right, Atzerodt, the last to be bound, recoils at what he sees.

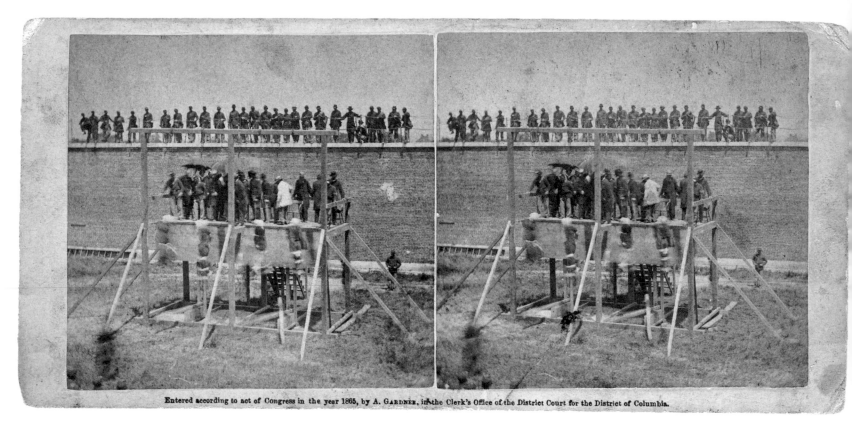

191. *The Drop.* Gardner's stereo camera records the death struggles. Powell and Herold did not die quickly.

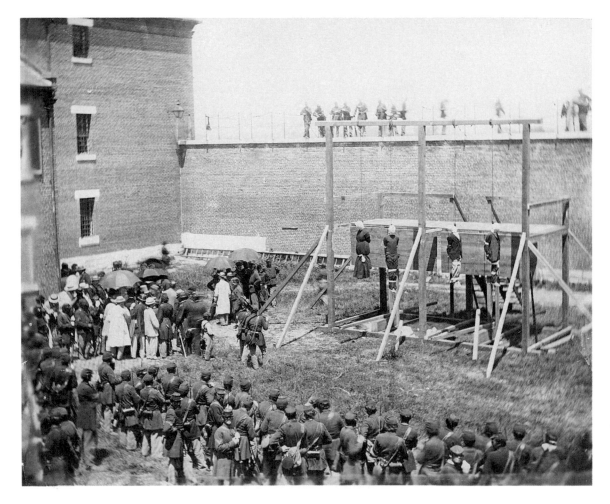

192. All is done. The bodies hang still, while members of the press gather around General Hartranft and his officers. A solitary boy remains transfixed by the dead.

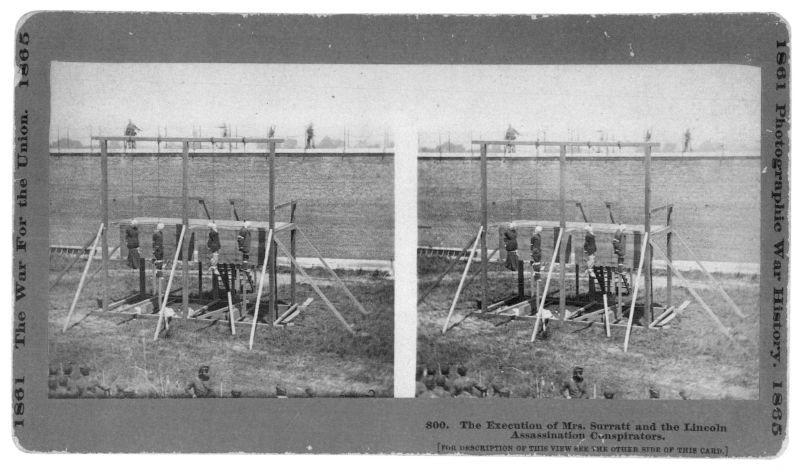

800. The Execution of Mrs. Surratt and the Lincoln
Assassination Conspirators.
[FOR DESCRIPTION OF THIS VIEW SEE THE OTHER SIDE OF THIS CARD.]

193. As the soldiers on the wall depart, the stereo camera captures the final view of the four conspirators in death.

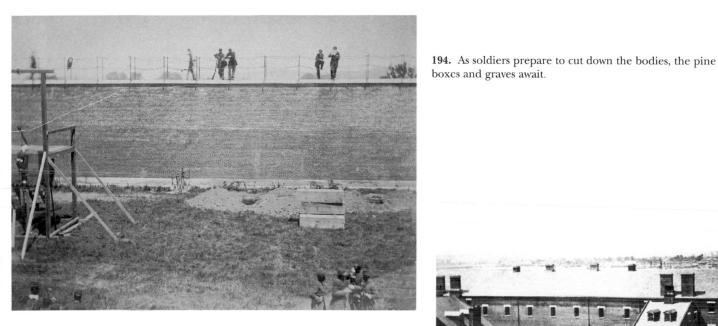

194. As soldiers prepare to cut down the bodies, the pine boxes and graves await.

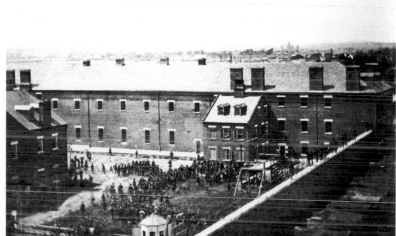

195. The pine boxes are stacked in front of the scaffold, and the bodies are about to be cut down. To take this bird's-eye view, Gardner moved his camera to the top of the Old Arsenal.

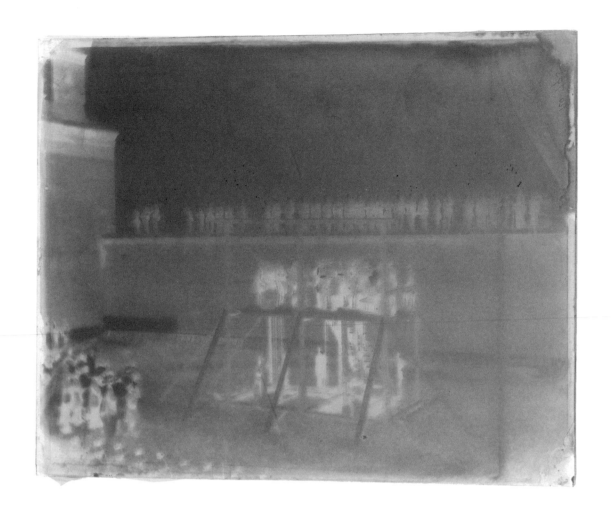

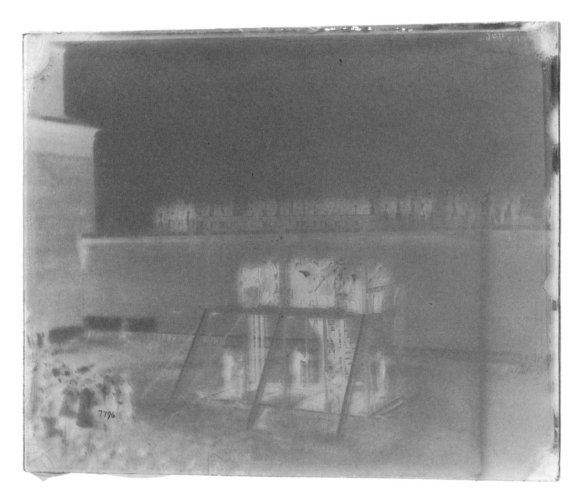

196. & 197. Ghostly shadows. Two of Alexander Gardner's original collodion glass-plate negatives made on July 7, 1865. These artifacts, never before shown, depict the *Arrival on the Scaffold* and *Reading of the Charges.*

198. General John Hartranft's military frock coat, worn on the day of the execution.

199. Segments of the four hanging ropes. Souvenir hunters chipped wood from the gallows and divided the ropes.

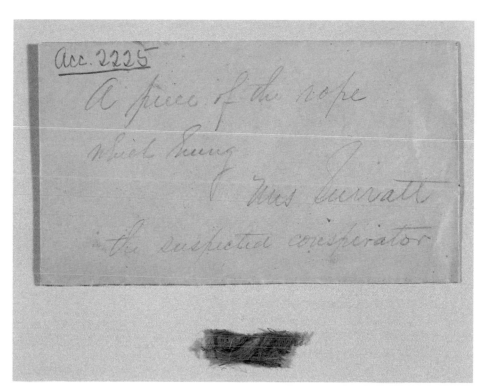

200. Another rope souvenir.

THE NEW YORK HERALD.

WHOLE NO. 10,540. NEW YORK, SATURDAY, JULY 8, 1865. PRICE FOUR CENTS.

EXECUTION.

EXPIATING THE GREAT CRIME.

Hanging of Mrs. Surratt, Payne, Harold and Atzerott.

Full and Complete Details of the Affair.

Efforts to Defer the Execution of Mrs. Surratt.

A Writ of Habeas Corpus Issued for Her, but it is Disregarded by President Johnson's Orders.

How the Prisoners Passed Their Last Night.

Mrs. Surratt and Payne Preserve Their Stolid Indifference to the End.

Terror and Agitation of Atzerott and Harold.

HOW THEY DIED.

TERRIBLE STRUGGLES OF PAYNE.

THE FINAL SCENE OF THEIR BURIAL.

SKETCHES OF THE CRIMINALS,
&c., &c., &c.



THE ASSASSINS.

Sketch of Mrs. Mary E. Surratt.

Sketch of David E. Harold.

Sketch of Lewis Payne.

Sketch of George A. Atzerott.

Sketch of Samuel G. Arnold.

CONTINUED ON FIFTH PAGE.

201. Newspapers published intricate details of the execution, none too small to report.

Commercial images of the assassination. Although the daily
newspapers gave wonderful written accounts of the execution,
there was no time to create woodcuts to accompany the stories.
To see with their own eyes what had happened, the public had
to wait for the illustrated weeklies (figs. 202, 204, 207, 213,
214, 216, 217, and 218), cartes-de-visite and stereo cards (figs.
203, 206, and 212), pamphlets (fig. 208), lithographs (figs.
210, and 211), and, eventually, glass lantern slides (fig. 215).
These images took viewers through the execution chronologi-
cally, step by step. Harper's Weekly had an advantage over its
competitors—the cooperation of Alexander Gardner (fig.
205), as revealed by his inscription on the verso of figure 204.

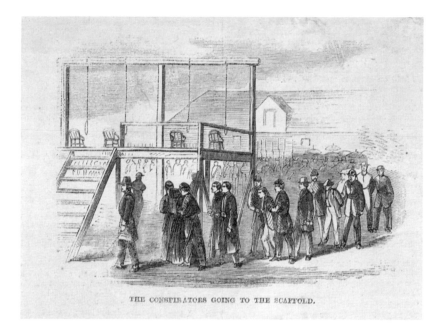

THE CONSPIRATORS GOING TO THE SCAFFOLD.

202.

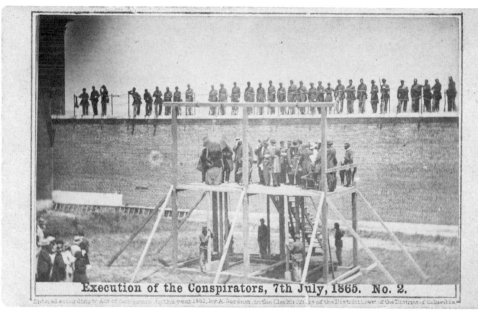

Execution of the Conspirators, 7th July, 1865. No. 2.

Entered according to Act of Congress, in the year 1865, by A. Gardner, in the Clerk's Office of the District Court of the District of Columbia

203.

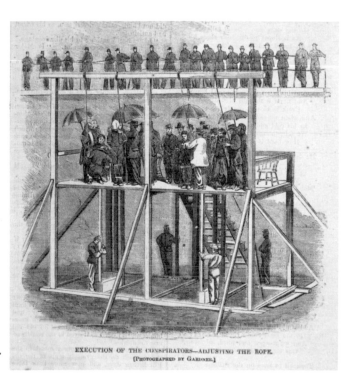

204.

EXECUTION OF THE CONSPIRATORS—ADJUSTING THE ROPE.
[PHOTOGRAPHED BY GARDNER.]

205.

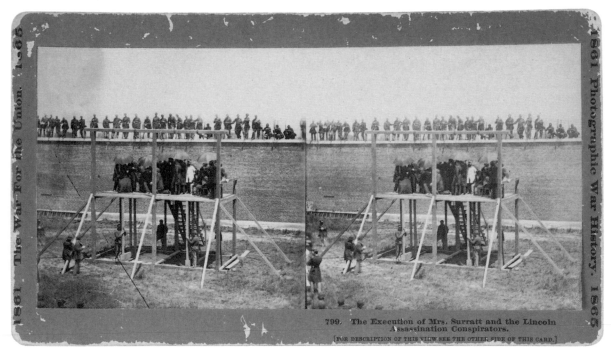

799. The Execution of Mrs. Surratt and the Lincoln
Assassination Conspirators.

[FOR DESCRIPTION OF THIS VIEW SEE THE OTHER SIDE OF THIS CARD.]

206.

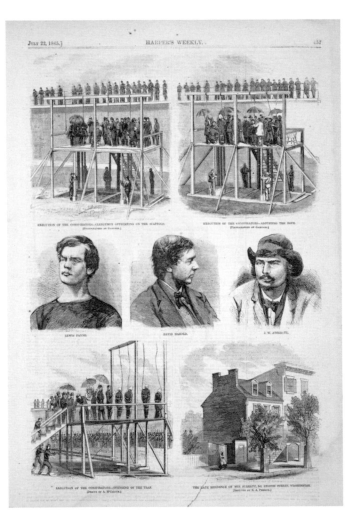

207.

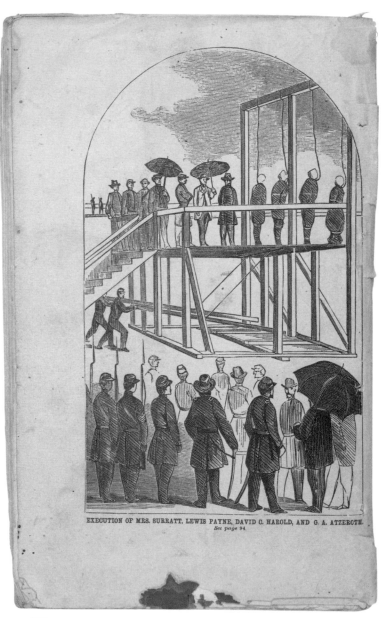

EXECUTION OF MRS. SURRATT, LEWIS PAYNE, DAVID C. HAROLD, AND G. A. ATZEROTH.
See page 94.

208.

NATIONAL POLICE GAZETTE.

GEORGE W. MATSELL & CO.
EDITORS AND PROPRIETORS.

NEW YORK: FOR THE WEEK ENDING JULY 15, 1865.

VOL. XX. NO. 1037.—PRICE TEN CENTS.

EXECUTION OF THE CONSPIRARORS.

Payne in his Cell on the Morning of the Execution.

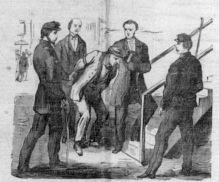

Atzerott on his Way to the Scaffold.

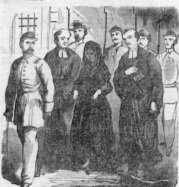

Mrs. Surratt on her Way to the Scaffold.

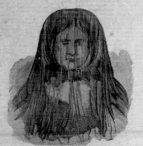

Mrs. Surratt.

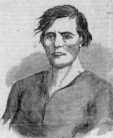

Powell alias Payne.

Harold.

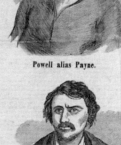

Atzerott.

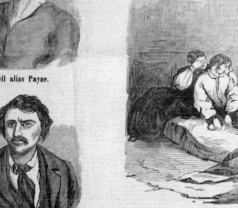

Mrs. Surratt Preparing for Death.

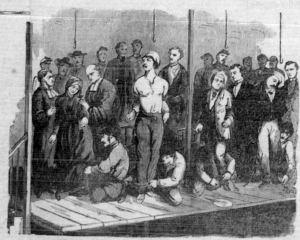

The Conspirators on the Scaffold, being Prepared for Execution.

LEAVES FROM THE UNPUBLISHED DIARY

OF A CELEBRATED

BURGLAR AND PICKPOCKET.

HARRY THE "LAGGER" UNFOLDS HIS PLANS TO THE "MOB."

Joe is Desirous of Knowing the Value of the Church "Wedge."

HE BECOMES SENTIMENTAL.

Bill Connolly, the "Gun's," Estimate of America.

JOE ENQUIRES PARTICULARLY ABOUT THE "FENCES" IN ENGLAND.

He Receives Decidedly Unpleasant Information.

We "lotted up" the gems and followed the "lagger" into the back room, where, having seated ourselves around him, our "mob" on the move, he began.

"Now, boys, I've got a good thing on hand—something that will pay for the trouble of "doing" it; but first let me tell you, Are you willing to join in?"

"Won't I, jus' willin' in its easy bloody thing an'l being in th' "doder'—won't I? if so' bet on 'our was in it, boys?"

"Bill I don't want to get fobs 'do' in anything. I've in hand evident having their word first that they means "grafting" after they know what him."

"Well's, wot I'm referentet sheeat! I won't I and then I ever pulling ov 'either in my something tha'd pro 'anger'd in ad 'Biche?—wot is t'a wegrits her?"

"I'm waiting to hear what the others say, that's all."

"Oh! I'm ready to 'go in' at whatever Joe's willing to undertake," said I.

"And so am I, Harry," replied Folkstone; "I won't back out of anything they are willing to take in hand. Let us hear it now, before any one closes in."

"Well, seeing you are all willing to 'graft,' I'll now tell you what it is. You all know Howe's Church, don't you? Well sen, I've figgad out that a very rich lady has made a present to that church of a brass box communion service, and that on next Sunday it will be used for the first time. Now, wouldn't it be a bloody fine lark to 'punch' that 'crib' as soon as they get through with it, all. Thinder me himself if I could sleep these two nights for thinking about it! So, this morning, when I got up, out I went and made for the church, where I had a 'gemmy' of hope it shout, and before I 'left it' I'd made up my mind that old Harry Hill would either 'creep' off the 'stuff' that was bundo or get 'lag'd in the siloeuph. Well, I know that I couldn't menage it all myself, and poor Harry Jones is sick abed, nearly a 'dresden;' so I inquired about you fellows, and heard, from where in town, and knowing what kind of stuff you were made of, I thought 'dose best to see you if you were working for him 'so.'"

"Wy, yes, we're soul willing, but I say, Harry, is there enough 'wedge' in 'rdge' to pazy cat out fur our trubbid, don t'a think? one Fikged th' was I came to the r I seem in hea 'th' of nothin' as me'rint paz' as Harry wot, an. Harry s point at a rether dugger-sblu' in layse again wot 'a roright as well oulys a tru, aphis whole th grave? I'm the 'graftin' bylo bind foloe blacks ninely, as? I'm go th Monsgor in Pen maildle snud th bury a one act of 'nothe' Walk's don o' that, hairy?"

"That's poor enough, Joe, but what do you want with a new set of tools? ain't those what you had that night we 'done' the 'crib' at Boalze good enough?"

"Aye! they ar good enad bit I tol 'em, but wot 'ery, and knok, iwery sene o' them iither bee've in gettin' aeter a bloosty was ecrap left 'ergt a 'pos' ant in 'Storwd' ast et th' better on in 'or easy?"

"They did that some aroun, Joe! Why! that's a dreadful dead lonk th sh. It a sum's 'graft' nothind 'tools' and sa'er a fellow of my corporadenes bes say to land. What will we do?"

"Don't t'ma Peo, mu'd lad Wot did t'a only thing' wir agen to puez the 'Bik'?"

"On next Sunday, I heard," replied Harry.

"Well's. Shall'd 'blust mest this 'ers bffoken for a 'f, one i've 'bis an' 'gaged a bran new set th 'carry some 'molyke az oh rest ean I 'howl for th' anin 'Hohs' an molyke th' oflore, an' I've just de 'te some as th' 'sugar' right dcwen in 'ers 'em ready for mi, ahove, by mid Sunday. Sea thea sem, wry, preveh dimes preveyke for sad things?"

"I'm glad to hear it, Joe. Bliffen me! if I wasn't beginning to think a 'croak' was agoing to be put on our 'graft for want of 'tools.' Are you sure he's have them finished in time for 'grafo' on Sunday night, Joe?"

"Well, I rakkon 'a will, 'a's dead, I'll tura 'te bloodly ond 'aenh' anset f th' 'duteid, but, I conl'sa s 'b you 'em dus. Annyway's, I'm boo to go duwen the o' i'm' anoth'ad' owr 'a'twhilz 'n bon 'grash' on 'em of zotu. Wl't's crim wt 'ed f th'' mera? 'Anry.' This was settled upon, and then out went the old 'busbee' and to some another 'stund o' home.'"

"Cousa, wal Sae I's think it 'll run in it' an gar it 'and 'th 'te rigtha', eh? Will us 'ere as smuk as 'th teght'n so aset o' th'' mankary?'"

"I couldn't say, Joe," I replied. "You know in much about that as I do, if notmore?"

"Say, I'll goo to Insida br I kum dway thin', sherot it. I iyvely sent motthh f thes their plaizne, 'argh I wot wan I waz 'elewfih' far th' 'Sky;' but iz it's np to ad mutsh in that wol oz sae'd f th' koth's sekdll wan us 'recpted 'do' doctiso ne? 'a 'riolly daisy I las 'lagged in I'd mlyke new 'kentssy' fur mi 'crox f?"

"Oh Joe, Me adtms samehog mey alidd ses he few 'dkl' ars hatshed. Wat coul we getthe 'away, and then me'll seon kouls kou mouk it will 'raoe to a heod; we havn't meds much for recksfig frew prez zumaze?"

"Let us go bock and have another gune, Joe," said Folkstone; "I want to be doing something."

"Wel's, gra 'ems in Kinvry Fleketne, an' ther'd wry 'be; thi t'a sneert lyke ints a parmsir sun a fellw in evert to do. Aafer sotne, I've bin 'shrigkeed up a week, and sinds I won't 'bi' 'Lnxe' I soxgite a promise to knows that I'd ouly seear to tose thes I 'graed in, an' fmud somonst in th' bleach. Com'se me tems of md, Funkstion, an' we'll see 'ow th' 'corfer is goine along 'bgan' begotn'ongmstier tme nofcos 'very thnkiy' that tha'e wold I mey f ur 'lane, an' i dueyds ad her whose and merisbei selse, thia is, clone, fer nd 'tsotuse,' te' bodosmar we'll send us Alezondro's."

We left the Huver, and bent our way home, our

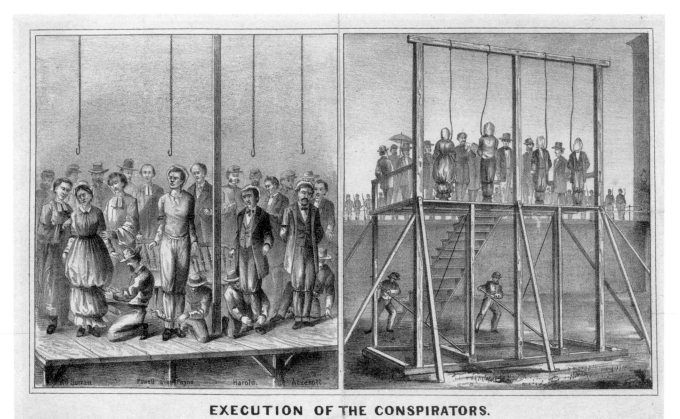

EXECUTION OF THE CONSPIRATORS.

PRAPARING FOR EXECUTION, SPRINGING OF THE TRAP

210.

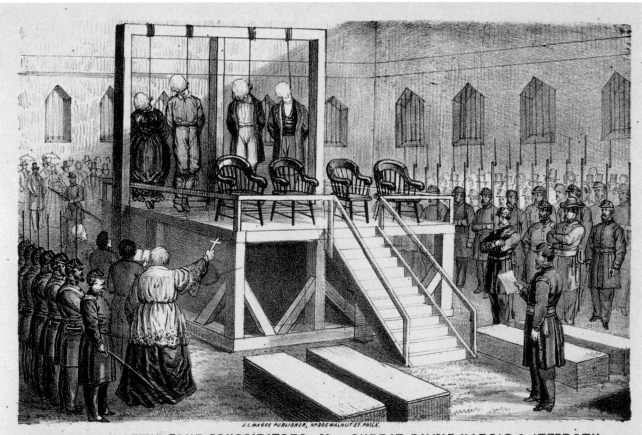

J.L.MAGEE PUBLISHER, N°305 WALNUT ST. PHILA.

EXECUTION OF THE FOUR CONSPIRATORS: Mrs. SURRAT, PAYNE, HAROLD & ATZEROTH.

AT WASHINGTON, D.C. JULY 7, 1865.

211.

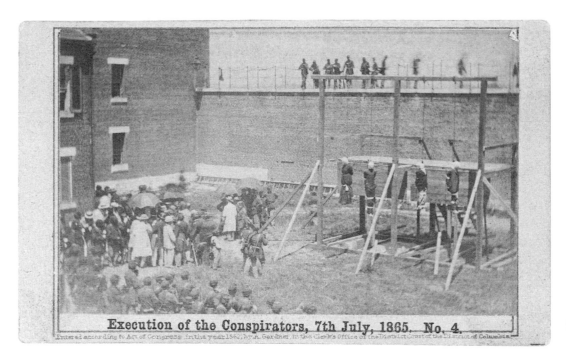

Execution of the Conspirators, 7th July, 1865. No. 4.

Entered according to Act of Congress, in the year 1865, by A. Gardner, in the Clerk's Office of the District Court of the District of Columbia.

212.

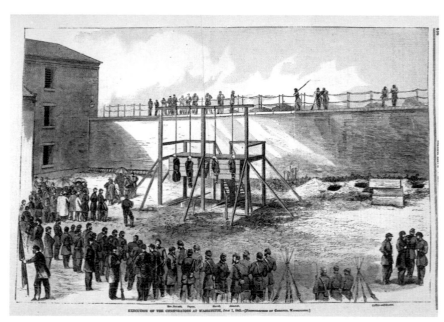

213.

EXECUTION OF THE CONSPIRATORS AT WASHINGTON, July 7, 1865.—[PHOTOGRAPHED BY GARDNER, WASHINGTON.]

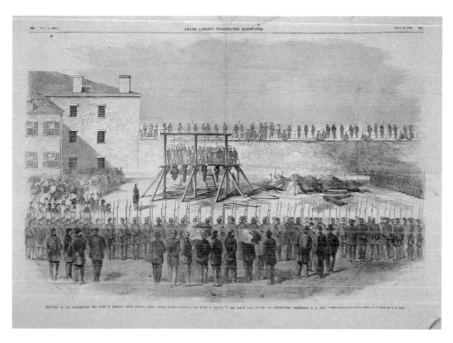

214.

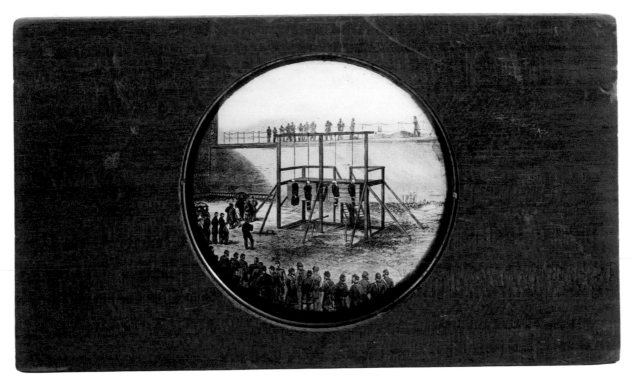

215.

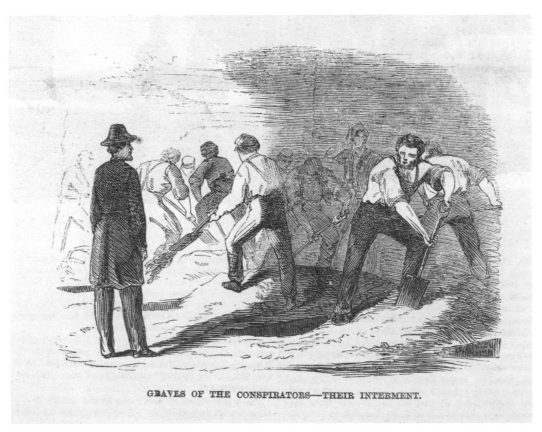

GRAVES OF THE CONSPIRATORS—THEIR INTERMENT.

216.

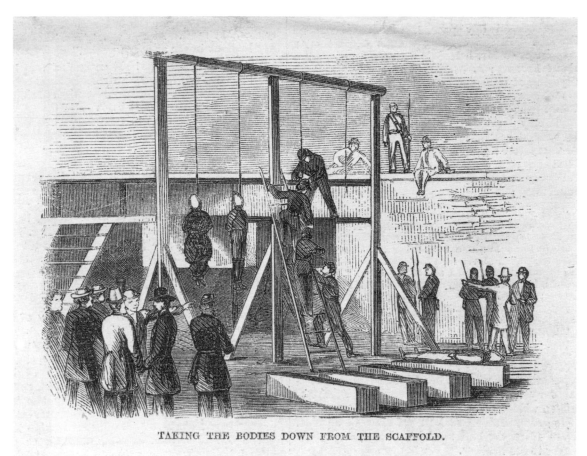

TAKING THE BODIES DOWN FROM THE SCAFFOLD.

217.

218.

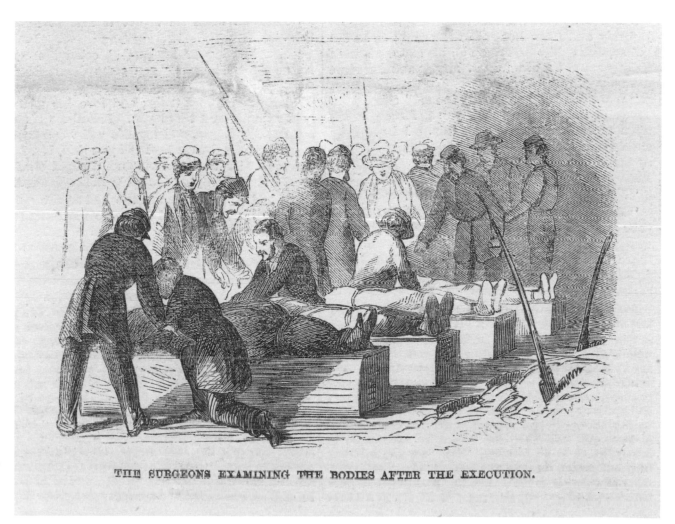

THE SURGEONS EXAMINING THE BODIES AFTER THE EXECUTION.

Washington, D.C.
July 9th 1865

Genl. Hartranft,

Genl. Hancock told Mr.
Holohan that you had some things that
belonged to my poor Ma, which, with
my consent, you would deliver to him.
Don't forget the pillow upon
which her head rested, and her prayer
beads if you can find them — these
things are dear to me.

Some one told me that you wrote
to the President stating that the
Prisoner Payne had confessed to you
the morning of the Execution that Ma
was entirely innocent of the Presidents
assassination, and had no Knowledge
of it. Moreover, that he did not think
that she had any Knowledge of the

219. On July 9, just two days after her mother's execution, Anna Surratt wrote this heartbreaking letter to General Hartranft.

abduction plot, and that you believe
that Payne had confessed the truth.
I would like to know if you did
it, because I wish to remember and
thank those who did Ma the least
act of kindness. I was spurned and
treated with the utmost contempt
by everyone at the White House.

Remember me to the Officers who had
charge of Ma and I shall always think
Kindly of you—

Yours Respectfully—

Anna Surratt

220. The broadside announcing the December 30, 1870, Washington, D.C., lecture that John Surratt never gave.

CHAPTER SIX

EPILOGUE – THE TRIAL OF JOHN H. SURRATT

And I only am Escaped Alone to Tell Thee.

—Herman Melville, *Moby Dick*

JOHN H. SURRATT FLED THE COUNTRY, thereby saving himself from the military commission that had sentenced his mother to death and would have likely done the same to him. After hiding in Canada, he traveled to Europe and, incredibly, joined the Papal Zouaves at the Vatican. His freedom did not last long. In 1866 a fellow Zouave recognized and denounced him. He was captured, but made a spectacular escape by leaping from a precipice. He was later recaptured and finally brought back to Washington for trial by a civil criminal court, not a military commission.

His return caused a brief sensation. Newspapers wrote about him, *Harper's Weekly* and *Frank Leslie's Illustrated Newspaper* published woodcut portraits, and people purchased his photograph. The trial resurrected many of the witnesses who had testified against his mother, Mary. After the long trial—its transcript filled two volumes—John Surratt was not convicted. He was released in August 1867.

For a time he vanished from the public eye. Then he began a lecture tour, delivering his first lecture in Rockville, Maryland, on December 6, 1870. Adopting the jaunty pose of a gentleman adventurer and cavalier, Surratt admitted freely—even boasted of—his occupation of Confederate agent and courier and his role in Booth's plot to kidnap Abraham Lincoln. Curiously, he said little of his mother, and he failed to plead her innocence to the audience. Although his remarks were contradictory and self-serving, and revealed little beyond what was already in the public record, he thrilled his listeners.

Emboldened by his success before a sympathetic southern crowd, he gave other lectures in New York City and Baltimore. Then he decided to return to the scene of the crime—Washington, D.C.

Surratt planned a lecture for December 30, 1870, and had large broadsides printed to advertise his talk at the Odd Fellows Hall at Seventh Street above D, only a few blocks from Ford's Theatre and his mother's old boardinghouse. The broadside tantalized readers with promises of exciting revelations: "His introduction to J. Wilkes Booth, and the plan arranged to kidnap, not murder President Lincoln"; "The attempted abduction and its defeat, together with the abandonment of the plot"; "Running the Gauntlett of Stupid Detectives"; "Louis J. Weichman a party to the Abduction"; "Life Among the Papal Zouaves in Rome"; "Arrest and return to the United States!"

Surratt's lecture, intended to clear his name, was seen as an outrageous attempt to profit from the assassination just five years after Lincoln's murder. News of the forthcoming event provoked protests, for the broadside asserted that "all reports to the contrary" Surratt will "most positively deliver his lecture." In fact, the event was canceled, and John H. Surratt never lectured again.

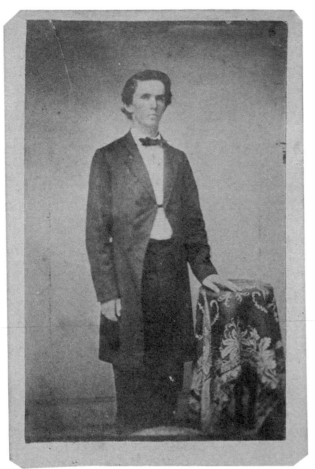

221.

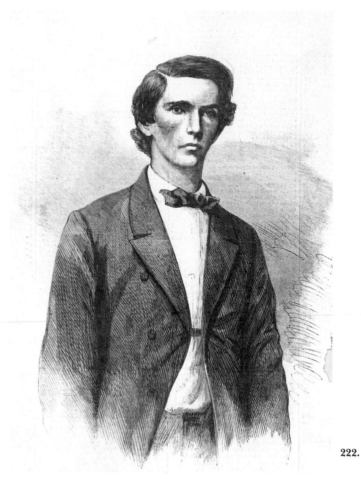

222.

After Abraham Lincoln was assassinated in April 1865, the government used this photograph (fig. 221) to aid in the hunt for John Surratt, John Wilkes Booth, and the others. The search for Surratt proved futile, and he escaped to Europe. When news of Surratt's capture in late 1866 reached America, *Harper's Weekly* resurrected the old photo and rushed this woodcut (fig. 222) to press in its December 29, 1866, issue.

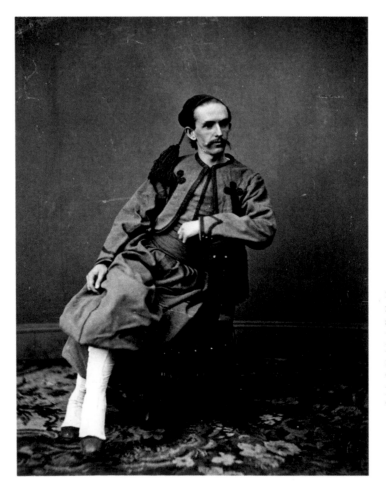

223. John Surratt in the Zouave uniform of the Papal Guard, where he served before his capture and return to the United States. His service in Rome fueled rumors that the assassination of Lincoln was part of a Catholic conspiracy. Copies of this photograph were sold to the public during Surratt's 1867 trial.

Washington D.C.
Oct. 17 1863

How. E. M. Stanton
Secretary of War,
Sir;

Having been informed that vacancies have lately arisen in the "Paymaster Generals Department," I have determined to make application to you, in hopes of obtaining a position in said Bureau, or in any other in which clerks are needed.

Though almost an utter stranger to you, I am firmly convinced that you will at least, not cast aside my petition, especially, when you reflect that I am the only son of a widow, dependent, in a great measure, on me for support. I have passed through a four years course of collegiate study, and my education is such as to enable me to fill any position to

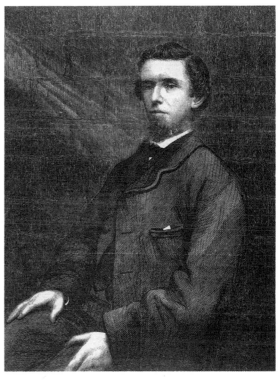

224. *Frank Leslie's Illustrated Newspaper* also based this woodcut from its January 5, 1867, issue on a photograph.

which you may think proper to assign me
As to reference, with regard to character or capacity; I most respectfully beg leave to call your attention to the testimonials by which this letter is accompanied.
Humbly awaiting your answer and confidant that you will do all in your power.
I remain Honored Sir,
Very Resp.
Your Obt. Servant
J. H. Surratt

225. In this mysterious letter dated eighteen months before the assassination, John Surratt asks Secretary of War Edwin M. Stanton for a job in the Paymaster General's Department. It is possible that he sought a government post to gather intelligence for the Confederacy.

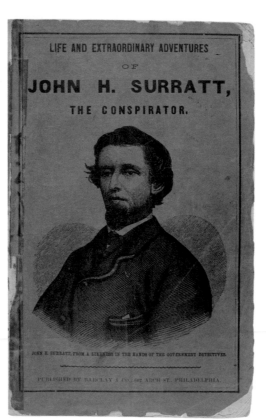

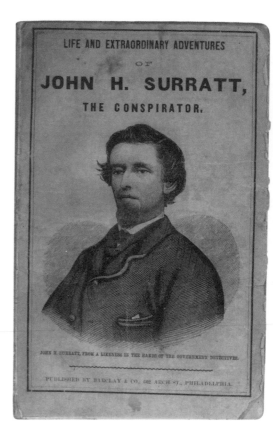

226. The argument against John Surratt by prosecuting attorney Edwards Pierrepont was published separately in this Government Printing Office pamphlet.

227. The capture of Surratt gave the ubiquitous publisher Barclay & Company another opportunity to profit from public interest in the Lincoln assassination. Like *Frank Leslie's*, this pamphlet, bound in colorful wrappers, copied its portrait from a photograph.

228. Another Barclay pamphlet on the dramatic story of John Surratt.

229. In the middle of John Surratt's trial, the U.S. Marshal's Office in Washington, D.C., ordered his release for bail. Someone thought the better of it and crossed out Surratt's name. He would not be given a second chance to flee the country and escape justice.

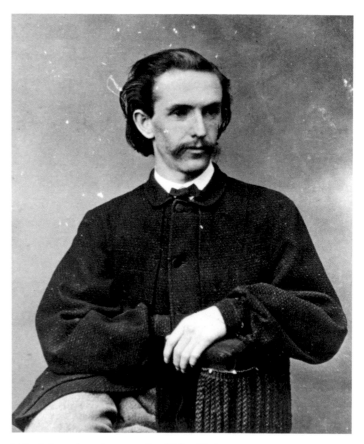

230. A flattering photograph of John H. Surratt in confident repose, probably taken after his release from prison in 1867

TRIAL

OF

JOHN H. SURRATT

IN

THE CRIMINAL COURT

FOR

THE DISTRICT OF COLUMBIA.

Hon. GEORGE P. FISHER Presiding.

VOLUME I.

WASHINGTON:
GOVERNMENT PRINTING OFFICE.
1867.

This book was the property for sixty years of Louis J. Weichman, principal United States Government witness at the trial of the Lincoln Conspirators in 1865 at Washington, D.C.

The undersigned, his sisters living with him in Anderson, Ind. at the time of his death, June 5, 1902, hereby certify to the above fact, on this day, July 9, 1925.

Mrs C. O'Crowley
M. C. Weichman
Louise E. Lewis, witness

232. The flyleaf of Louis J. Weichmann's personal copy of *Trial of John H. Surratt*. Weichmann, a clerk for the War Department, resided in Mary Surratt's boarding-house and observed the comings and goings of the conspirators. He was one of the most important witnesses at the 1865 trial and was one of two people most responsible for the guilty verdict against John Surratt's mother, Mary. Weichmann also testified against John Surratt in 1867. John Surratt denounced Weichmann during his 1870 lecture, and they carried on a bitter feud for the rest of their lives. Weichmann's copy of the Surratt trial transcript, which was collected by the historian Lloyd Lewis, bears an inscription from his sisters: "This book was the property for sixty years of Louis J. Weichman, principal United States Government witness at the trial of the Lincoln Conspirators in 1865 at Washington, D.C. The Undersigned, his sisters living with him in Anderson, Ind. at the time of his death, June 5, 1902, hereby certify the above fact."

231. *Trial of John H. Surratt in the Criminal Court for the District of Columbia.* The jury trial of John H. Surratt lasted from June 10 to August 11, 1867, and resulted in his release when the jury could not reach a verdict. The two-volume hardbound transcript filled 1,383 pages and revisited the themes and resurrected many of the witnesses from the conspiracy trial two years prior.

233. "The drama's done. Why then here does any one step forth?—Because one did survive the wreck." Melville's *Moby Dick* suggests the fate of John H. Surratt. Booth was killed on April 26, 1865. George Atzerodt, David Herold, Lewis Powell, and Mary Surratt were hanged on July 7, 1865. Michael O'Laughlin died in prison on September 23, 1867. After their release, Edman Spangler died on February 7, 1875; Dr. Samuel A. Mudd on January 10, 1883; and Samuel Arnold, the last of the conspirators tried in the spring and summer of 1865, on September 21, 1906. John Surratt remained the one man alive with personal knowledge of the great conspiracy. Disappointed at the failure of his 1870 lecture tour, plagued for the rest of his life by the accusation that he was a coward who abandoned his mother to die, bedeviled by the memory and living presence until 1902 of Lewis Weichmann, his former friend and a principal government witness against his mother and then himself, John H. Surratt died on April 21, 1916, half a century after the great crime. What secrets he knew, he took to the grave.

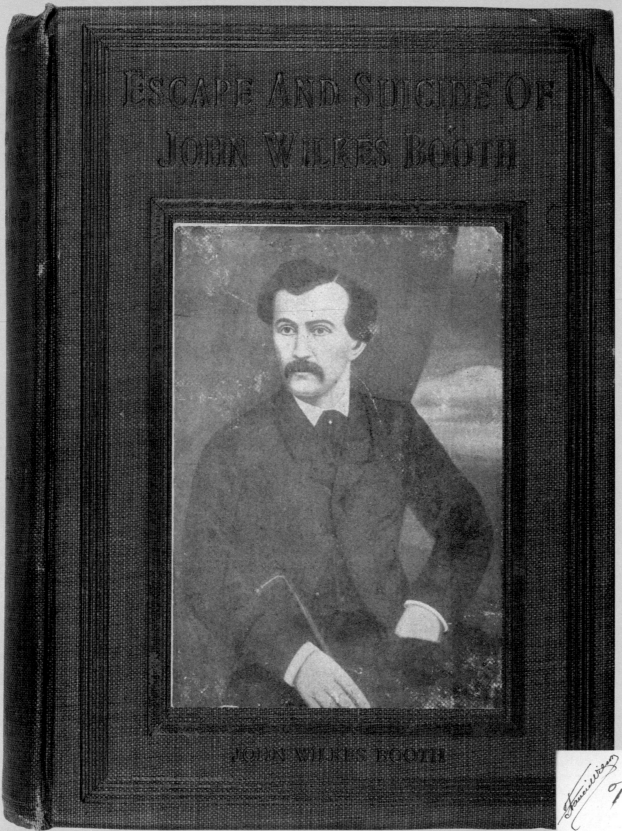

ESCAPE AND SUICIDE OF

JOHN WILKES BOOTH

JOHN WILKES BOOTH

234. Memory becomes myth in *The Escape and Suicide of John Wilkes Booth*. In 1907, Finis L. Bates published this far-fetched yet entertaining account of Booth's alleged escape from Garrett's farm and his subsequent friendship with the author. This piece of sensationalism became one of the most popular Lincoln books ever—more than 75,000 copies were sold. Appropriately, this fictional tale was hawked during public exhibitions of the alleged mummified corpse of Booth. The book's success is evidence of the enduring popularity of the assassination theme more than forty years after the great crime. Bates argued that Booth was not killed at Garrett's farm on April 26, 1865. Instead, he claimed, Booth escaped, assumed the name John St. Helen, and died in Enid, Oklahoma, in 1903.

235. One escape artist invokes the name of—allegedly—another. In a moment of inside humor, magician and escape artist Harry Houdini presented this copy of *The Escape and Suicide of John Wilkes Booth* to his friend and Booth biographer Francis Wilson.

Francis Wilson

To my friend
Francis Wilson
Best wishes
Houdini

Feb 17/21

CHAPTER SEVEN

MEMORY AND MYTH

"That mass of myth. . . was rising to hide Abraham Lincoln and most of the actors in the drama of his assassination and its epilogue, the trial of the conspirators. . . . Out of that black welter of primitive emotion and superstition came a great American myth, rising very naturally on the wave of supernaturalism to spread across the land."
—Lloyd Lewis, *The Great American Myth*

THE ASSASSINATION OF ABRAHAM LINCOLN, the death of John Wilkes Booth, and the trial and execution of the conspirators entered American folklore. Lincoln's martyrdom at his supreme moment of victory—the very week the Civil War was won—assumed symbolic and even mystical importance in the public mind. Perhaps these events were fated to be. The president himself believed in the prophecy of dreams and inexorable destiny. Perhaps it was the intent of the almighty that like Moses, Abraham should be raised up to see the promised land, where he had led his people but was forbidden to enter, his journey done. Perhaps Booth, like Judas, served a higher purpose. Walt Whitman and Herman Melville lamented and mythologized the death of their hero.

The story of John Wilkes Booth was transformed into popular myth. When the assassin's body was brought back to Washington, the government took rigorous steps to confirm the identity of the man killed at Garrett's farm. All personal effects collected at the scene were scrutinized by the secretary of war. Witnesses who knew Booth in life were summoned to identify him in death. During a careful autopsy, surgeons confirmed the presence of a distinctive scar and an old tattoo—"JWB"—that Booth had given himself years before with ink. Alexander Gardner was even called in to make photographs—which have never been found—of the corpse. The government wanted desperately to forestall the birth of a Booth survival myth.

In the last quarter of the nineteenth century, several imposters claimed to be the real John Wilkes Booth. The mummified corpse of one of them was displayed for decades at state fairs and carnivals.

Several books fueled the myth, and one author claimed to be Booth's secret daughter. The legend of a Booth who would not die suggests the traditional fate of the damned—of the assassin's soul that can find no rest and is fated to wander the earth.

Like the generals who re-fought the Civil War for decades through their books and memoirs, the veterans of the trial and execution retried the case for the rest of their lives. For General Holt, proving that he did show President Johnson the clemency petition for Mary Surratt became an obsession. One of Mary Surratt's priests lectured on her innocence, and fifteen years after the execution, one of her attorney's, John W. Clampitt, wrote an article claiming that she was innocent and that the commission had murdered her. Former Attorney General James Speed joined the fray. Several participants in the execution, including the hangman, Christian Rath, published reminiscences of that day. General Thomas Harris wrote a book about the conspiracy and insisted that the trial and punishments were just. A lawyer responded with a book saying that Mary Surratt had been judicially murdered.

At the turn of the century, Samuel Arnold, the last surviving conspirator from the trial of 1865, published his reminiscences. Dr. Mudd's daughter published a collection of his letters, Hollywood made a motion picture about him, and for more than one hundred years his family has lobbied—despite the evidence against him—to clear his name.

The words about the great crime have never ceased. Today, nearly a century and a half later, they continue to be written.

236.

236. – 239. Finis L. Bates commissioned oil paintings of Abraham Lincoln, Andrew Johnson, and several of the assassination conspirators to publish in *The Escape and Suicide of John Wilkes Booth* and to display to the public. The paintings of Johnson, Mary Surratt, and the long leather boot Booth wore when he shot Lincoln, and which he abandoned at Dr. Mudd's house, are long lost. But four of the oils were recently

237.

rediscovered. They are published here for the first time in color and for only the second time since 1907. All the paintings are accurate likenesses except Booth's, which was distorted deliberately to advance the author's Booth escape fantasy. Strangely, Bates commissioned two different paintings of Booth, the distorted painting and the one that appears on the cover of his book, which is a good likeness of the actor.

238.

239.

F. L. BATES, LAWYER,
297 SECOND STREET,
MEMPHIS, TENN., U.S.A.

F. L. BATES, LAWYER.
297 SECOND STREET.

MEMPHIS, TENNESSEE, U. S. A.

Dec 9th 1902

Dear Sir:

I had John Wilks Booth as my client in Western Texas from about 1875 to 1877 or 8: I have a picture of him taken & delivered to me for his identification, and have from him the true story of the assassination of Lincoln & his escape &c,

yours &c
F L Bates

240. & 241. In this preposterous letter, still in its original envelope and mailed on December 9, 1902, to the editor of the *Baltimore American*, F. L. Bates insists that "I had John Wilkes Booth as my client in Western Texas from about 1875 to 1877 or 8: I have a picture of him taken and delivered to me for his identification, and have from him the true story of the assassination of Lincoln and his escape."

242. A paperback edition extended the popularity and longevity of Bates's book.

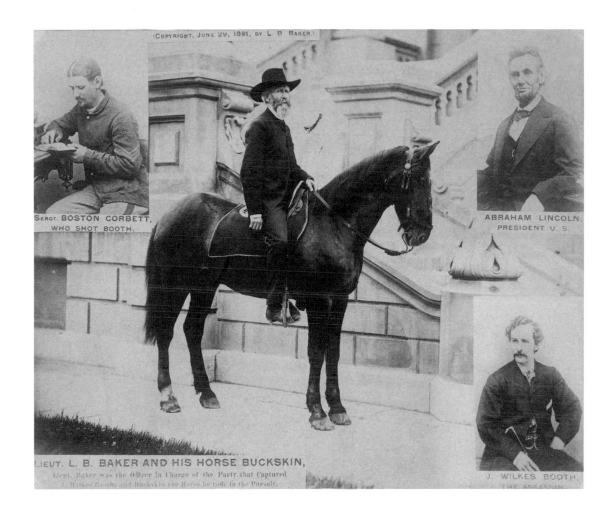

243. 244. & 245. John Surratt was not the only man who attempted to make money by lecturing about the Lincoln assassination. Luther B. Baker, brother of the controversial War Department detective LaFayette Baker, went on the circuit to tell of his role in the hunt for Booth and the conspirators and to sell a large souvenir photograph with an explanatory note that, curiously, was written in the voice of Baker's horse.

246. Assassination bookshelf. A core collection of trial transcripts, accounts by participants, and early critical commentary. The complete bibliography of the trial and execution of the Lincoln conspirators contains several hundred titles.

THE

JUDICIAL MURDER

—OF—

MARY E. SURRATT.

DAVID MILLER DeWITT.

BALTIMORE:
JOHN MURPHY & CO.
1895.

THE ASSASSINATION OF

ABRAHAM LINCOLN

AND ITS EXPIATION

BY
DAVID MILLER DEWITT
author of "THE IMPEACHMENT AND TRIAL OF PRESIDENT JOHNSON"

New York
THE MACMILLAN COMPANY
1909
All rights reserved

247. 248. & 249. In two pioneering books, Baltimore lawyer David Miller DeWitt attacked the legitimacy of the military commission and the fairness of the sentences. In 1895, thirty years after the trial and execution of Mary Surratt, his controversial book, *The Judicial Murder of Mary E. Surratt,* opened old wounds and raised new questions. DeWitt explained her execution as a symptom of the hysteria and lust for vengeance that the murder of Lincoln excited. Miller followed up in 1909 with *The Assassination of Abraham Lincoln and Its Expiation.* DeWitt's books, despite their biases, remain essential references today.

250. In 1892 General T. M. Harris, a member of the military commission, published *The Assassination of Lincoln. A History of the Great Conspiracy. Trial of the Conspirators by a Military Commission and a Review of the Trial of John H. Surratt.* Harris wrote to defend the reputation of the commission and to counter "efforts that have been made . . . ever since the execution of the assassins that were condemned to death, to prejudice public sentiment against the government by the assumption of the innocence of one of the parties executed—Mrs. Surratt."

THE LIFE
OF
Dr. Samuel A. Mudd

CONTAINING HIS LETTERS FROM FORT JEFFERSON,
DRY TORTUGAS ISLAND, WHERE HE WAS IM-
PRISONED FOUR YEARS FOR ALLEGED COMPLICITY
IN THE ASSASSINATION OF ABRAHAM LINCOLN

WITH

STATEMENTS OF MRS. SAMUEL A. MUDD,
DR. SAMUEL A. MUDD, AND EDWARD
SPANGLER REGARDING THE ASSASSINATION

AND

THE ARGUMENT OF GENERAL EWING
on the Question of the Jurisdiction of the Military Commission,
and on the Law and Facts of the Case

ALSO "DIARY" OF JOHN WILKES BOOTH

EDITED BY HIS DAUGHTER
NETTIE MUDD

WITH PREFACE BY
D. ELDRIDGE MONROE
OF THE BALTIMORE BAR

New York and Washington
THE NEALE PUBLISHING COMPANY
1906

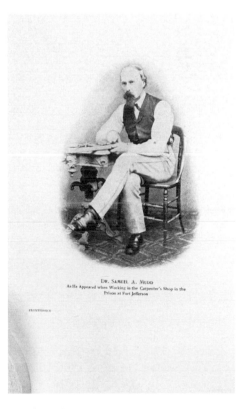

DR. SAMUEL A. MUDD
As He Appeared when Working in the Carpenter's Shop in the
Prison at Fort Jefferson

251. 252. & 253. In 1906, the daughter of Dr. Samuel A. Mudd published this collection of her late father's letters written from prison at Dry Tortugas, Florida.

254. In a letter written three years after the trial, Major General Winfield Scott Hancock explains that he was not president of the military commission, but that he was served the writ of habeas corpus for Mrs. Surratt on the morning of the execution: "The return to the writ was made by me in person, bearing a return from the President of the United States suspending the writ of habeas corpus in this case, and directing the Execution to proceed."

255. Three decades after the trial and execution, Christian Rath, the hangman on July 7, 1865, writes to a correspondent that "I am the man that executed the Lincoln Conspirators." For the rest of their lives, the principals from the trial and execution received mail from souvenir hunters, who beseeched them for relics, photos, and documents. Rath answers here that he has none and claims disingenuously that "such a thing was considered worthless at that time, neither have I ever had a desire for any thing of their belongings about me." In fact, relics were prized, and it was Rath who had cut the hanging ropes into pieces and distributed them as souvenirs twenty-seven years earlier.

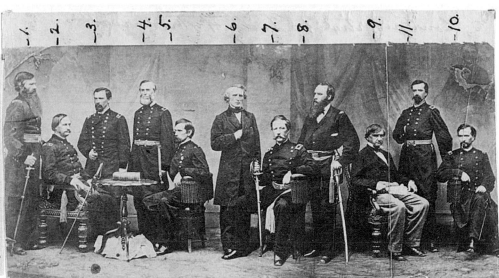

WAS MARY SURRATT GUILTY?

Her Counsel in Chicago Loses His Evidence by Fire.

CHICAGO, March 23.—Fire has just destroyed the last documentary evidence that, it is alleged, would have removed the stain of the charge of conspiracy to assassinate Abraham Lincoln from the name of Mary Surratt. This woman, who suffered death, had for her counsel John W. Clampitt of Highland Park, in whose possession was the evidence that he thinks would have shown that in the passion of the hour an innocent person had been sacrificed.

For thirty years Colonel Clampitt had been collecting evidence and had it so complete that he believed none would doubt it. It was ready for publication, and then came the fire which destroyed his residence and all the evidence accumulated since that day, thirty years ago, when he strove to save the woman from the gallows. Among the documents burned was a statement from Father Walter of Washington, recently deceased, who administered the last sacraments to Mrs. Surratt. Father Walter said it had been evident to him that the War Department, while bent on convicting, had doubts of the guilt of Mrs. Surratt. Father Walter was sent for by the department the day before the execution, and had been told that he would not be allowed to see Mrs. Surratt on the day of her death unless he would pledge his faith and honor as a priest of God that after he had absolved her and she had received the sacrament he would prevent her from making any protestation of her innocence. In other words, as the price of being allowed to minister to a dying woman, Father Walter was forced by the War Department to consent to allow her to die without one word from her lips to the world as to her innocence. The fact that she did not declare her innocence when in the state of grace following absolution has been used as an argument in favor of her guilt. The truth is that this woman on the scaffold, shrived for eternity, turned to her spiritual adviser and said:

"Holy Father, can I not tell these people before I die that I am innocent of the crime for which I have been condemned to death?"

Father Walter replied: "No, my child, the world and all that is in it has now receded forever; it would do no good, and it might disturb the serenity of your last moments."

Colonel Clampitt says he also secured evidence that in the military commission which tried Mrs. Surratt it was first proposed to acquit her or at least spare her life, but it was finally decided to render the same judgment as in the cases of the others accused, with a recommendation to mercy in her case. The recommendation for mercy was detached in the War Department and never reached President Johnson until two years after Mrs. Surratt had been hanged.

Indianapolis, Ind.,
March 3, 1895.

Mr. A. E. Allen:

Dear Sir:

I send the photo at last. Beg pardon for the delay.

The trial of the assassins was perfect in every respect. No judicial inquiry was ever more fairly conducted.

The names of the officers composing the court, are as follows, beginning at the left of the photo.

(1) Gen. Harris : (2) Gen. Hunter : (3) Gen. Kautz : (4) Gen. Ekin; (5) Gen. Wallace : 6. Mr. Bingham : (7) Gen. Howe : (8) Col. Tompkins : (9) Gen. Holt : (10) Mr. Burnett : (11) Gen. Foster.

Gen. Hunter was first officer,

Respectfully,
Lew. Wallace.

14

HE MIGHT HAVE HANGED.

Peril of a Man Who Stood Talking with Booth Just Before the Shooting of Lincoln.

[Washington Post.]

"I once came within an ace of being hanged" was the alarming statement made the other day by Mr. Lloyd Moxley, the city bill poster. Mr. Moxley has been in the theatrical business for thirty-two years, but for some time he has not been engaged in active work. It was when he had been in the business only a few years that he came so near having his neck stretched, and, although his name has never been used in connection with the affair, it was at the time Lincoln was assassinated. Mr. Moxley was an intimate friend of Booth, and tells the story in the following way:

"Yes, sir, I firmly believe that I came as near to being hanged as any condemned criminal with the death-watch set upon him. It was when Lincoln was shot by Booth. I had been in the theatrical business as a manager, and in this way became acquainted with Booth. On that eventful evening I was standing just outside the President's box, on the right-hand side of the door, when Booth came by. He stopped, and I had no suspicion of the dreadful deed he was about to commit. He stayed there with me, talking and chatting in a low tone, for about twenty minutes, and in that time about half a dozen persons who knew us both came by and saw us. I knew every one who came by so well that they scarcely looked at me, and in that lay my safety, for had I been recognized by any one I would have been arrested as one of the conspirators.

"It was only after Booth had fired his shot that I realized what might follow if any one had seen me talking with him. There I had stood with him for nearly half an hour, just outside the President's box, preceding the commission of crime. The evidence against me would have been overwhelming, and no power on earth could have saved me from conviction as the principal accomplice. As soon as I could do so unnoticed I left the theatre and hurried home, expecting to be arrested every moment. If I had not been so well known all the theatre people passing would have noticed me at once. How I escaped is a mystery to me even now, and for weeks I remained at home, for fear I might meet some one who had seen me that night, and thus revive my impression in his mind. I did not feel safe until the trial was over and the conspirators hanged. I am certain that if I had not escaped recognition I would have been hanged with Mrs. Surratt, Payne, Atzerott, and Herold.

"Another strange thing that happened the evening of the crime is one of those coincidences which happen so often when we least expect them. The Peterson house on Tenth street, where Mr. Lincoln died, was a boarding-house for actors at the time of the tragedy, and I have it on reliable authority that Booth had a room in the house during his stay in the city. About 3 o'clock in the afternoon he came in and went directly to his room, and tried to sleep on the bed. Now here is the strange part: The very room that he had was the one that Mr. Lincoln was carried to after the shot, and the very bed on which Booth tried to sleep before the commission of his crime was the bed upon which his victim died. So far as I know, this has never been made public, but that it is true I have not the slightest doubt."

256. This scrapbook page made up decades after the assassination includes a photograph of the military commission and a letter from Major General Lew Wallace. Writing thirty years after the events of the spring and summer of 1865, Wallace asserts that "The trial of the assassins was perfect in every respect. No judicial inquiry was ever more fairly conducted."

SELECTED BIBLIOGRAPHY

Abott, Abott A. *The Assassination and Death of Abraham Lincoln.* New York: The American News Co., 1865.

Arnold, Samuel Bland. *Defense and Prison Experiences of a Lincoln Conspirator, Statements, and Bibliographical Notes.* Hattiesburg, Miss.: The Book Farm, 1943

Baker, LaFayette Charles. *History of the United States Secret Service.* Philadelphia: King and Baird, 1868.

Bates, Edward. *The Diary of Edward Bates, 1859–1866.* Edited by Howard K. Beale. Washington, D.C.: Government Printing Office, 1933.

Bates, Finis T. *Escape and Suicide of John Wilkes Booth.* Memphis: Pilcher Printing Co., 1907.

Bingham, John. A. *Argument of John A. Bingham.* Washington: Government Printing Office, 1865.

Borreson, Ralph. *When Lincoln Died.* New York: Appleton-Century, 1965.

Bryan, George S. *The Great American Myth.* New York: Carrick and Evans, 1940.

Buckingham, J. E. Sr. *Reminiscences and Souvenirs of the Assassination of Abraham Lincoln.* Washington, D.C.: Press of Rufus H. Darby, 1894.

Burnett, H. L. *Some Incidents in the Trial of President Lincoln's Assassins/The Controversy between President Johnson and Judge Holt.* New York: The Commandery of the State of New York; Appleton and Co., 1891.

———. *Assassination of President Lincoln and the Trial of the Assassins.* New York: Ohio Society of New York, 1906.

Campbell, Helen Jones. *The Case of Mrs. Surratt.* New York: G. P. Putnam's Sons, 1943.

Carter, Samuel, III. *The Riddle of Dr. Mudd.* New York: G. P. Putnam's Sons, 1974.

Chamlee, Roy Z. Jr. *Lincoln's Assassins: A Complete Account of Their Capture, Trial, and Punishment.* Jefferson, N.C.: McFarland & Company, 1990.

Chase, Salmon P. *Inside Lincoln's Cabinet.* Edited by David Donald. New York: Doubleday and Co., 1965.

Christie's East. Auction catalogs of 12 May 1999 and 12 September 2000.

Clampitt, John W. "Trial of Mrs. Surratt." *North American Review* 131 (September 1880): 223–240.

Cooney, Charles F. "The Trial of the Lincoln Conspirators: The Reminiscences of General August V. Kautz." *Civil War Times Illustrated,* vol. 13, no. 6 (August 1975).

Cottrell, John. *Anatomy of an Assassination.* New York: Funk and Wagnalls, 1966.

Coxshall, William. "'One of the Grimmest Events I Ever Participated In': William E. Coxshall and the Execution of the Lincoln Conspirators." Edited by Daniel E. Pearson. *The Lincoln Ledger: A Publication of the Lincoln Fellowship of Wisconsin,* vol. 3, no. 4 (November 1995).

Curran, John W. *The Lincoln Conspiracy Trial.* Chicago: Home of Books, 1939.

Dana, Charles A. *Recollections of the Civil War, with the Leaders at Washington and in the Field, in the Sixties.* New York: D. Appleton and Co., 1902.

DeWitt, David M. *The Assassination of Abraham Lincoln and Its Expiation.* New York: Macmillan, 1909.

———. *The Impeachment and Trial of Andrew Johnson.* New York: Macmillan, 1903.

———. *The Judicial Murder of Mary E. Surratt.* Baltimore: John Murphy and Co., 1895.

Doster, William E. *Lincoln and Episodes of the Civil War.* New York: G. P. Putnam's Sons, 1915.

Douglass, Henry Kyd. *I Rode with Stonewall*. Chapel Hill: University of North Carolina Press, 1940.

Eisenschiml, Otto. *In the Shadow of Lincoln's Death*. New York: Wilbur Funk, Inc., 1940.

————. *Why Was Lincoln Murdered?* Boston: Little Brown, 1937.

Flower, Frank A. *Edwin McMasters Stanton*. Akron: The Sadfield Publishing Co., 1905.

Forester, Izola. *This One Mad Act*. Boston: Hale, Cushman, and Flint, 1937.

Frank, Seymour J. "The Conspiracy to Implicate the Confederate Leaders in Lincoln's Assassination." *The Mississippi Valley Historical Review*, vol. 40, no. 4 (March 1954).

Giddens, Paul H. "Benn Pitman on the Trial of Lincoln's Assassins." *Tyler's Quarterly Historical and Genealogical Magazine* (July 1940).

Gleason, D. H. L. "Conspiracy against Lincoln" *Magazine of History* 13 (February 1911): 59–65.

Gray, John A. "The Fate of the Lincoln Conspirators: The Account of the Hanging, Given by Lieutenant-Colonel Christian Rath, the Executioner." *McClure's* 82 (October 1911): 626–636.

Haco, Dion. *John Wilkes Booth, the Assassinator of President Lincoln*. New York: T. R. Dawley, 1865.

Hanchett, William. *The Lincoln Murder Conspiracies*. Urbana: University of Illinois, 1983.

Hancock, Almira. *Reminiscences of Winfield Scott Hancock by His Wife*. New York: Charles L. Webster and Co., 1887.

[Hantranft, John F.]. National Archives. U.S. Army Continental Commands, 1821–1920. "Records of Brevet General John Frederick Hartranft as Special Provost Marshal for the Trial and Execution of the Assassins of President Lincoln." RG 393. National Archives Bureau of Archives and History, Harrisburg, Pa.

Harris, Thomas M. *The Assassination of Lincoln: A History of the Great Conspiracy: Trial of the Conspirators by a Military Commission and a Review of the Trial of John H. Surratt*. Boston: American Citizens Co., 1892.

Hayman, Leroy. *The Death of Lincoln: A Picture Story of the Assassination*. New York: Scholastic Book Services, 1968.

Higdon, Hal. *The Union vs. Dr. Mudd*. Chicago: Follett Publishing Co., 1964.

Hoyt, Harrow. *Town Hall Tonight*. Englewood Cliffs, N.J.: 1955.

Hunter, David. *Report of the Military Service of General David Hunter, U.S.A.* New York: D. Van Nostrand Co., 1892.

Jones, Thomas A. *J. Wilkes Booth—An Account of His Sojourn in Southern Maryland after the Assassination of Abraham Lincoln*. Chicago: Laird & Lee, Publishers, 1893.

Katz, Mark. *Witness to an Era: The Life and Photographs of Alexander Gardner*. New York: Viking, 1991.

Kimmel, Stanley. *The Mad Booths of Maryland*. Indianapolis: Bobbs-Merrill Co., 1940.

Kunhardt, Dorothy Meserve, and Kunhardt, Philip B. Jr. *Twenty Days*. New York: Harper & Row, 1965.

Laughlin, Clara E. *The Death of Lincoln: The Story of Booth's Plot, His Deed, and the Penalty*. New York: Doubleday and Co., 1909.

Leupp, Francis E. *The True Story of Boston Corbett: A Lincoln Assassination Mystery Fifty Years Later*. Putnam, Conn., 1916.

Lewis, Lloyd. *Myths After Lincoln*. New York: Harcourt, Brace & Company, 1929.

Lomax, Virginia. *The Old Capitol and Its Inmates. By A Lady, Who Enjoyed the Hospitalities of the Government for a "Season."* New York: E. J. Hale and Co., 1867.

McCarty, Burke. *The Suppressed Truth about the Assassination of Abraham Lincoln.* Philadelphia, 1924.

McKee, Irving. *"Ben-Hur" Wallace: The Life of General Lew Wallace.* Berkeley and Los Angeles: University of California Press, 1947.

McLaughlin, Emmett. *An Inquiry into the Assassination of Abraham Lincoln.* New York: Lyle Stuart, Inc. 1963.

Mogelever, Jacob. *Death to Traitors: The Story of General Lafayette C. Baker, Lincoln's Forgotten Secret Service Chief.* Garden City, New York: Doubleday and Co., 1960.

Moore, Guy W. *The Case of Mrs. Surratt.* Norman: University of Oklahoma Press, 1954.

Mudd, Nettie, ed. *The Life of Dr. Samuel A. Mudd.* New York: The Neale Publishing Co., 1906.

Neely, Mark E. Jr. *The Abraham Lincoln Encyclopedia.* New York: McGraw-Hill Book Company, 1982

Nicolay, John, and John Hay. *Abraham Lincoln: A History.* 10 vols. New York: The Century Co., 1886.

Oldroyd, Osborn H. *The Assassination of Abraham Lincoln: Flight, Pursuit, Capture, and Punishment of the Conspirators.* Washington, D.C., 1901.

Ownsby, Betty J. *Alias "Paine": Lewis Thornton Powell, the Mystery Man of the Lincoln Conspiracy.* Jefferson, N.C.: McFarland & Company, 1993.

Pratt, Fletcher. *Stanton: Lincoln's Secretary of War.* New York: W. W. Norton, 1953.

Prior, Leon O. "Lewis Payne, Pawn of John Wilkes Booth." *Florida Historical Quarterly* (June 1965).

Roscoe, Theodore. *The Web of Conspiracy: The Complete Story of the Men Who Murdered Lincoln.* Englewood, Cliffs, N.J.: Prentice-Hall, 1959.

Searcher, Victor. *The Farewell to Lincoln.* New York: Abington Press, 1965.

Shelton, Vaughan. *Mask for Treason: The Lincoln Murder Trial.* Harrisburg, Penn.: Stackpole Books, 1965.

Steers, Edward Jr. *Blood on the Moon: John Wilkes Booth, Samuel A. Mudd and the Assassination of Abraham Lincoln.* Lexington: University Press of Kentucky, 2001.

Steers, Edward Jr. *His Name Is Still Mudd: The Case Against Dr. Samuel Alexander Mudd.* Gettysburg: Thomas Publications, 1997.

[Surratt, John H.] *Life, Trial, and Adventures of John H. Surratt, the Conspirator: The Correct Account and Highly Interesting Narrative of His Doings and Adventures from Childhood to the Present Time.* Philadelphia: Barclay, 1867.

Taft, Charles Sabin. *Abraham Lincoln's Last Hours from the Notebook of Charles Sabin Taft, MD, an Army Surgeon Present at the Assassination, Death and Autopsy.* Chicago: The Black Cat Press, 1934.

Tanner, James. *While Lincoln Lay Dying: A Facsimile Reproduction of the First Testimony Taken in Connection with the Assassination of Abraham Lincoln as Recorded by Corporal James Tanner.* Philadelphia: The Union League of Philadelphia, 1968.

Thomas, Benjamin P., and Harold M. Hyman. *Stanton: The Life and Times of Lincoln's Secretary of War.* New York: Knopf, 1962.

Tidwell, William A., James O. Hall, and David W. Gaddy. *Come Retribution: The Confederate Secret Service and the Assassination of Abraham Lincoln.* Jackson: University Press of Mississippi, 1989.

Townsend, George Alfred. *The Life, Crime, and Capture of John Wilkes Booth: With a Full Sketch of the Conspiracy of Which He Was the Leader, and the Pursuit, Trial, and Execution of His Accomplices.* New York: Dick and Fitzgerald, Publishers, 1865.

Turner, Thomas Reed. *Beware the People Weeping: Public Opinion and the Assassination of Abraham Lincoln.* Baton Rouge: Louisiana State University Press, 1982.

War of the Rebellion. A Compilation of the Official Records of the Union and Confederate Armies. 128 vols. Washington, D.C.: Government Printing Office, 1880–1901.

Watts, R. A. "The Trial and Execution of the Lincoln Conspirators." *Michigan History* 1, no. 1 (1922): 81–110. Published serially in the *Adrian (Michigan) Telegram,* April 1914.

Weichmann, Louis J. *A True History of the Assassination of Abraham Lincoln and the Conspiracy of 1864.* Edited by Floyd E. Risvold. New York: Alfred Knopf, 1975.

Welles, Gideon. *The Diary of Gideon Welles.* 3 vols. Boston: Houghton Mifflin, 1911.

U.S. Congress. House. *Assassination of Lincoln.* 39th Cong., 1st sess., 1866. Rept. 104.

TRIAL TRANSCRIPTS AND SUMMARIES

Pitman, Benn, comp. *The Assassination of President Lincoln and the Trial of the Conspirators.* New York: Moore, Wilstach and Baldwin, 1865.

Poore, Ben: Perley, ed. *The Conspiracy Trial for the Murder of the President: and the Attempt to Overthrow the Government by the Assassination of Its Principal Officers,* 3 vols. Boston: J. E. Tilton and Co., 1865

[Spangler, Edward]. *Testimony for the Prosecution and the Defence in the Case of Dr. Samuel A. Mudd, Charged with Conspiracy to Assassinate the President of the United States, &c. Tried before a Military Commission, of Which Major-General David Hunter Is President.* Washington, D.C.: Polkinhorn & Son, Printers, 1865

Trial and Execution of the Assassins and Conspirators at Washington, D.C., May and June, 1865, for the Murder of President Lincoln. Philadelphia: T. B. Peterson & Brothers, 1865.

Trial of the Assassins and Conspirators for the Murder of Abraham Lincoln . . . The Evidence in Full, with Arguments of Counsel on Both Sides, and the Verdict of the Military Commission. Philadelphia: Barclay & Co., 1865.

Trial of John H. Surratt in the Criminal Court of the District of Columbia. 2 vols. Washington, D.C.: Government Printing Office, 1867.

Tried for Conspiracy to Murder the President, before a Military Commission, of Which Major-General Hunter Was President, Washington, D.C., May and June, 1865. Thomas Ewing, Jr., Counsel for the Accused.

NEWSPAPERS

Evening Star
Frank Leslie's Illustrated Newspaper
Harper's Weekly Illustrated Newspaper
Milwaukee Free Press
National Intelligencer
National Police Gazette
New York Herald
New York Times
Philadelphia Inquirer
Washington Daily Morning Chronicle
Washington Sunday Morning Chronicle
Washington Weekly Chronicle

CREDITS

Caption continued from page 37:

Figure 1. Booth was "the handsomest man in Washington," according to Ford's Theatre treasurer Henry Clay Ford. The actor Sir Charles Wyndman described him: "Picture to yourself Adonis, with high forehead, ascetic face corrected by rather full lips, sweeping black hair, a figure of perfect youthful proportions and the most wonderful black eyes in the world. Such was John Wilkes Booth. At all times his eyes were his striking features but when his emotions were aroused they were like living jewels. Flames shot from them. . . . He could hold a group spellbound by the hour at the force and the fire and the beauty of him. . . . He was the idol of women. They would rave of him, his voice, his hair, his eyes. Small wonder, for he was fascinating." Booth presented this photograph, according to an inscription on the verso, to T. Valentine Butsch, owner of the Metropolitan Theatre in Indianapolis, Indiana, where Booth played in November 1862 and January 1863. Booth presented a second copy to his brother Edwin, who cherished it at his bedside at The Players in New York until his death in 1893.

ACKNOWLEDGMENTS

We could not have written this book without the help of others. We thank our friends in the Lincoln community for their advice and generosity. James O. Hall, Edward Steers Jr., Joan Chaconas, Michael Kauffman, Laurie Verge, and William Hanchett have, through their research, articles, and books, enhanced our understanding of the assassination of Abraham Lincoln and guided us to some of the important materials included in this book. Frank Williams, passionate Lincolnian and in his spare time Chief Justice of the Supreme Court of Rhode Island, gave freely of his collection. Helen and Ron Shireman, keepers of the General Hartranft archive, went to extraordinary efforts to provide materials essential to the book. Donald Dow, veteran of the Lincoln scene and an expert on Booth and the great conspiracy, gave us some of our favorite images. And Timothy Hughes, our friend and an expert on nineteenth-century newspapers, provided indispensable issues.

We also thank the curators, archivists, and librarians who provided invaluable assistance. Some believe that institutions move slowly, but we have found that all the people we contacted, many of whom did not know us, acted swiftly on our behalf, with both interest and concern in our endeavor. They include Clark Evans, Mary Ison, Carol Johnson, and Erica Kelly at the Library of Congress; Mike Maione and Timothy Goode of the National Park Service; Nancy Buenger and Keshia Whitehead of the Chicago Historical Society; Peggy Appleman at the Washingtoniana Division of the Martin Luther King Jr. Memorial Public Library in Washington, D.C.; Michael Musick at the National Archives; Joanne Spragg of the Lew Wallace Study; Susan Sutton of the Indiana State Historical Library; Lisa Kathleen Grady at the Smithsonian Institution; Brenda Wetzel and John Zwierzyna at the State Museum of Pennsylvania; Mark Harvey and Karen Wojcik of the Michigan Historical Museum; Carolyn Texley at the Lincoln Museum; Allan Aimone, Susane Christophe, Michael McAfee, and Susan Lintelman with the U.S. Military Academy at West Point; John Rhodehamel at the Huntington Library; Jonathan Stayer of the Pennsylvania State Archives; Susan Lemke at the National Defense University; Mark Harvey at the State Archives of Michigan; Chris Coover and Richard Ashton at Christie's; and the staff of the Surratt Society.

We thank the photographers who produced these superior images: Principal photographer Adam Reich of New York; Bill Goes of Chicago; Jim Higgins of the Library of Congress; Michael Brooks, David Buffington, Jon Denker, and Ted Spiegel.

Thanks to Lisa Bertagnoli for expert editorial advice and literary encouragement, to Victor Skrebneski and Dennis Minkel for astute comments on the aesthetics of Civil War photography, and to Elizabeth Snead for valuable insights.

Sylvia Castle of the Abraham Lincoln Book Shop must be given a very special thank you. She put up with the authors' daily queries and demands over many months. She did this not only with her usual efficiency and professionalism but with grace and good humor as well.
—James L. Swanson —Daniel R. Weinberg

I thank Lennart and Dianne Swanson for their foresight in making Lincoln's birthday my own, and for supporting my obsession, and thanks to my grandmother Elizabeth who, when I was ten years old, gave me an old newspaper clipping and framed print of the pistol that killed Lincoln, which made me want to read more. Thanks to Mara Mills for suggesting this book. Finally, I thank Professor John Hope Franklin and Chief Judge Douglas H. Ginsburg of the U.S. Court of Appeals in Washington, D.C., for their good counsel and inspiration.

—JLS

I wish to thank Audrey and Zev Weinberg, my wife and son, who certainly needed humor to put up with my incessant late nights and commandeering of the computer. And thanks to my mother, Ruth Weinberg, who barely saw me for three months but continued her usual encouragement. My thanks for their love and devotion needed to be placed in print.

—DRW

AUTHORS' REQUEST

⊹—⧉—⊹

We seek, for future research and projects, all items related to Abraham Lincoln's life and death, including the following:

BROADSIDES (reward posters and death announcements); JOHN WILKES BOOTH MATERIAL (letters by or about him, playbills, photographs, newspaper reviews of his performances); PHOTOGRAPHS (of the conspirators, the execution, and Ford's Theatre, plus Civil War and slavery views); AUTOGRAPHS, DOCUMENTS, LETTERS (related to Lincoln, the Civil War, and the assassination, especially eyewitness accounts); LINCOLN FUNERAL MATERIAL (prints, silk ribbons, mourning badges, funeral ceremonies, and other memorabilia and ephemera); NEWSPAPERS (complete runs or individual issues of Washington, New York, Chicago, Baltimore, and Philadelphia papers covering the fall of Richmond, the surrender of Lee, the assassination of Lincoln, the trial and execution of the conspirators, and the trial of John Surratt; we especially seek Washington, D.C., papers, including the *Daily Morning Chronicle,* the *National Intelligencer,* and the *Evening Star,* as well as the *National Police Gazette, Harper's Weekly,* and *Frank Leslie's Illustrated Newspaper*); BOOKS AND PAMPHLETS.

We also seek DESCENDANTS of the conspirators, principal officials, soldiers who pursued Booth, and eyewitnesses to any of the events related to the assassination.

Contact
James L. Swanson, P.O. Box 76166, Washington, D.C. 20013
Telephone 202.608.1505; e-mail james.swanson@heritage.org
or www.JamesLSwanson.com.

⊹—⧉—⊹

This book was originally published in 2001 by Arena Editions.

HarperCollins books may be purchased for educational, business, or sales promotional use.
For information please write: Special Markets Department, HarperCollins Publishers,
10 East 53rd Street, New York, NY 10022.

First William Morrow edition published 2006.

Art direction and design by Elsa Kendall

Special thanks to the following people for their substantial contributions
to this book: production: Freddy Cante, Kathleen Sparkes, and Mia McDaniel;
text editing: Peg Goldstein.

Library of Congress Cataloging-in-Publication Data has been applied for.

ISBN-13: 978-0-06-123761-4
ISBN-10: 0-06-123761-2

06 07 08 09 10 10 9 8 7 6 5 4 3 2 1